NAVAJO
SANDPAINTING

NAVAJO SANDPAINTING

From Religious Act To Commercial Art

Nancy J. Parezo

UNIVERSITY OF ARIZONA PRESS
TUCSON, ARIZONA

About the Author . . .

NANCY J. PAREZO has long been active in the investigation of
Indian arts and crafts as they relate to culture change. She completed
a post-doctoral fellowship at the Smithsonian Institution in 1982
where she was working on a project analyzing the role of an-
thropologists and museums in the development of Southwest Indian
arts and crafts.

THE UNIVERSITY OF ARIZONA PRESS

Copyright © 1983
The Arizona Board of Regents
All Rights Reserved

This book was set in 11/13 V-I-P Times Roman
Manufactured in the U.S.A.

Library of Congress Cataloging in Publication Data

Parezo, Nancy J.
 Navajo sandpainting.

 Bibliography: p.
 Includes index.
 I. Navajo Indians—Art. 2. Sandpaintings. 3. Indians of North
America—Southwest, New—Art. I. Title. II. Title: Navajo sand painting.
E99.N3P35 1983 750'.8997 83-4966

ISBN 0-8165-0791-0

Dedicated to
my father, Charles Parezo,
and the memory of my mother,
Georgia Parezo,
for years of encouragement.

CONTENTS

List of Illustrations ix

Foreword xiii

A Word From the Author xvii

1 Against the Backdrop of Tradition 1

2 From Sacred to Secular: the Development
 of Permanent Sandpaintings 22

3 Navajo Reaction to Permanent Sandpaintings 63

4 The Process of Rationalization 75

5 Founding and Spread of Commercial Sandpainting 100

6 Reasons for Learning to Sandpaint 144

7 The Economic Development
 of Commercial Sandpainting 164

Appendixes 193

Bibliography 219

Acknowledgments 244

Index 247

TABLES

2.1 Earliest Known Date for Secular Uses of Navajo
Sandpaintings 25

5.1 Mode of Instruction for Commercial Sandpainters
by Sex of Student 123

5.2 Comparison of Sex of Teachers and Students for
Commercial Sandpainters 132

6.1 Reasons for Starting to Sandpaint by Time Period 151

6.2 Reasons for Starting to Sandpaint by Sex of Maker 154

6.3 Reasons for Starting to Sandpaint by Age of Painter 156

6.4 Income Levels for Contemporary Sandpainters
in 1976 162

7.1 Submarket Specialization by Sex of Painter and
Date of Starting 166

7.2 Type of Subject Matter by Submarket for
Commercial Sandpainters 168

7.3 Households With More Than One Sandpainter
by Focus of Submarket Production 179

ILLUSTRATIONS

Figure 1.1 Diagram of a Radial Sandpainting 17

Figure 1.2 Diagram of a Linear Sandpainting 17

Figure 1.3 Diagram of a Typical Holy Person 18

Figure 1.4 Ceremonial Sandpainting in Actual Use 19

Figure 2.1 Reproduction of a Sacred Sandpainting
 by a Navajo Singer 24

Figure 2.2 Earliest Photograph of an Actual
 Sandpainting Being Made 31

Figure 2.3 Sandpainting Demonstration in a Museum 34

Figure 2.4 Permanent Sandpainting Exhibit
 by Sam Chief 37

Figure 2.5 Sandpainting Rugs 43

Figure 2.6 Sandpainting Used as Wall Decoration 53

Figure 2.7 Sandpainting Design in Easel Art 55

Figure 2.8 Earth Color Painting and Comparison to
 Sacred and Commercial Sandpaintings 58

Figure 4.1 Substitution of Major Figures in
 Mountainway Painting 83

Figure 4.2 Change in Layout of Major Figures of
 Sandpainting 83

Figure 4.3 Simplification of Sacred Sandpainting
 With Minor Changes 84

Figure 4.4 Simplified Sandpainting of Single Figure
 of Holy People 84

Figure 4.5 Sandpainting Completely Enclosed
 by Border 85

Figure 4.6 Addition of Non-Sandpainting Elements 87

Figure 4.7 Subjects Avoided by Most Sandpainters 88

Figure 4.8 Examples of Good Subject Matter for
 Sandpaintings 89

Figure 4.9 Variations on a Sacred Sandpainting:
 Chiricahua Windway Painting 90–91

Figure 4.10 Non-Traditional Subject Matter 94–99

Figure 5.1 Sandpainting Reproduction
 by Mae De Ville 102

Figure 5.2 Permanent Navajo Sandpainting
 by Mae de Ville 103

Figure 5.3 Sandpainting of Pueblo Village
 by Mae de Ville 103

Figure 5.4 Sandpainting of Navajo Indians
 by E. George de Ville 105

Figure 5.5 Fred Stevens Demonstrating at the
 Arizona State Museum 108

Figure 5.6 Sandpainting by Red Robin 111

Figure 5.7 Permanent Sandpainting
 by Luther A. Douglas 114

Figure 5.8 Permanent Big Starway Sandpainting
by Luther A. Douglas 115

Figure 5.9 Early Permanent Sandpainting
by Fred Stevens, Jr. 116

Figure 5.10 Holy People Sandpainting
by Fred Stevens, Jr. 117

Figure 5.11 Sandpainting by Annie Tsosie,
Showing Influence of David Villaseñor 120

Figure 5.12 Number of Commercial Sandpainters
by Date Each Began to Paint 137

Figure 5.13 Spread of Commercial Sandpaintings
in 1962 138

Figure 5.14 Spread of Commercial Sandpaintings
in 1970 139

Figure 5.15 Spread of Commercial Sandpaintings
in 1975 140

Figure 5.16 Spread of Commercial Sandpaintings
in 1978 141

Figure 7.1 Tourist and Souvenir Sandpainting 165

Figure 7.2 Gift and Home Decoration Sandpainting 167

Figure 7.3 Full Reproduction of a Sacred
Sandpainting 169

Figure 7.4 Sandpainting as Fine Art 171

Figure 7.5 Comparison of Two Sandpaintings for
Craftsmanship 181

Figure 7.6 Elaboration and Standardization of
Sandpainting Size 182

Figure 7.7 Sandpainting, Signed and Dated 183

Figure 7.8 Sandpainting as Example of
Experimentation 184

Figure 7.9 Sandpainting of Rodeo Scene 185

Figure 7.10 Sandpainting on Non-Traditional Surfaces 187

MAP

Map 1.1 Map of the Four Corners Area 3

FOREWORD

WHAT NANCY PAREZO ORIGINALLY INTENDED to be a study of changing art style has been transformed into something rather more comprehensive and more important. In the best tradition of American ethnology Parezo has paid as much attention to history as to the analysis of institutions and cultural variables. It is, I think, because of this comprehensiveness and attention to detail that we are presented here with some new and unexpected insights about innovation and change.

The history of Indian craft production since the conquest follows a similar course in every region of the continent. First, the collapse of aboriginal life ways brought virtually all craft production to a halt. Then the dire economic straits the tribes found themselves in, coupled with stimulus from Anglo entrepreneurs, led to craft revivals and the development of non-Indian markets. Subsequent revivals expanded the markets from the tourist to the art patron and collector. Non-Indian influence typically included innovations in design, materials, and often the craft object itself. Thus, beads of European manufacture displaced porcupine quillwork; European flower motifs were adopted by tribes of the Eastern Woodlands and eighteenth-century British officers returned home with beaded Glengarry bonnets and smoking hats. A century later, Navajo women were induced to weave rugs instead of blankets,

dresses, and belts by traders who introduced such new design elements as arrows and swastikas. Later, during the Great Depression, anthropologists, art patrons, and the Indian Arts and Crafts Board created by the New Deal administration helped start a "revival" of aesthetically sophisticated vegetable dye rugs which appealed to the affluent upper class of the East. Similar developments took place in the production of jewelry and Pueblo pottery.

The creation of a commercial Navajo sandpainting craft conforms to this general pattern. Anglo artists, drawn to the Southwest during the depression, were instrumental in developing the technique of bonding the sand to the boards without which the product would not have become commercially viable. Economic need motivated fully 96 percent of all Navajo craftsmen during the early years. It is still the prime motivator. If there was nothing more to the story than this, it would be an interesting addition to our knowledge and support for the view that contemporary Indian arts are less an indigenous aesthetic, created for Indians, than a strictly bread-and-butter response to Anglo influence. But the body of Parezo's work reveals that sandpainting on boards is one of the few cases of commercialization of truly sacred items to be found in the Southwest.

The notable exception is the seemingly unlimited production of Zuñi fetishes. Originally, individual Zuñis were induced to part with their personal fetishes. As the demand for these esoteric items soon exceeded the supply, counterfeits were produced from around 1920 through the 1940s at which time openly modern commercial items began to be sold. More recently, Hopi *kacina* rattles have been made for the tourist market. The sale of masks and altar paraphernalia are still tabu and are not sold openly in reputable stores. Fetishes and rattles are personal property, while masks and altar pieces belong to religious societies and thus are the property of the entire village or tribe. By contrast Navajo religion is remarkably individualistic. The Navajo singer chooses his avocation rather than inheriting the position as does the Pueblo priest. There are no religious societies among the Navajos and no corporate groups larger than the extended family, or possibly a local

lineage. The Navajo singer practices as an individual. The paraphernalia for each ceremony, or sing, called a bundle (*jish*), is the property of the individual singer. Yet it is not wholly private property. It may not be destroyed, buried with the owner, or passed on to someone who does not have the appropriate ceremonial knowledge. According to Gladys Reichard there are Navajo ceremonies which belong in some way to the whole tribe. Often the Mountain Soil bundle of the Blessingway is thought to belong to a family or an extended kin group. In my opinion it is this vaguely expressed notion of corporate ownership of the *jish* which has discouraged people from commercializing such items as the Talking Prayersticks or the Wide Boards which might have the same sort of appeal as Zuñi fetishes. Because the sandpainting is always destroyed after its ceremonial use, no idea of property is attached to it. In consequence, the singer might feel freer to make an individual choice about replicating it.

One of the most interesting and important chapters in this book is ''The Process of Rationalization.'' Here Parezo documents the various ways individual craftsmen protect themselves from supernatural power harmful to them when the sandpaintings are profaned. An important finding is that the earliest Navajo makers of sandpaintings on boards were themselves singers, that today singers are just as likely to produce commercial sandpaintings as nonbelievers, and that the process of secularization is not the indicator of decline of Navajo religion. A fascinating sidelight is the fact that the secularization of the Zuñi fetish proceeded more rapidly than that of the sandpainting because of a technical problem and not because one tribe is more or less traditional, conservative, or adaptable than the other. It seems that the growth of the industry had to wait for the development of an adequate glue. With the appearance of Elmer's glue, production could soar, but not before then.

In Chapter 6 the author's analysis of learning patterns shows that both men and women make sandpaintings in about equal proportions. Until the development of sandpainting as craft, traditional division of labor by sex was the rule. Navajo women wove rugs while the men made jewelry. Pueblo men

wove and the women were the potters. The first experimenters with sandpaintings on boards were male singers, and even the early weavers of sandpainting rugs were male although the weavers of the very first rugs are not known. Once the process of secularization was complete, women, who up to this time had experimented only with the nonsacred yei rugs, took over the weaving of sandpainting rugs. The men, who learned the craft from Fred Stevens, Jr., later taught their wives and children. In fact, the number of women producers increased rapidly and seems to have been a response to the changing economic situation—a condition found also at Zuñi during roughly the same period. Since the late 1960s Zuñi jewelry-making has come to be dominated by women. This is not so much a matter of changing attitudes as it is the need to increase production in a home industry. It is, in fact, possible that the Indians of the Southwest are participating in the transformations of the work force which are changing women's roles nationwide.

JERROLD LEVY

A WORD FROM
THE AUTHOR

ALTHOUGH FASCINATED BY NAVAJO SANDPAINTINGS since 1974, it was not until the summer of 1977 that I was able to begin systematic fieldwork on the history and development of the craft. In order to discover who Navajo sandpainters were, where they lived, the marketing and economic history of the craft, I visited 394 retail establishments in Arizona, New Mexico, and southern Colorado. I concentrated on towns, such as Scottsdale, Gallup, and Flagstaff, which sold large volumes of Indian art, as well as curio shops located along major highways with lots of tourist traffic and trading posts all over the Reservation. I visited art galleries, museum gift shops, art shows, hotels and restaurants. I would even find sandpaintings in camera shops and grocery stores. One Colorado auto parts store, at which I had stopped to buy coolant, had a wall lined from floor to ceiling with sandpaintings! For the two years of my fieldwork, I never went anywhere without my camera and notebook.

Living on a shoestring out of my car and a small tent, I stayed in some towns overnight and in others for several days. I found all the merchants uniformly cordial. Extensive and numerous discussions were held with those who stocked huge inventories. These men and women taught me how the market

in Indian arts and crafts worked, gave hints about the history of sandpainting, and explained how they as middlemen influenced the development of the craft. When they were busy I sometimes helped out behind the counter selling sandpaintings, answering customer's questions, or stocking shelves. Proponents of western hospitality, some of them looked after me when I became ill and actually took me into their homes. They worried about me as a young woman traveling alone and several merchants even told me when I arrived that they had been expecting me. I became known as the "Sandpainting Lady" even by some of the Navajo sandpainters.

During 1977 and 1978 I examined 10,279 sandpaintings, noting name of maker, size, price, and subject matter for each so that I could gage the production of each artisan and assess the types of sandpaintings sold. Of this number, I photographed 1,825 to use for the artistic analysis. They were representative of the paintings available in 1977 and 1978 as well as examples of each artist's work.

Working with the retail market eventually brought me to the painters. I discovered the names of 451 individual Navajo commercial sandpainters who lived in at least 58 communities (see Appendix 1) based on chapter areas (the local unit of political organization) or local trading posts. Since residence on the Reservation is dispersed with few nucleated settlements and no clear boundaries between communities, each sandpainter identified his own community of residence. Commercial sandpainters were not easy to track down because of their settlement patterns, dual residence, and their great mobility, but in the summer and fall of 1978 and the summer of 1979 I went to 77 households and obtained information from or about 302 sandpainters. Fourteen of these households contained individuals who had started sandpainting by 1970 and were important in the founding and development of the craft as well as its diffusion; 32 men and 45 women were the primary informants in each case. These artisans interviewed were from all parts of the reservation, in order to control regionalism. I usually spent only a day or two with each family, sometimes driving 50 to 75 miles between each

interview, and pitched my tent behind the hogan of the family I had spent the day with. Like the Anglo merchants, the Navajos often worried about me; several feared the potential harm of ghosts due to my living arrangements, while others were concerned about my being lonely. They would sometimes send a small child with me to the next household to keep me company as well as show me the correct road. When I got sick, one family attributed my illness to my having gone to work with the sandpaintings without proper ritual preparation. One woman, who was a diagnostician, told me that the study I was conducting was extremely dangerous. She and her family said Blessingway prayers for me.

I received a uniformly cordial reception among all the sandpainters I visited. They were all willing to show me their work; again many expected me even before I arrived. In only one case was I refused an interview, because the young woman had to care for her own and several of her sister's children (seventeen in all).

In the winter of 1978 and the spring of 1979 I collected data on reproductions of sacred Navajo sandpaintings as well as archival information about demonstrations to add to the information gleaned in shops and from the Navajo. In all I photographed 1,201 out of a possible 1,600 reproductions housed in museums across the United States. These reproductions were used as the baseline for the comparison of commercial sandpaintings to sacred ones.

Finally, during this period I talked to anyone and everyone who might know something about the development of commercial sandpaintings: Navajo tribal officials, reservation school teachers, museum curators, even Borden Chemical Company chemists.

While this book is specifically about the growth and development of permanent and commercial sandpaintings from their sacred prototype, about how and why they were made, the economic and religious consequences of this development and about the people who make them, it is also about the growth of an idea. Specifically the idea that intrigued me was that of the decision to alter a piece of traditional

material culture and turn it into art which can be sold to members of another culture as what is commonly called tourist or ethnic art. This resulted in an examination of the processes of innovation, diffusion, and commercialization as they occur in a culture contact situation, and a study of secularization and the resulting problems and adjustments that come in its wake.

This pursuit gradually resulted in a rare opportunity to study ongoing processes of culture change, to see how people develop new norms, to learn how people rationalize and attempt to adjust their cultural ideals and values to fit situational realities. It was a way to clarify the complex processes of change and diffusion by bringing it down to the level of identifiable individuals and subgroups. While most studies of change in anthropology, particularly in the study of art, have focused on patterns of diffusion between cultures, in this study I saw an opportunity to search for patterns within a culture by focusing on recognizable individuals and seeing how and why the idea to develop and market commercial sandpaintings spread in a patterned step-by-step fashion. By focusing on a recent craft which is still in the early stages of development, the problem of analyzing only the successes from hindsight could be avoided. Almost all of the founders were still alive so that there would be no unavoidable loss of data due to second or third hand information. By studying a group with a long tradition of craft production for sale to other groups and a group which was continually developing new crafts, I could be sure that the commercialization of sandpainting was not an isolated event but one which would be important to the group being studied. And finally, while there have been many fine monographs on sacred Navajo sandpaintings and Navajo religion, little more than passing mention has been made in the literature on Southwestern Indian arts and crafts about Navajo permanent sandpaintings. Many misconceptions exist. This thorough study of Navajo sandpaintings was thus needed to fill a gap in our knowledge of Native American art.

I focused on the artists rather than the art, for it is people who make decisions and respond to actual situations. Art here is seen embedded in its social context. Sandpainters are not seen as an anonymous mass who somehow "make

things,'' but as individuals, all kinds of individuals, including the well-known, highly successful artists and stylistic trend-setters as well as the less outstanding craftsman. Each artisan, simply by becoming a sandpainter, played a role in the development and spread of the craft. The underlying assumption of this study is that it is more interesting and fruitful to focus on the people who make art and on the people who have new ideas, than to view the objects themselves in isolation, ignoring their cultural and social framework.

With the increase of mass tourism in the 1960s and 1970s, the growth of interest in tourist and ethnic arts has been phenomenal. Poor countries with little industry, rapidly changing economies, limited resources, an overworked agricultural base, demographic problems, and high unemployment rates have purposefully developed tourism to attract travelers from more affluent societies. An offshoot of this development has been a growth in the demand for souvenirs and ethnic art by visitors. In Tunisia, for example, traditional arts are bought by tourists for uses that have no relation to their original functions (camel muzzles are made as handbags) and craftsmen have responded to the demand by changing their designs and techniques. In some cases this development has led to the degeneration of the traditional or folk culture, in others to its preservation and revival. Occasionally governments encourage minority or ethnic groups, rural populations or the urban poor, to produce, revive, or even invent art which can then be sold to tourists. Sometimes these forms become national symbols. The rationale for this promotion is that these developments alleviate unemployment among unskilled and marginal workers. However, few governmental reports or projections analyze how the processes of this development actually take place or even ask artisans why they began or how they learned. Instead, it is assumed that such development occurs solely for economic rewards, as a direct result of contact with Western European, capitalistic societies. Motivations for accepting the idea of producing art, however, are not necessarily the same as the reason for founding a craft; rather motivations vary with social characteristics of the artisans and the developmental stages of the craft.

While groups were developing ethnic art to sell to other cultures well before World War II, and in several cases before European contact with nonliterate societies, the scope of these endeavors has never been as great as it is today. New forms of art for the international market in ethnic art are being developed and sold every year in all parts of the world. It behooves us, therefore, to study closely these developments in order that we might come better to understand our world and ourselves. To that end I have devoted several years of study, and this book is the result of my effort.

NANCY J. PAREZO

NAVAJO
SANDPAINTING

Chapter 1

AGAINST THE BACKDROP OF TRADITION

THE NAVAJO WORD FOR SANDPAINTING (*'iikááh*) means "place where the gods come and go." Sandpaintings serve as impermanent altars where ritual actions can take place. But they are much more than that. In their proper setting, if ritual rules are followed, they are the exact pictorial representation of supernaturals. These stylized designs are full of sacred symbols and through consecration are impregnated with supernatural power, thereby becoming the temporary resting place of holiness. They are essential parts of curing ceremonies whose purpose is to attract the Holy People so that they will help with the complex curing process. The supernatural power sandpaintings contain is considered dangerous, and they can be safely used only in the proper controlled context, at the right time, under the direction of highly trained specialists. They are not "art" in the western sense of the term for they are not spontaneous creations; rather, the stylized designs created during the ceremonies are strictly prescribed and they are always destroyed at the end of the ritual.

Commercial sandpaintings by contrast are secular objects made by the Navajo for sale in the international market as luxury items in the form of fine art, decorative art, and souvenirs. The permanent paintings are made of pulverized dry materials which are glued onto a sand-covered wood backing. They are made by laymen and are not bought or used by the Navajo.

The production of sandpaintings is an industry—a way of making a living in a situation where earlier economic pursuits are no longer feasible and few other viable economic alternatives exist. Commercial sandpaintings are a recent development, the result of technological innovations by Anglo-American artists and a Navajo singer in the 1930s and 1940s which began to spread among the Navajo only after 1960. Since then sandpainting as a craft and an art has been sold nationwide, and the market in the 1970s has expanded and diversified quite rapidly due to increasing consumer demands and the marketing efforts of painters and Anglo wholesalers. Sandpainting has become an economic success, and a widely appreciated art form, one which has allowed its artisans to rise above the level of extreme poverty.

By a complex but traceable process, Navajo sandpaintings changed from an exclusively ephemeral sacred form to a permanent decorative art. This was a process which involved two basic steps: one, commercialization; and two, secularization. Commercialization is defined here as the process by which art or material culture used primarily for social, political, religious or aesthetic purposes is transformed into objects made intentionally to market as part of an economic transaction. The new art is called commercial art to distinguish it from its traditional form which is the one which has been handed down from generation to generation and recognized widely within the culture. Any commercial art form may serve secondary functions, be it aesthetic or social, but like farming, working in a factory, or teaching school, its production is primarily an occupation. The term commercial art in this book is distinguished, therefore, from its more common usage as art used in advertising, industry, and the like. Commercial art is understood here as art produced in order to make a living; it carries no derogatory connotation of being inferior or mass produced. Commercial is used in the sense of buying and selling goods, regardless of quality. The commercialization of sandpaintings involved solving technical problems such as finding a way to permanently glue colored sands to sands, developing a market, and training artisans.

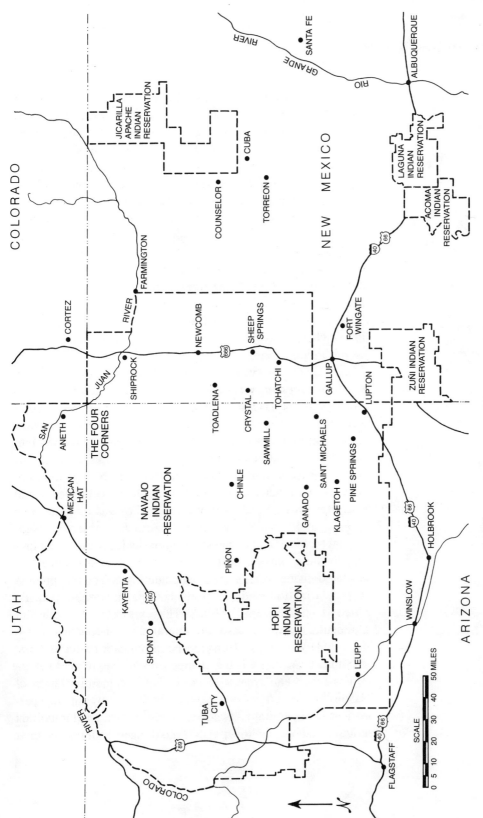

Map 1.1 Map of the Four Corners area.

The second major process was secularization or the shifting of sandpaintings conceptually from the sacred to the secular domain. This process was not one of total displacement of religious sandpaintings by the new secular sandpaintings, but one of a separation and a diversification of forms and functions. Other Navajo crafts which are currently sold to Anglo-Americans, such as weaving and silver jewelry, were always secular items not surrounded by supernatural sanctions against their use in economic contexts. Thus the development of permanent sandpaintings posed problems for the founders of the craft and contemporary sandpainters because there were many Navajo who saw the production and sale of sandpaintings as a sacrilege and threat to the Navajo religious system. Artisans began to develop ways to avoid committing a sacrilege. This involved changing the rules which surrounded the use of sandpaintings.

Of the two processes, secularization began much earlier than commercialization. Sandpaintings were first reproduced outside their ceremonial setting in the 1880s, and at about the same time a few Navajo women began to weave sandpainting designs and isolated sandpainting motifs into rugs. Anthropologists and other scholars made copies of sandpaintings to illustrate books dealing with Navajo religion. Later the paintings themselves became the object of study and were reproduced in order to preserve what was thought to be a dying tradition. By the 1930s, secular and sacred sandpaintings existed, and Navajo singers had developed rationalizations and ways to justify their existence in a manner that separated them from sacred sandpaintings. Yet the process of secularization and religious change generated conflict which is still evident in 1982. The existence of permanent and secular sandpaintings is not tolerated by all Navajos.

Any process of change has implications for the rest of culture, especially if the change throws deeply held beliefs into question and creates conflict. The commercialization of Navajo sandpaintings is a case in point, for by making permanent sandpaintings, Navajos were breaking an important religious taboo. Unless painters no longer believed in their

traditional religion, they had to come to grips with their sacrilege and the possible supernatural repercussions of this act. Because of this problem it has been suggested in the literature on arts and crafts that few, if any, sacred artifacts have ever been commercialized and if they were, it was only because traditional religion of the artisans had died out. However, while Navajo religion was changing before the commercialization of Navajo sandpaintings, there is still no indication that it is in danger of extinction, although the idea that Navajo religion was doomed was an important factor convincing Navajo singers to make permanent sandpaintings in the first place. On the contrary, the facts point to the coexistence of a commercial art with its sacred prototype. What can be concluded is that successful commercialization of religious art is more likely to occur in cultures which are pragmatic and receptive to change and whose history has been characterized in other areas by constant attempts at adaptation. This has always been true of Navajo life, but even more so since World War II.

NAVAJO ECONOMIC SYSTEM

To understand why the Navajos began to more readily accept the secularization of sandpaintings and developed commercial sandpaintings, it is helpful to briefly review Navajo economic history and the role handicrafts have played as an economic option. Navajo economy has changed continually. Navajos have always been receptive to innovations which would enhance their resource base. When the Navajo arrived in the Southwest around A.D. 1500, they were hunters and gatherers, like other Apacheans. By borrowing new methods of subsistence from their Pueblo and Spanish neighbors, however, they quickly developed a mixed economy of agriculture and pastoralism. By the early eighteenth century they owned goats, sheep, horses, and cattle. Raids for livestock and ''slaves'' were a means for the poor to achieve wealth and status. During this period they learned how to make masks, textiles, sandpaintings, prayersticks, and pottery.

This system of livestock raising, agriculture, and raiding, supplemented by hunting, was in effect operative until the Fort Sumner period (1864–1868), when relocation and confinement destroyed the old economic system. A modified system slowly emerged after the reservation was established in 1868. Livestock became the basis of the economy, supplemented by agriculture and the sale of handicrafts. Livestock, and hard goods, such as jewelry, were the basis of wealth and prestige. During this period of recovery which lasted from 1869 through 1900, old social patterns were reestablished, but not without the influence of Anglo customs. The U.S. government established political control, traders introduced a market and cash economy, and attempts were made to convert the Navajos to Christianity. Anglo settlers put pressure on the land base, and with the arrival of the railroad in 1881, wage labor was added to the economic base. Over the next hundred years, there was an increasing dependency on wage work, especially as the overgrazed land could no longer support a pastoral economy. This situation had become critical by the Depression, so that following systematic reduction of livestock between 1934 and 1940 families no longer had herds large enough to meet subsistence needs. During World War II, off-reservation labor increased, bringing Navajos into more direct contact with Anglo-American culture with its drastically different world view and values; this demonstrated the value of understanding and speaking English and of formal education if the Navajo were to survive as a culture and compete in the Anglo controlled socio-economic system. The end of World War II, however, brought a crisis for the Navajo when many lost their jobs to returning Anglo veterans. The situation was alleviated in the 1950s, partly by the use of relief funds. Navajos living on-reservation became partially dependent on welfare payments. Since 1940 reliance on unearned income has increased to more than 20 percent in many areas according to Henderson and Levy (1975:116).

The Navajo economic situation in the 1950s and 1960s when commercial sandpaintings were developed and began to be made by numerous Navajos was precarious. While

wage work increased and discoveries of oil, natural gas, and uranium supplemented employment opportunities on the reservation, there was still a shortage of jobs and many of the available jobs were seasonal in nature. Most work was unskilled and wages were very low. The reservation lacked primary and secondary industries, producing a situation analogous to developing countries: in 1958 Navajos were still among the lowest-level income groups in the United States (Young 1958: 107–108). In addition, out-migration became a necessity because most wage work had to be found off-reservation. Men could either leave their families for part of the year or relocate the entire family in some distant city. For a society like the Navajos which is based on close kinship ties, where the support of relatives is considered crucial, such relocation was avoided whenever possible. Thus new economic options such as commercial sandpainting which allow individuals to remain on-reservation have tended to be accepted and utilized rapidly.

The Navajos, practical and resourceful people, have responded to this complex situation of a depleted and marginal land base, a decline in relative importance of traditional economic pursuits, and an increase in welfare and intermittent employment by developing a mixed economy. The Navajo family, according to Aberle (1969:244), has attempted to maximize all possible sources of income by forming a single labor pool and relying on a combination of herding, farming, craft production, wage work, and welfare. By this strategy, traditional economic pursuits can endure as hedges against disaster. Thus, while the arid land will not permit cash crops, small family plots are common; most groups own a few sheep. Lack of specialization is the key in this type of strategy since none of the fluctuating and unpredictable resources can be relied upon as a steady and sufficient source of income. Nor can any source of income be relinquished unless the resource base is drastically changed.

Another intermittent income resource used by the Navajo even before the Reservation period was the sale of handicrafts. However, the introduction of desired Anglo

goods (food stuffs and clothing) in trading posts and the encouragement of BIA agents in an effort to bring the Navajos into the American cash economy led to an increase in the utilization of this resource. Production of crafts varied with time and by area: there were a few basketmakers and potters in the western area, for example, and by the early twentieth century, both crafts had all but died out. Silversmiths were concentrated in the southeastern portion of the reservation near the railroad. Weaving was the most widespread craft, and Amsden (1949:179–182) estimated that in 1923 over 5,500 women were weaving in various parts of the reservation, and that in 1931 sales amounted to over one million dollars.

While total income from the major industries such as weaving and silversmithing steadily increased, for all but the best artisans craft production was primarily a part-time occupation. Most weavers worked for approximately five to ten cents an hour until the market changed dramatically in the 1970s (Shepardson 1963:23). In the 1930s, silversmiths averaged $80 to $170 per year (Adair 1944:108–117). While we have no truly comparable statistics, it appears that reliance on income from arts and crafts declined when economic conditions were favorable and when steady wage work was available. Communities near urban areas like Gallup tended to rely less on income from crafts. However, while reliance on arts and crafts in the 1960s and 1970s was not as great as in earlier decades, it continued to be an important supplement for many households (Callaway, Levy, and Henderson 1976:34)—especially important for households headed by unskilled laborers. In Sheep Springs, for example, 41 out of 65 residence groups earned income from weaving in 1966 (Lamphere 1977:24). Thus, even if the return from production of arts and crafts is small when compared to the total income of the tribe, this economic activity can provide a meaningful advantage to Navajo families, especially when cash is needed to purchase large appliances, trucks, mobile homes, and even clothes.

A new craft such as commercial sandpainting, therefore, fits easily into the existing economic structure of Navajo extended families. At the same time sandpaintings began to be

marketed other Navajos were developing other crafts as well: since the mid-1970s, pottery-making has enjoyed a limited revival on the western portion of the reservation and dolls, baskets, beadwork, god's eyes, and easel art are produced. The development of commercial sandpaintings is thus not an isolated process. However, its development differs from the development of these secular items because of the problems involved in secularization. An understanding of the Navajo ceremonial system and the place of sandpaintings within this system is essential, therefore, in order to understand the kinds of cultural changes that were necessary for the successful development of commercial sandpaintings.

RELIGIOUS TRADITION

It is generally felt that the Navajo borrowed the idea of drypainting, along with other aspects of their ritual paraphernalia and mythology, from Puebloan peoples, and then elaborated on it to fit into their own religious system. However, because of their ephemeral character, there is little direct evidence as to when, exactly where, and under what circumstances this process occurred. Keur (1941:64) found ground mineral pigments at a pre-1800 Navajo site on Big Bead Mesa in New Mexico. Indirect evidence, mainly pictographs and murals, points to the Gobernador Phase, immediately following the Pueblo Revolt of 1680 (Schaafsma 1963:58; 1980:305–326; Forbes 1960:263–273), or the preceding century. During the eighteenth century, motifs and subject matter (i.e. Monster Slayer, Humpback Yei) found in modern sandpaintings appeared in pictographs, first in the Upper San Juan-Navajo Reservoir districts, and then spread to the Gobernador, Largo, Chaco Canyon and Big Bead Mesa regions. Several researchers have also noted stylistic similarities between Navajo sandpaintings and the murals at the pre-1700 pueblos of Awatovi (Antelope Mesa, Hopi Reservation), Kawaika-a on the Jeddito Wash, Arizona, and Kuaua, a Pueblo IV village on the northern Rio Grande

(for example Smith 1952, Brody 1974). Cushing (quoted in Mallery 1893:211) and Tanner (1957:28) suggest that Navajo drypaintings were inspired by these impermanent and permanent kiva paintings and altar reredos. The Navajos, lacking wall surfaces suitable for permanent paintings as a result of their migratory life style, turned to the use of an impermanent floor medium. But since the Pueblos already used sand and meal paintings which the Navajo could easily see, direct borrowing is just as likely.

Because of their stylistic similarity to kiva murals and the use of designs in rock art, it has also been suggested that Navajo sandpaintings originally were permanent (Brugge 1963: 22–23, 1976), implying that the Navajo rule for impermanency is a recent development. The evolution of this rule, therefore, may be a result of the period when Navajos were harassed by other Indian tribes, by Spaniards, and later by Anglo-Americans. Navajos probably began memorizing the paintings for safety, for in this way no one could steal the paintings' power. Indirect evidence for the beginning of this shift, consisting of burned hogans and the building of defensive sites, begins in the 1740s.

The Navajo theory of the origin of sandpaintings and the development of rules surrounding their use differs from this Anglo archaeological and ethnohistorical interpretation. Navajos believe that sandpaintings were given by the supernaturals to the protagonist of each Chant origin myth, who in turn taught it to the Earth People. For example,

> Rainboy in the Land-beyond-the-sky was instructed for the Hail Chant: "You will not make the paintings in this form in the future. Instead you will use powdered rock—dark, blue, yellow, white, pink, brown, and red. If we give you the paintings on the stuff we use, they will wear out, so it is better to make them of sand each time anew" (Reichard 1944b:147).

Sandpaintings are then a gift of the Holy People. The materials come from evil beings who have been brought under supernatural control.

According to many myths, sandpaintings were originally made on buckskin, unwounded deerskin, cotton, black or white clouds, sky, or spiderwebs. The Franciscan missionaries (1910:398) found that generally the original paintings were held to be a kind of "sewing" (*naskhá*) composed of five kinds of materials. These were unrolled for the prototype ceremony held in the myth for the protagonist after which they were rolled up and carried home by the deities. But because of the delicacy, value, and sacredness of the sewings, the gods decreed that sandpaintings would be used by Earth People. Other reasons listed in the myths include that the "sewings" might be stolen, soiled, damaged, lost, or quarreled over. Also paintings might become material possessions that outsiders would be able to steal. Mythological rationales and supernatural proscriptions mandated keeping sandpaintings impermanent. To disobey would bring disaster, blindness, illness, or death to the individual and drought to the tribe.

The Navajo Ceremonial System

Navajo religion integrates all of Navajo culture and encompasses philosophy, medical theory, and psychotherapy. Ritual, the active part of religion, is concerned with healing. Because sickness is an uncontrollable, occasional, and unpredictable event, so are the majority of Navajo curing rituals. There is no organized system of religious services, no fixed ceremonial calendar, and no institutionalized priesthood. However, Navajo ceremonies are conducted by highly trained specialists called *hataałí*, or "singers." The singer knows all the details of the rituals including chants, prayers, and the myth which justifies these practices, and he supervises the construction of sandpaintings during ceremonials where they are used.

Navajos believe that the universe is an orderly, all-inclusive unity of interrelated elements and that a principle of reciprocity governs man's relations with these elements (Wyman 1970b:1). This universe contains both good and evil, which are complementary yet embodied in each other in a complicated duality (Reichard 1944a:4). Evil is the absence of

control which depends upon knowledge; good is that which has been brought under control. Evil can be brought under control by investing it with holiness. Holiness is distinct from both good and evil and refers to some power which has been manipulated. Control is ritual, and by ritual, such as the ritual of constructing a sandpainting, one can attain a desired condition summarized by the word *hóẓǫ́*. *Hóẓǫ́* can be inadequately translated as beautiful, harmonious, blessed, pleasant, satisfying, for it summarizes the idea of the controlled integration of all forces, both good and evil, natural and supernatural, into a harmonious world. Reichard (1963:35) states it in similar fashion:

> One purpose of ritual is to extend the personality so as to bring it into harmonious relation with the powers of the universe. The opposite of this endeavor, actually another aspect of it, is to keep a man from contact with evil.

Thus ritual is at the same time curative and preventive. All illness is caused by improper contact with inherently dangerous powers, breach of a taboo, excess, or misfortune and results in disharmony and departures from the normal order of the universe. Harmony, balance and order are restored through the use of knowledge and the correct performance of orderly procedures in a controlled ritual environment (Reichard 1963:11). Recovery occurs through sympathetic magic.

Navajo ritual is subsumed in a highly complex, fluid system of various kinds of song ceremonies (including curing chants), of divination rites, prayer ceremonies and other minor rites (see Wyman and Kluckhohn 1938:36 and Reichard 1963). Sandpaintings are used in most Navajo rites, but are best known in song ceremonials which are rituals in which a rattle is used, accompanied by singing (Haile 1938:639). Song ceremonials include Blessingway rites, which are prophylactic rather than curative, and curing ceremonies. Blessingway ceremonies utilize sandpaintings, but those that are made correspond to Puebloan meal paintings consisting of small, simple but colorful designs made in vegetal materials as well as pulverized minerals. Curing ceremonials include Lifeway ceremonies, performed following an accident, Evilway chants

that deal with improper contact with ghosts or witches and aims for the explusion of evil, and Holyway chants that correct problems resulting from improper contact with supernatural forces and excess, while protecting against future misfortune. While Holyway chants all utilize sandpaintings, Lifeway chants do not and Evilway chants only rarely do.

Each Holyway chant is a framework for coordinating the various details of dogma and has a name and an origin legend (Reichard 1963:xxxiv). It is a complex of individual ceremonies or rites, each of which has a separate function. Some are fixed, appearing in every chant, while others are supplementary. Although each chant varies in detail, a basic five-night ritual consists of ten to twelve standard ceremonies (see Wyman 1970a: or Haile, Oakes and Wyman 1957). These are divided into two main sections: purification and dispelling of evil; and attraction of goodness, strength and power. Each section is accompanied by night chanting. It is during the second section that sandpaintings are made.

A curing ceremony is sponsored by the patient and his or her kinsmen. Their help involves securing the services of the singer, paying his "fee," securing gifts for his assistants, and feeding all who attend the ceremony. For large chants this may run to a thousand or more people and expenses are great. Depending on the type of ceremony, expenses vary from twenty-five dollars to several thousand (Kluckhohn 1962:97–122). A ceremony must be held in a hogan, usually in the home of the patient or at that of a close matrilineal kinsman. Because of the time and expense, a ceremony is not undertaken lightly. Variation which occurs in a ceremony is due partly to the economic constraints and the ability of the family, the desires of the patient and sponsors, as well as the nature of the specific illness.

Variation can be expected in the performance of chants, because rituals are not permanently recorded and are sporadically performed; there is no organized priesthood and the distances between settlements on the reservation are great. This variation is enhanced by the Navajo belief that it is dangerous for a practitioner to teach everything he knows to his pupil and by the need to avoid wearing out sandpaintings

and other paraphernalia by constant repetition and use. No singer ever gives two identical performances (Kluckhohn and Wyman 1940:11). Even with this caveat, similarity and stability in ceremonies as well as sandpaintings appear to be remarkable.

How Curing Ceremonies and Sandpaintings Work

Curing works by ritually attacking evil and forcing it under control, hence yielding to good. The best summary of Navajo curing comes from Reichard (1963:112–113):

> The ritualistic process may be likened to a spiritual osmosis in which the evil in man and the good of deity penetrate the ceremonial membrane [sandpainting] in both directions, the former being neutralized by the latter, but only if the exact conditions for the interpenetration are fulfilled. One condition is cleanliness, the ejection of evil so that the place it occupied may be attractive to good powers. The chanter's ultimate goal is to identify the patient with the supernaturals being invoked. He must become one with them by absorption, imitation, transformation, substitution, recapitulation, repetition, commemoration, and concentration.
>
> The purpose of sandpaintings is to allow the patient to absorb the powers depicted, first by sitting on them, next by application of parts of deity to corresponding parts of the patient—foot to foot, knees to knees, hands to hands, head to head. In some chants parts of the drypainting may be slept on to give more time for absorption; sleep seems to aid the process. The chanter applies the bundle items to the body parts of the gods, then touches parts of the patient's body with his own—foot to foot, hand to hand, shoulder to shoulder in the ceremonial order—and finally with the bundle equipment; this is an elaborate rite of identification. The powers, represented by the sandpainting, are conveyed indirectly by the chanter through the bundle equipment and his own body to the patient's, all because the chanter has obtained power to do this by his knowledge.

The sandpainting can be viewed as the "ceremonial membrane" that allows this transference to take place. Called irresistibly by their likenesses, the supernaturals impregnate the painting with their power and strength, curing in exchange for the offerings of the patient and singer. The rule of reciprocity governs this exchange.

While most sandpainting compositions are highly complex, even the portrayal of a single figure of the main theme is enough to call the supernaturals to the hogan. This single figure fulfills the functions of the sandpainting ceremony, which are therapeutic, invocatory, commemorative, and symbolic (Haile, Oakes and Wyman 1957:159).

A sandpainting ceremony is performed once in a two-night sing and successively on the last four days of a five- or nine-night sing. One painting is made each day during Holyway ceremonies in order to receive the sun's blessing. (For exorcistic chants the paintings are made at night.) A different design, representative of a group of numerous paintings (Reichard 1963:xxxvi), is used on each occasion. The choice of the painting depends partly upon the extent of the singer's knowledge and power; success of the painting in the past; which paintings have been used recently; etiological factors; and the sex of the patient.

A sandpainting is made only under the direction of the singer who may or may not actually produce the painting. Assistants, male relatives of the patient, and any other men in the community with the requisite artistic skill are likely to perform the actual construction. Women, however, seldom help unless they are curers or apprentices. Although women are not barred from helping, they are usually not welcome in the hogan until the painting is completed. Anglo female anthropologists, however, have helped make sandpaintings. It is also said that the construction period is dangerous for a Navajo who has not been the patient in a sing previously (Kluckhohn and Wyman 1940:61–62).

At the beginning of the sandpainting ceremony, a sandpainting set-up is erected in front of the hogan door, while the hogan is cleaned and the central fire moved to one side. Next, the floor is covered with clean, riverbed sand and smoothed with a weaving batten. Colored pigments, that have been collected by the family sponsoring the ceremonial and previously ground with a mortar and pestle on the northwest side of the hogan, are placed in various containers near the central area. These colored pigments (which include

sandstones, mudstones, charcoal from hard oak, cornmeal, powdered flower petals, and plant pollens) are trickled through the thumb and flexed forefinger. No adhesive is used because the painting will be destroyed at the end of the ceremony. Although paintings vary in size from a foot in diameter to more than twelve feet square, most are approximately six-by-six feet, or the floor area of the average hogan.

The average size sandpainting requires the labor of three to six men and takes roughly four hours to complete. The more elaborate the composition, the more time it takes, with the most complex requiring as many as forty painters each working ten hours (Reichard 1963:xxxv). Smaller, simpler paintings work, but because power is increased by repetition, larger ones are more effective and, therefore, more desirable. The factors determining size include the amount sponsoring families can afford to spend, the number of available men to make the painting, and finally, the chant in which the painting is used.

Sandpaintings are made freehand, except for the occasional use of a taut string to make guidelines straight and insure that the main figures will be the same size. Extreme coordination and speed are necessary to make a thin, even line. Mistakes will be covered over with clean background sand and the figure begun again. Anyone may criticize in the quest for an error-free ceremony. Unknown mistakes that could be harmful to the makers or invalidate the ceremony are neutralized by a covering prayer from Blessingway.

Construction, placement of figures, composition, and the use of the ritualized artistic designs are strictly prescribed by the Holy People. These rules must be followed exactly in order for the cure to be effective. The same is true for the construction of each figure: when a picture of a Holy Person is made, the entire torso is made first in one color. Then the figure is clothed in a technique called overpainting. Only then is decoration (i.e. masks, headdresses) added. Also, the picture is begun at the center and constructed outward in a sunwise direction (east to south to west to north). All workers then proceed together following this pattern. Finally the guardian and the paired guardians at the east (see Figs. 1.1 and 1.2) will

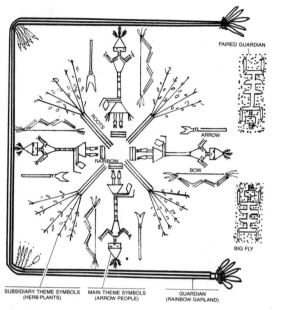

PAIRED GUARDIAN

ROOTS

ARROW

RAINBOW

BOW

BIG FLY

SUBSIDIARY THEME SYMBOLS
(HERB PLANTS)

MAIN THEME SYMBOLS
(ARROW PEOPLE)

GUARDIAN
(RAINBOW GARLAND)

Fig. 1.1

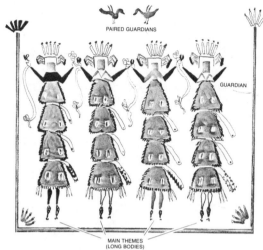

PAIRED GUARDIANS

GUARDIAN

MAIN THEMES
(LONG BODIES)

Fig. 1.2

Figure 1.1 is a radial sand-painting: Arrow People from Shootingway, showing various types of figures and symbols commonly found in sacred and commercial sandpaintings. Adapted from Reichard 1939b: Plate XII.

Figure 1.2 A linear sandpainting: Long Bodies from Mountainway. This diagram also shows the location of various types of figures and symbols which are most often found in sacred and commercial sandpaintings. Adapted from Wyman 1975:97.

be constructed last. The only allowable individual deviations are the kilt designs (see Fig. 1.3) and the decoration of the pouch which hangs from the waist of many figures.

Subject matter consists of symbolic representations of powerful supernaturals who are invoked to cure the patient. These may be the etiological factors (for like can cure like), human-like portrayals of the protagonist of the myth, figures of Holy People, *yeis* (a special class of Holy People), or various personified beings whom the protagonist met on his or her mythological travels. Holy People (Figs. 1.1–1.3), the most common forms, are depicted as personified plants, animals, anthropomorphic beings, natural or celestial phenomena, mythological creatures, or natural objects, in addition to identifiable deities. Animals and plants are also painted in a naturalistic or semi-stylized form as subsidiary symbols. Location and other important symbols are also shown. While many paintings are illustrations of events occurring in the origin myths, few are actually narrative or realistic.

Figure 1.3 Diagram of a typical Holy Person: Holy Man from Shootingway. It shows the major parts of the body and symbols of a Holy Person as found in sacred and commercial sandpaintings. Adapted from Reichard 1939b: Plate X.

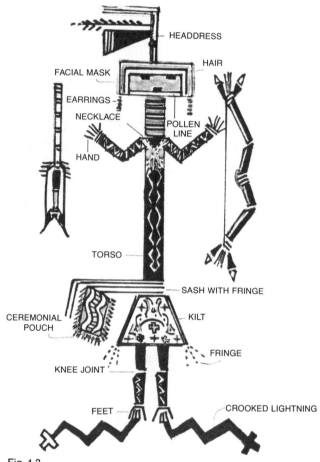

HEADDRESS

HAIR

FACIAL MASK

EARRINGS

NECKLACE

POLLEN LINE

HAND

TORSO

SASH WITH FRINGE

CEREMONIAL POUCH

KILT

FRINGE

KNEE JOINT

FEET

CROOKED LIGHTNING

Fig. 1.3

When the painting is completed, the singer inspects it once more. If satisified that there are no errors, he places the sandpainting set-up around the painting, intones a protecting prayer, and sprinkles the composition with sacred pollen (which becomes powerful medicine) in the specific order of construction, ending with the guardian. The painting is now used immediately.

The patient, generally not present during the construction of the sandpainting, now enters and reconsecrates the painting. (Fig. 1.4) He sits on a specified portion facing east. The singer, while praying and singing, applies sand from the

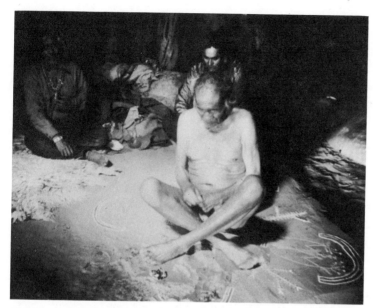

Fig. 1.4

Figure 1.4 Actual sandpainting
in ceremonial use: Cactus
People and Medicine Plants. A
singer is chanting over a patient
immediately preceding the trans-
ference of power in a Windway
ceremony. The painting has been
blessed and is therefore sacred.
Photo courtesy of the Los
Angeles County Museum.
Neg. No. A.5280-8.

figures depicted in the painting to matching parts of the
patient's body, usually from feet to head, right to left.
This procedure is repeated four times along with other ritu-
alistic acts.

These procedures have been said to identify the patient
with the deities represented in the paintings (Reichard
1963:xxxvi; Wyman 1970b:7). Their supernatural strength
and goodness is transferred from the sand via the singer, to
the patient. The patient becomes like the Holy People for he
has been able to partake of the nature of divinity. As a result
the patient is dangerous to himself and to anyone who is not
similarly immune to so much supernatural power. Violations
of ceremonial requirements may reinfect the patient or in-
jure anyone who uses his utensils (Wyman and Kluckhohn
1938:14). For these reasons there are restrictions on the
patient's behavior for the four days following the ceremony.

Upon completion of the sand application, the patient
leaves, and friends may hastily apply some of the sand to their
own bodies. Matthews (1887:426) stated that people also col-
lected the corn pollen and some of the sand for later use, but

Kluckhohn and Wyman (1940:100) found that the practice is rare. As the women leave—for it is dangerous for them to see the erasure—the singer erases the painting in the opposite order in which the figures were laid down. The sand is deposited north of the hogan under a lightning-struck tree. (Levy, personal communication). Material from each sandpainting forms a separate pile usually placed just north of that deposited on the previous day. Kluckhohn and Wyman (1940:68) suggest that the disposed sand acts as a barrier to the return of evil spirits which have been driven to their home in the north.

As a sacred object containing extremely dangerous power, a sandpainting, like masks or medicine bundles, should be used with respect. It is feared as well as revered (Reichard 1944b:22). The painting never remains in a pristine form unattended for the longer it remains intact, the greater is the possibility that someone will make a mistake in its presence and cause harm. Therefore, sandpaintings should never be made in a permanent form. A layman who made one, especially outside the controllable environment of the ceremonial, and did not have the necessary knowledge and hence power, would be harmed. The paintings would draw the Holy People who, because of the principle of reciprocity, would have to come, but they would be displeased because their rules had been disobeyed and they would bring sickness and possibly death to the offender.

Given their sacred nature, it is not surprising that making sandpaintings in a permanent form and using them for commercial purposes was unpopular. Use in any secular context was in direct opposition to rules governing Navajo religious practices and was interpreted as an affront to deeply held beliefs. Most Navajos were and still are afraid to disobey the Holy People and will not reproduce sandpaintings in any permanent form, particularly those which strive to be exact replicas of ceremonial designs. But Navajo sandpaintings have been made as permanent, secular items for many years; they have been used for a variety of mundane purposes. Beginning in the late 1880s, sandpaintings were reproduced outside their

ceremonial context: anthropologists used them to illustrate books and articles on Navajo religion; Navajo weavers incorporated the design motifs in rugs; designers used them to decorate public buildings, fabric, and dishes; and finally, Navajo artists used them as decorative and fine art. By 1920 some types of sandpaintings had shifted to the realm of everyday life. The function of sandpaintings became multiple. This included education, decorative art, historic documentation, aesthetic pleasure, economics and the prevention of culture loss in addition to their religious functions.

The development of secular sandpaintings, however, from sacred ones was often a painful and arduous process. It involved technological innovations, marketing developments, education of potential consumers, increased contact between Navajo and Anglo-American cultures, and last but by no means least, cultural and ideological changes by Navajo artists and singers. This process is not yet completed; as happens when new norms which test beliefs are developed, conflict ensued among the Navajo and disagreement over the boundaries of the new concept of secular and commercial sandpaintings persists.

Chapter 2

FROM SACRED TO SECULAR: THE DEVELOPMENT OF PERMANENT SANDPAINTINGS

THE DEVELOPMENT OF COMMERCIAL SANDPAINTINGS was not an isolated event but the last in a series of developments among Anglo-Americans and Navajos. Two major steps were prerequisites to the making of commercial sandpaintings. They had to be put in permanent form and taken outside the ceremonial context for reasons which had nothing to do with their ritual use but which served other interests of the entire community. Both steps had to be accomplished without bringing misfortune to the community. The change came through two groups: First, Navajo singers and Anglo scholars who were trying to preserve Navajo culture while advancing scholarly knowledge of "primitive" peoples and their religion before they died out; and second, traders, entrepreneurs and artisans who were trying to expand and exploit the Anglo market for Navajo crafts. The singers and anthropologists provided the all-important rationalization which allowed the shift from sacred to secular realms to occur, while demands from the second group helped create a market for sandpainting motifs in crafts long before commercial sandpaintings were invented.

SANDPAINTING REPRODUCTIONS
AS PERMANENT RECORDS

Ceremonial Reproductions

The first use of permanent sandpaintings was as reproductions of ceremonial sandpaintings collected by scholars who were interested in studying Navajo religion and mythology. Color and black-and-white reproductions of these sacred sandpaintings were collected and published by Washington Matthews, an army physician stationed at Fort Wingate in the 1880s. Matthews first heard about sandpaintings in 1880 from Jesus Arviso, a Mexican captive who had been reared among the Navajo. Arviso told Matthews that "the Indians make figures of all their devils" (Matthews 1887:39). Matthews's first report was of a Mountainway ceremony, seen at Hard Earth, New Mexico, in October 1884. He was given access to the ceremonial hogan and sketched the sandpaintings, much to the horror of most of those present. Two were reproduced in 1885 and another four in 1887.

The history of making permanent sandpainting reproductions follows the history of anthropological interest in Navajo religion, although scholarly research focusing specifically on Navajo sandpaintings was sporadic until the early 1920s. The ceremonies described were the large, spectacular ones which included God Impersonator dances. Few sandpaintings were recorded and researchers like James Stevenson and Alfred Tozzer looked expressly for paintings to compare to those collected by Matthews. The Franciscan Fathers (1910) collected myths which accompanied each ceremony, analyzed the origins of sandpaintings and their place in the ceremonial system. While scholars were focusing on other research problems, sandpainting reproductions were being collected, but not published, by traders on the reservation. For example, Sam Day, Jr., the trader at St. Michaels, and his brother Charles, a trader at Chinle, had reproductions made by four Navajo singers, Speech Man (Fig. 2.1) White Singer, Stops Abruptly, and Old Man's Son, from 1902 to 1905. They had additional reproductions made at the request

Figure 2.1 Reproduction of a sacred sandpainting entitled Wind People Dressed in Snakes from Navajo Windway. This linear sandpainting reproduction was made with tempera paint and ink on construction paper about 1903 by Speech Man, a Navajo singer, at the request of Sam Day, Jr. The wavy black lines in the background are black clouds drawn to encourage rain. The painting is now part of the Huckel collection and housed at the Taylor Museum, the Colorado Springs Fine Art Center.

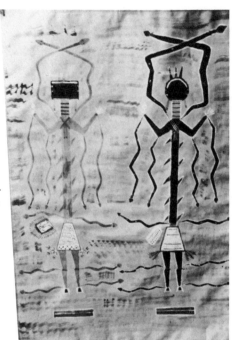

Fig. 2.1

of photographer Edward Curtis who used them in his well-known photographic essay of 1907. While most sandpainting reproductions were collected from singers living on the eastern and central portions of the reservation, some of the earliest and most important collections were made by singers from western Arizona, such as Big Lefthanded. A singer, he produced a number of reproductions between 1905 and 1912 for Matthew M. Murphy, Navajo agent and trader in Tuba City. These 28 paintings, described by Wyman (1970b) are from Shooting-way, Nightway, Mountainway, Big Starway, Beautyway, Plumeway and Navajo Windway. They are now housed in the Smithsonian Institution as the Walcott collection.

Franc J. Newcomb, a trader's wife and self-taught Navajo ethnographer, recorded over 700 sandpaintings, more than any other individual. She came to the reservation in 1913 from Wisconsin, and served for two years as a teacher at Fort Defiance. She married Arthur Newcomb and moved to Nava,

TABLE 2.1
Earliest Known Dates for Secular Uses of Navajo Sandpaintings

Event	Earliest Recognized Historical Date
Earliest sketch of sandpainting by an Anglo anthropologist	1884
Publication of sandpainting reproduction by Anglo	1885
Yei and yeibichai rugs	1885
Inspiration for isolated motifs in easel art	1885
Demonstration by a singer at an art show, Chicago World's Fair	1893
Photograph of actual painting in ceremonial use	1894–1904
Sandpainting rug	1896
Reproduction on paper actually made by a singer	1902
Permanent museum exhibit made by an Anglo	1902
Beginning of major collections of sandpainting reproductions	1902
Permanent exhibit made by a Navajo singer	1918
Use of motifs for Anglo arts and crafts classes	early 1920s
Use of motifs and reproductions as wall decoration (public building)	1923
Photograph of staged demonstration	1924
Picture writing	1924
Decorative items using sandpainting motifs made by Anglos (tea pots, etc.)	by late 1920s
As subject matter for easel art	1928
Film of an actual ceremonial	1928
Earth color paintings developed in Santa Fe	1932
Commercial sandpaintings made by Anglos	1932
First major publication devoted to sandpaintings	1937
Use of motifs in silver jewelry	by late 1940s*
Commercial sandpaintings made by Navajos	early 1950s
Spread of commercial sandpaintings to Navajo communities	1962

*Possibly 1920s.

New Mexico. After her arrival in Nava in late 1915, she became a friend of Hosteen Klah, one of the most famous medicine men of his day. A berdache and an extremely extraordinary and unorthodox Navajo who was responsible for several innovations in religious practices, Klah knew at least

four chants: Hailway, Chiricahua Windway, Mountainway, and Nightway. His teachers had been Matthews's informants. He was the only Hailway singer left on the reservation and the major informant for numerous scholars. Klah took Newcomb to her first sing, a Nightway, in 1917. She tried to memorize all the designs on the four drypaintings used in the ceremony. Later she attempted to draw them without success. Seeing her problems, Klah offered to draw them for her. He sketched the paintings in pencil and Newcomb made watercolor reproductions. These she hung in her bedroom so that none of the other Navajos would be offended or afraid. Klah watched Newcomb for a period. Seeing that no punishment followed, and noting her pleasure in the reproductions, he proceeded to draw 27 additional paintings for her in late 1917 and early 1918. At the same time Klah taught her the symbolism associated with the Navajo pantheon (Newcomb 1964:126).

Other singers, convinced of her sincerity and interest, and often prompted by Klah, eventually invited Newcomb to their sings. Gleason Begay and Hosteen Djolii, Shootingway singers, watched her over a four-year period and when no harm came to her or Klah because of their work, they decided it would be all right to allow her to sketch a few of her drawings. In time Newcomb became a respected authority in ceremonialism, even among the Navajo. Wendell T. Bush, professor of religion at Columbia University, obtained a research grant for Newcomb and purchased 30 of her sketches which were later housed at Columbia University and eventually supplemented by other paintings recorded by Newcomb and Gladys Reichard. Newcomb and Reichard then published the first major book devoted primarily to Navajo sandpaintings and their place in the Navajo ceremonial system. Forty-four of the fifty-six Shootingway paintings in Newcomb's collection were published in *Sandpaintings of the Navajo Shooting Chant* (1937).

Gladys Reichard began her lifelong study of Navajo religion, social organization, and weaving in the late 1920s. One of the first scientists to speak with authority on sandpainting tapestries, she learned to weave by living with the family of Miguelito, a famous singer from Ganado. Forming a

pseudo-kinship and apprenticelike relationship with this singer who knew numerous chants—similar to that of Hosteen Klah and Newcomb—Reichard published *Navajo Medicine Man, the Sandpaintings of Miguelito* in 1939, which dealt with sandpaintings of Shootingway and Beadway. This book, along with the earlier publication with Newcomb, made Navajo sandpaintings well-known in the eastern United States.

Hosteen Klah also worked with other female researchers besides Newcomb, including Reichard and Mary Cabot Wheelwright. He was eager to record his myths, rituals, and sandpaintings so that his intimate knowledge would not be lost after his death owing to lack of Navajo students, especially for the longer, more detailed ceremonials. (Klah's main apprentice, Beaal Begay, died in 1931 and Klah like Miguelito never had another.) Klah even urged Wheelwright to build a "house" or museum which would be a repository of Navajo ceremonial knowledge. Wheelwright, who met Klah and saw her first Navajo ceremony in 1925 while visiting the Newcombs (Wheelwright 1942:9), agreed to finance the cost of the museum. The Museum of Navajo Ceremonial Art was founded in Santa Fe in 1937. It was designed in the shape of a Navajo hogan as an appropriate place for producing and exhibiting sandpaintings. Unfortunately Klah did not live to preside over the dedication ceremonies.

The museum grew as Klah and Wheelwright had envisioned it would. Father Berard Haile, O.F.M., one of the first researchers to classify the complicated chant system collected 51 paintings from many chants between 1929 and 1934 and placed the reproductions in the museum. Newcomb donated copies of her paintings as well. Still others, like Maud Oakes and Laura Armer, worked closely with Navajo singers and collected many sandpaintings, often from previously unrecorded chants.

Other individuals amassed impressive collections of Navajo sandpaintings, not because they were interested in studying Navajo religion and mythology, but because they were initially intrigued by the designs and only later realized their educational, historical, and ethnographic importance. One such individual was John H. Huckel, who joined the

Fred Harvey Co., in 1898 and became fascinated by almost everything connected with American Indians. He founded the Indian Department of the Fred Harvey Co., complete with museum and salesroom in Albuquerque. Huckel began his sandpainting collection when he decided to decorate the walls of the El Navajo Hotel. He purchased Day's collection of 84 watercolor reproductions and in 1923 and 1924 had Miguelito augment it.

Other small, miscellaneous collections have been made for private and public institutions over the years (see Appendix 3). For example, the Museum of New Mexico had a number of drypaintings reproduced by Sam Tilden and his son-in-law in 1940. Nils Hogner of the Ethnografiska Museet, Stockholm, made the only collection of Navajo sandpainting reproductions housed in a European museum in 1929 and 1930. In 1930 Roman Hubbell had Miguelito make a set of reproductions which later served as pattern for sandpainting rugs. Leland Wyman and Clyde Kluckhohn each collected a small number of reproductions over the years, as did other anthropologists such as David McAllester, Charlotte Frisbie, Robert Euler, and Kenneth Foster. While Karl Luckert is carrying on the tradition today, the size of recent collections does not compare to those made before 1950.

With a few exceptions the majority of reproductions available in 1978 were made in watercolor, crayon and ink on almost any kind of paper by Anglo artists, traders and anthropologists. The few Navajos who made reproductions before the 1940s were all singers or apprentices to singers. All were unorthodox because of the amount and intensity of their associations with Anglos. Anglos, however, considered these men their equals and the intellectual elite of the Navajo and treated them with respect. These ceremonialists were either persuaded by large sums of money or were convinced that Navajo religion was dying out and needed to be preserved. This argument, which was first used in 1884, was still being used by Karl Luckert in 1973 to convince a Coyoteway singer to record his chant. Although traditional Navajo religion could not be said to be dying, the number of different ceremonials held had been decreasing and shorter versions of chants were

conducted. While some chants, such as Shootingway, were still performed, others, such as Awlway and Earthway, had become obsolete. In addition, as outside forces affected the Navajo, fewer young men were undertaking the many years of training necessary to memorize a complete nine- or five-day chant (Wyman and Kluckhohn 1938).

Cognizant of this situation, many anthropologists, traders, and collectors became interested in saving the religious life of the Navajo. They thought assimilation was inevitable. While conducting scholarly research, they sought to preserve for posterity the beauty and compelling designs found in the sandpaintings. Much of the recording was thus done in the spirit of "salvage ethnography," in haste, before the information was lost. Researchers felt it a duty to collect this information, almost in the sense that it was their mission in life. They argued down the singers' fears by convincing them that preservation was crucial. They succeeded because singers assessed their situation and decided that the anthropologists and interested Anglo laymen were right—that it was worth risking supernatural displeasure and sickness rather than lose their knowledge. They debated with themselves and came up with the argument that the new media—permanent recording in writing and pictures—were acceptable and preferable to losing this vital tribal knowledge, valuable not just to themselves, but to the whole world. This was reinforced by the attitude Reichard (1963:25) noted for Hosteen Klah. He believed that a people different from the Navajo would travel to the next world when this one had been destroyed. Feeling that these people of a different sort would be Anglos, he taught those Anglos who were willing to learn so that they could accurately carry the fundamentals of Navajo religion with them to the next world. Recording and teaching were acceptable because they were done out of respect and also because of the possibility that when sandpaintings were no longer made, a catastrophe would occur and mankind would be destroyed.

The methods by which the singers came to grips with this dilemma varied. A few singers, like Hosteen Gani, were persuaded only to supervise the Anglo-Americans who would

reproduce the sandpaintings so that while their knowledge would be preserved after death they themselves would not be breaking a sacred injunction against permanency. Others, like Sam Chief and Big Lefthanded, made the reproductions themselves. Even those singers who at first were very upset about the projects, like Miguelito, made reproductions themselves when the expected punishment did not occur and when Anglos were seen to be truly sincere in their requests. One hundred ninety-five Navajo singers eventually shared their knowledge with Anglos.

Thus bolstered by belief in their own power, by their prestige in the eyes of Anglo scholars and friends, who treated them as the intellectual elite of Navajo society and by the fact that those who made the reproductions usually did not become ill, the singers took on the Anglo researchers as the apprentices many could not find among the Navajo. Like apprentices, the Anglos paid for their instruction, hence the "adequate compensation" referred to by recorders. Traders and researchers always paid singers for their time and effort as well. In fact, one reason Miguelito completed the Huckell collection, even though BIA personnel tried to dissuade him (as they had others who were attempting to save their religion), was the large sum of money he had been paid for his knowledge. To Miguelito and other singers the money they earned was conceived as the same type of payment which was given to singers by Navajos whenever they imparted their knowledge. If an economic transfer did not take place, under the laws of reciprocity, the exchange of knowledge would not be complete. While this economic remuneration may have been an important consideration, the preservation of Navajo heritage was, nevertheless, the principal reason for the reproduction of ceremonial sandpaintings on paper.

Films and Photographs

Photographs and films of sandpaintings in actual ceremonial use are much rarer than reproductions made on paper. Besides the difficulty of photographing in the dark hogan, researchers found that it was much more difficult to justify their use

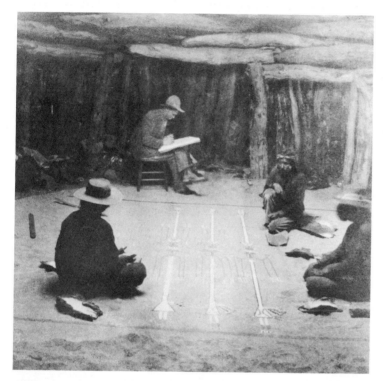

Figure 2.2 The First Dancers from Nightway, the earliest known photograph of a Navajo sandpainting being made in a ceremonial hogan. The photograph is also unusual in that it is one of the earliest of a person either taking notes or sketching the impermanent design. The photograph was made between 1894 and 1904. Smithsonian Institution, National Anthropological Archives Neg. No. 55094-a.

Fig. 2.2

for educational and historical purposes. It appeared that the ceremonial context was being polluted. For example, Clyde Kluckhohn (1923) spent many hours trying to convince Hosteen Latsanith Begay to let him photograph the sandpainting for a Nightway ceremony near Thoreau, New Mexico, in November, 1923. Begay felt that a photograph would take something away from the painting and as a consequence not be as pleasing to the Holy People who could then not be compelled to cure. Kluckhohn even had to overcome objections to photographing through the smokehole because Begay believed this would close the opening so that evil, which would contaminate the hogan, could not escape.

The earliest photographs of sandpaintings from Nightway were made by John F. Line (Fig. 2.2) sometime between 1894 and 1904. It was not until 1925 that photographs were

first published in a magazine article by artist Laura Armer. In 1924 she persuaded a singer, perhaps Moquisto, to make a painting of Pollen Boy and Corn People from Shootingway. At first the singer flatly refused because the paintings were sacred and dangerous and hence could not be made outside their ceremonial context. Several weeks later when the singer visited Armer at her makeshift studio on the first floor of the school at Oraibi (a Hopi village), she finally convinced him to make the paintings by debating about the actual time when the sandpainting became sacred. The singer believed that the moment of consecration came when the painting was sprinkled with sacred pollen, so he agreed to make it leaving off this final step and on the condition that the painting be made, photographed and destroyed in the same day. He was unable, however, to find any assistants, so the painting took from nine one evening to noon the next day. Two friends finally helped the singer complete the rainbow guardian, Armer took her photographs, and the painting was destroyed.

Armer also made what was probably the first movie of an actual ceremony in February 1928 (Armer 1956, 1961). It was filmed on the sixth day of a nine-night Mountainway ceremony at the hogan of Hosteen Tsosie near Ganado under the direction of Na-Nai. The movie cost trader Roman Hubbell $15,000 to produce exclusive of goods and gifts. (Everyone who participated in the ceremony had to be given gifts to lessen the opposition.) This film was shown at the International Congress of Americanists in 1929, the American Anthropological Association meeting in 1930, and to numerous civic and women's groups around the country. It greatly expanded Anglo knowledge about Navajo religion. Armer also made a short film of a star gazing divination rite in 1929 which included two sandpaintings.

A few other films have been made of ceremonies as well as a number of still photographs. For example, the Museum of Navajo Ceremonial Art has had films made in 1946 and 1963 of Mountainway and Red Antway ceremonies. The American Indians Film Groups of the University of California, under the direction of Samuel A. Barnett, made three films of Red Antway, Mountainway and Nightway

ceremonies in 1963 as well. However opposition to films is still strong and since 1978 the Navajo Medicine Man's Association (see Chapter 4) has tried to stipulate that filming will be allowed only under the rarest circumstances, and then only with the approval of the association. They believe such restrictions will prevent Navajo ceremonies from becoming tourist attractions as has happened to parts of Pueblo ceremonies. While the opinions and pressure of the association will carry weight, permission or refusal to allow photographing of ceremonial sandpaintings will be the choice of the individual singer and the family of the patient.

Sandpainting Demonstrations

Few records exist of sandpainting demonstrations by Navajo singers or laymen for non-Navajo audiences outside the ceremonial context in exchange for monetary compensation or for educational purposes, although hearsay attests that such demonstrations have occurred in museums, department stores, and arts and crafts shows all across the country since 1900. Although they have never been common, there appears to be a trend toward increasing frequency. This may have been due to relaxation of Navajo rules after Navajos saw sandpaintings annually made at such public events as the Gallup Ceremonial without ill effects on the singers. Non-singers also began to demonstrate, but it is impossible to say when this shift occurred. (Several who started demonstrating in the mid- to late-1970s are also producers of commercial sandpaintings.) The earliest demonstrators were all singers, but when they did not become ill from making the secular sandpaintings, laymen slowly began to give it a try. The transition was gradual because illness, according to the Navajo conception of disease, does not always immediately follow a transgression.

While 1900 is a conservative beginning date for sandpainting demonstrations, 1893 at the World's Columbian Exposition in Chicago is probably when the earliest demonstration was staged. Present at the New Mexico Pavilion were a Navajo weaver (Hosteen Klah), several Pueblo weavers, a

Fig. 2.3

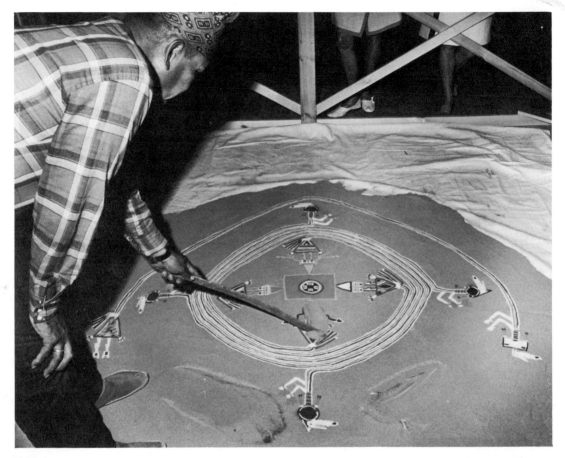

Figure 2.3 The sandpainter erases an impermanent sandpainting during a demonstration at the Arizona State Museum in the late 1950s. The painting is of Whirling Rainbow People from Windway. The sandpainter uses a weaving batten to erase it in the opposite order in which it was made, beginning with the paired guardians at the east. Photograph courtesy of the Arizona State Museum, Helga Teiwes, photographer. Neg. No. 25915.

woman potter of unknown tribal affiliation, a Navajo silversmith, and an elderly Navajo singer. Although not verifiable, it seems likely that the singer was demonstrating the making of sandpaintings. Museums housing ethnographic and art collections definitely scheduled occasional educational demonstrations by 1920. The earliest such recorded demonstration was at the Arizona State Museum, Tucson. They later occurred all over the country, sponsored by traders like B.J. Staples of Coolidge, New Mexico (Fig. 2.3). Although most of the sandpaintings were destroyed at the end of each day, occasionally they remained overnight. One such instance occurred at the Museum of Navajo Ceremonial Art when in May 1963, Son of the Late Tall Deschini, a singer of Red Antway,

allowed his sandpainting of Red Ant People to remain on the floor overnight. He reasoned that it was safe to do so since no patient had been treated, and hence, the painting contained no evil, only blessings. (Wyman 1965:35).

In addition to the demonstrations held in museums for educational purposes, there have been various staged demonstrations over the years. Many of these were arranged by photographers who used the events to illustrate articles and books or for postcards, professional slides, tourist brochures and the like. Published photographs of these decontextualized events go back to at least 1928 (see photographs in Westlake 1930: plate 36).

Indian arts and crafts shows were often sites for sandpainting demonstrations even though sandpaintings were not yet commercial crafts. These shows were originally designed to: educate the public about Indian art, showing it as both fine art and decorative art; create a market for quality Indian art; serve as market places; encourage Indian artists; and, prevent traditional crafts and skills from dying out. As separate annual events, these shows began in the 1920s with the Santa Fe Indian Market (1923) and the Gallup Ceremonial (1922). Unlike expositions and world fairs of previous years, where Indian artists constituted but one segment of a state's exhibit, these shows were dedicated solely to Indian art. They were successful from the start, and other competitive and juried Indian art shows and markets slowly appeared. Special traveling exhibitions began in the 1930s, sponsored by the Bureau of Indian Affairs, the Indian Arts and Crafts Board of the Department of Interior, the Southwest Association of Indian Affairs and other interested private organizations. The first prominent exhibition of this kind opened in New York City in 1931, the famous Exposition of Indian Tribal Arts (Sloan and La Farge 1931). Others followed, such as the Century of Progress Exhibition in Chicago in 1934 and the Golden Gate Exposition at the San Francisco World's Fair in 1938 and 1939. At these and similar art shows impermanent sandpaintings were made, both as entertainment and as a means of educating the public in traditional forms of native art.

While weavers, silversmiths, potters, and other artisans also demonstrated, it was usually the sandpainters that captured people's attention. Even today, sandpainting demonstrations are more fascinating than other craft demonstrations; at the Sacred Circles exhibition held in Kansas City, the sandpainting demonstration was the most popular event in the entire show. Indirectly, these exhibitions created a potential market for commercial sandpaintings before the craft ever existed.

Olin (1972:71) has concluded that many singers were induced to demonstrate solely for money but how many, who they were, and what proportion of all singers this group comprised is unknown, for hard evidence of the motivations of these men is difficult to obtain, and the Navajo conception of the economic transaction is not considered. Most likely some of the demonstrations at early Indian markets and the Gallup Ceremonial were done primarily for monetary remuneration since prizes were given. For example, at the first Santa Fe Indian market the organizers tried to institute a sandpainting competition so that sandpaintings would be judged like pottery, rugs and silver, chili peppers, and the prettiest Indian baby. The prizes from 1923 to 1926 were $15 for first place and $10 for second. In 1924 and 1925 Paul Charley of Crownpoint won, as did William Charley in 1926; no second place prizes were ever awarded probably because there were not enough entrants. No one entered the competition in 1927 and B.J. Staples had to bring Hosteen Nelson Begay and Tochen Otsida to demonstrate at the last moment. The contest was finally dropped in 1928, and demonstrations were even discontinued in the 1930s when the nature of the fair changed. Singers apparently had no interest in competing artistically for while demonstrations for educational reasons were accepted, or at least tolerated by this time, competition was still objectionable. Nor were sandpaintings in the ceremonial context thought of as art, so that quality of workmanship, which was the criterion for judging at the art shows, was not a primary consideration. This was a conceptual gap necessary for the transformation of sandpaintings to a commercial art that had not yet been bridged. Demonstrations as art competitions required too radical a change. Today demonstrations at department stores, arts and crafts shows, and public functions are

Fig. 2.4a

Fig. 2.4b

definitely done for economic purposes, although many singers feel (as did Hosteen Klah) that they are teaching Anglos about Navajo religion.

While demonstrations minimally violated rules about using sandpaintings outside the ceremonial context and reproductions violated requirements of impermanency, sandpainters making permanent demonstrations which could remain as museum exhibits faced both problems, not to mention technical problems of how to keep the colored sands in place. In fact, the earliest permanent sandpainting was not made by a Navajo, but by anthropologist Alfred Tozzer in 1902, as an exhibit at the Peabody Museum of Archaeology and Ethnology at Harvard University. The painting was a copy, complete with set-up of the Four Rain Gods, from a Nightway ceremony which Tozzer had seen near Pueblo Bonito in 1900. There are no records of how the painting was fixed, and there is no evidence that Navajos even knew of the painting's existence.

In late 1918 the first Navajo-made demonstration sandpaintings not destroyed at the end of the day were made by Sam Chief (Yellow Singer) of Kayenta (see Fig. 2.4). Responding to the persuasion and friendship of Louisa Wetherill,

*Figure 2.4 The first permanent sandpaintings were made by Sam Chief (Yellow Singer) in 1918 at the Arizona State Museum. Pictured here are **a:** People of the Myth from Beautyway and **b:** Heroes of the Myth and Antelope from Plumeway. The paintings were made freehand from gypsum, malachite, azurite, red and yellow ochre and hematite. No adhesive was used. When the museum moved in 1926, the impermanent colors were solidified to insure their safe transfer with a solution of collodion and alcohol. Photograph courtesy of the Arizona State Museum, Helga Teiwes, photographer. Neg. Nos. 15899, 15900.*

Sam Chief allowed his six original sandpaintings to remain in the permanent collections of the Arizona State Museum. Convincing Chief to leave the paintings intact to serve as a blessing to the university proved to be no easy task (Cummings 1952:16–18; Cummings 1936). While he thought it was acceptable to make sandpaintings, it was unacceptable to leave one in place after sundown because if a painter did, he would go blind. Wetherill and anthropologist Byron Cummings, director of the museum, utilized the same strong arguments they had used to convince him to make reproductions on paper, namely that sandpaintings were disappearing and that it was the singer's duty to preserve them. In addition, they told Chief that it would be a great honor to be remembered as the man who had saved Navajo religion. What finally convinced Chief to risk angering the gods will never be known, nor will the exact reasoning that went into his decision. But an important decision it was; Chief had obviously succeeded in rationalizing the use of sandpaintings in a permanent form outside the ceremonial context. This was an important step in the transition which would allow commercial sandpaintings to be developed. Colored sands on sands left in a permanent form was much closer to a sacred sandpainting than were the designs drawn in poster paint on brown paper bags, even though an isolated figure of a Holy Person was capable of calling the gods. There was no question in Chief's mind that the Holy People would come and test him and his work. If the experiment had been ill advised a calamity would have befallen his people. Observing that no disaster occurred and that his eyesight actually improved, according to Cummings (1936:2), Chief interpreted this as a sign of supernatural favor. Cummings had told him the truth—he had performed his duty and the paintings would bless the university. The idea that permanent sandpaintings should be made so that they would bless the homes of Anglo-Americans was adopted by several commercial sandpainters.

Chief's paintings are no longer on permanent exhibit at the Arizona State Museum for through a series of unfortunate accidents, all but one have been destroyed. The permanent painting currently on display in the museum, Sun's House and Sky People from Shootingway, was made by

Fred Stevens, Jr., one of the founders of the craft of commercial sandpaintings.

Very few sandpainting demonstrations have become part of permanent exhibits in the United States or Europe, for in addition to the problems of convincing any singer to make one, the lack of an easy-to-apply fixative and the large size of the paintings mean that it cannot be moved without destroying it. This poses ethical problems for museums whose duty it is to conserve the materials which have been entrusted to them, and means as well that a museum with a sandpainting will run into problems if it wants to have an active exhibit program. This has meant that few museum professionals have striven to convince Navajo singers to make permanent demonstrations. One of the few museums which does have a permanent sandpainting is the Buffalo Museum of Science. On May 4, 1932, to celebrate the opening of the Hall of the Americans, Hosteen Yazzie Begay made a linear painting of two White Holy People flanking a twelve-eared white corn. The non-fixed painting, 5 by 7 feet, is surrounded by a Rainbow Goddess, and although under glass in the center of the room, it has been damaged by insects and vibrations caused by construction in other parts of the museum. Not wanting to destroy this ethnographically and historically important painting, the staff has been unable to significantly alter their exhibit plan since 1932. The Museum of Navajo Ceremonial Art conversely decided to destroy its huge central sandpainting when the museum underwent reorganization in the early 1970s because there was no way to move it without breaking it. In the exact center of the octagonal museum, Anglo artists Van Muncy and William Henderson, under the direction of Hosteen Klah, made the unique double painting from Male Shootingway in a shallow case on the floor. This stabilized sandpainting remained intact while large paper reproductions were hung on the walls.

Picture Writing

An innovation similar to reproductions on paper, but used by Navajos instead of Anglos, is picture writing, a mnemonic device in which representative symbols used in sandpaintings,

or the main ideas in a chant verse, are kept permanently on paper or cloth. When seen, they will jog the memory of the singer. The origins of picture writing are cloudy. Fishler (Newcomb, Fishler and Wheelwright 1956:52) concludes that it was either a development of the late 1940s or early 1950s or else had been a well-kept secret. Evidence is sketchy for both possibilities, although development by the turn of the century is questionable. Olin (1972:50) speculates that the 1890s photograph by John Line (Fig. 2.2) was taken surreptitiously and caught a singer in the act of consulting his notebook. While the subjects definitely do not appear to be posed, one must question whether it was even possible to take photographs secretly given the state of photographic equipment in the 1890s. Also the unidentified man in the background who is holding a notebook could just as easily be an Anglo taking notes as a Navajo singer consulting his "memory jogger." Without additional data this is hardly solid evidence for the early use of picture writing.

There is, however, solid evidence for the use of written mnemonic devices for religious symbols in the 1920s. In 1924 Gladys Reichard (1963:305–306) saw a collection of paper sketches for symbols for more than 30 prayersticks which were used by a 70-year-old singer. Other singers at this time referred contemptuously to the paper slips as an indication that the man was not a good singer because of his dependence and lack of confidence in his memory. There was not a negative reaction to the permanency of the designs and symbols.

Few singers used picture writing in the 1950s, nor was its use widely known or approved of. A prominent singer in Pinedale used them as did two apprentices who had to attend off-reservation schools while trying to learn their chants (Newcomb, Fishler and Wheelwright 1956:47–48, 52). Fishler's respondent, a Blessingway and Upward Reachingway singer who used picture writing, said that they were too dangerous for most singers to handle and also that they posed a threat to members of the singer's family. The central problem was that certain types of ceremonial knowledge can be used or referred to only at specific times of the year. For example, a

Nightway ceremony can be held only in winter after the snakes are asleep. Thus, if the symbols were around all the time, the gods would be angry, and someone in the house would become ill. John Yazzie, the singer, also stated that, like singers who made reproductions earlier in the century, his important knowledge should not be lost. Since his sons either could not or would not learn his ceremonies, he wanted to preserve his prayers and sandpaintings for his grandchildren. Thus the argument which anthropologists had had to advance to singers earlier in the century in order to convince them that Navajo ceremonial knowledge should be saved was now being freely given by a singer to an anthropologist in the 1950s as an explanation for his actions.

USE OF SANDPAINTING DESIGNS
IN ESTABLISHED CRAFTS

Sandpainting Rugs

At the same time that singers were beginning to hold demonstrations a few Navajo women on the eastern end of the Navajo Reservation began weaving more or less accurate reproductions of sandpainting designs and separate yei figures into their rugs. Three types of rugs utilized either partial or complete sandpainting designs, isolated figures of supernatural beings, or ceremonial items: yei rugs, yeibichai rugs, and sandpainting tapestries (Fig. 2.5). All three types of rugs as a unit span the same type of subject matter, the same range of complexity, and incorporate the same types of intentional and unconscious changes seen in commercial sandpaintings. The term yei, used to designate rugs which show simplified representation of Holy People, is actually a misnomer because the yei are a special type of Holy People who do not speak. They are led by Talking God, or the yeibichai, and are impersonated in Nightway, Coyoteway, Big Godway and related chants. It is almost impossible to tell whether the earliest examples show yeis from Nightway for the figures woven in these rugs are rarely identifiable yeis or specific Holy People, like Monster

Slayer. Yeibichai rugs show a linear row of human dancers impersonating the masked gods in Nightway and Big Godway ceremonies. The human figures dance with one leg slightly raised, arms bent at the elbow, and hands holding rattles and spruce boughs positioned at the waist. The figure gives the impression of being slightly turned to the side (although the face is in frontal position) and of having been stopped in mid-action. These rugs are highly stylized and, as will be seen, very similar to commercial sandpaintings of Navajo yeibichai dancers and clowns.

Yei and yeibichai rugs have been incorrectly called prayer rugs or ceremonial rugs (i.e. Smith 1939:28; Kielhorn 1936: Duclos 1942:13), but they are strictly secular, commercial items, although the symbolism they contain may sometimes be considered sacred by the Navajo. Blankets of this type were *not* used in ceremonies and no blankets depicting sacred symbols or figures were woven prior to the 1880s. The idea that these were traditional prayer rugs was probably the fabrication of a trader who was attempting to increase their value and hence increase sales, for it was evident that Anglo customers would pay more for a rug or object which is felt to be religious or symbolic. Clearly, the Anglo customers who bought the rugs in the early twentieth century considered them to be religious in nature, and this characterization along with their rarity and intrinsic interest contributed greatly to their popularity. Religious symbolism was not a feature of Navajo weaving, and it is highly questionable whether contemporary weavers consider yei rugs religious. The religious nature of these rugs themselves had been stressed by Anglos, especially traders, only to increase commercial demand. However, since even the depiction of a single Holy Person will call the gods, the making of yei rugs—and by extension yeibichai (since masks which are the holiest piece of religious paraphernalia are shown)—presented problems for makers and the Navajo community.

Yei and yeibichai rugs are generally thought to have originated in the San Juan region around 1900 but Wheat found that in 1885 a weaver placed a single, small figure of a Holy Person among geometric designs in a conventional blan-

Fig. 2.5a

Fig. 2.5b

Fig. 2.5c

*Figure 2.5 Weavers began using designs from Navajo sandpaintings in their rugs at about the same time singers began producing sandpainting reproductions. Three types of rugs using these designs are shown here. **a.** A yei rug made in the Shiprock style by Nellie George in the early 1960s. The two Holy People are placed between three stalks of corn. The composition is surrounded by a Rainbow Goddess and is so generalized that it cannot be identified by chant. Photograph courtesy of the Smithsonian Institution, Neg No. 82-15451, Vic Krantz, photographer. **b.** Yeibichai rugs do not contain sandpainting symbolism but depict rows of men impersonating the Yei during Nightway and Big Godway ceremonies. Prize-winning rug from the Museum of Northern Arizona's Navajo Craftsman Show, 1978. **c.** This sandpainting rug, a complex composition, is a modification of the radial version of the First Dancers from Nightway. In the sacred version Talking God (the white figure with an inverted triangle for a headdress) would be placed above the heads of the other two figures, First Dancer and Fringed Mouth. Photograph courtesy of the Los Angeles County Museum, No. 0-1683.*

ket. There are no other examples until the turn of the century and the Holy People as a predominant motif appear about 1905. Trader John Wetherill (of Chaco Canyon) told Father Stoner that he had arranged for a Navajo woman to make the "first" yei rug for the 1904 St. Louis World's Fair (Tanner

1968:80). The wife of trader Dick Simpson, Yana-pah, from Gallegos Canyon just east of Farmington began making yei rugs soon after 1900 but wove only four in her short career (McNitt 1962:298f). Writer George James was immediately attracted to the figurative rugs which were so unique, calling Yana-pah an inventive genius in design (G. James 1974:140). He also wrote of the daring of the woman and her intelligence because she had overcome her tribe's superstitious fears (an ethnocentric interpretation rightly questioned by Reichard in 1936). This early blanket was seen by a collector of blankets and bought for several hundred dollars, quite a large sum of money, especially considering that most rugs were sold by the pound at this time. Simpson repeatedly tried to induce his wife to make another yei rug but for a long time she refused, probably because of the community reaction and apprehension over the reactions of the gods. However, the rugs sold rapidly and several other women in the area began making them.

Yet yei rugs were always rare. There are no examples of them in photographs of the Shiprock Fair between 1912 and 1915, even though Shiprock was the region where the early weavers of yei rugs lived. Most of the early yei rugs are decontextualized portraits of single Holy People, although some time shortly after 1900 a rug with two rows of seven Holy People each, a partial reproduction of the First Dancer sandpaintings from Nightway, was woven. These types of rugs became standardized forms. The large single or double figures were placed vertically on a rug, a design concession which makes them different from other Navajo rugs. All rugs are made in a plain tapestry weave, usually in a modified serape size (Amsden 1934:105). At first the figures of the Holy People were woven with appropriate detail, but in the 1920s and early 1930s they became more generalized. Later, as books with sandpainting reproductions became available, some weavers began to make copies of more exact figures.

Yei rugs were popularized by Will Evans, a trader at Shiprock, following World War I. He developed a regional style of yei rug having brightly colored figures on a white background. He continued to price the rugs exceptionally high and made the buyer feel that he was purchasing something precious; however, not everyone liked the rugs. Many

Navajos and Anglos considered them travesties, items which would be purchased only by people who did not understand or respect Navajo religion. Reichard (1936:155–156) felt that they were "...hideous attempts at representations of Navajo gods, ugly because false in every respect...a perversion of the good technique of weaving and a prostitution of the noble art of sandpainting." They also were considered dismal failures artistically, because true sandpainting colors could not be duplicated. Weaving as a medium was inappropriate because the dyes used to color yarn at the time were gaudy, yarn was too coarse to allow detail to be made, and the textural qualities of the sandpaintings were lost. In addition, because of the way rugs had to be made, the figures were awkward. In short, as Amsden (1934:106) said, they were examples of bad taste, and hopefully, would be a passing fad.

Amsden was wrong in his prediction because yei rugs are still made today. Although a small number of weavers of yei rugs can be found scattered all over the Reservation, most are concentrated in two areas: Shiprock-Farmington and Upper Greasewood-Lukachukai. (None of these individuals also produces commercial sandpaintings.) Shiprock rugs characteristically have a white background, use a variety of very bright colors, commercial yarns, and are surrounded by a Rainbow Goddess open at the east as in ceremonial sandpaintings. They are made primarily as tourist novelties. Upper Greasewood-Lukachukai rugs typically are made of handspun wool and have a soft grey or brown background. Fewer colors are used than in Shiprock rugs, and the composition is surrounded by a completely enclosed border never seen in sacred sandpaintings. Shiprock rugs are usually small and are used as wall hangings, while Lukachukai rugs are larger and coarser and are usually placed on the floor. Less than three percent of all rugs produced in the late 1970s were based on sandpainting designs. While prices for yei and yeibichai rugs are still high, they are now much more equivalent to other styles because quality is becoming a more important determinant of price than esoteric design.

Sandpainting tapestries are more or less accurate copies of complete ceremonial sandpaintings rather than isolated figures. They correspond to the complex commercial

sandpaintings which are designed as reproductions while yei rugs correspond to simple commercial sandpaintings which are designed as souvenirs or items to decorate the home. They are much more complex and detailed than yei rugs and include main and secondary theme symbols, plants, location symbols, guardians, and paired guardians of the east. Most can be identified by chant. Like yei and yeibichai rugs, the sandpainting tapestries have no ceremonial function, but are made for sale to Anglo collectors, for educational purposes, and as a new medium in which to save Navajo religion.

The first sandpainting rug was woven in Chaco Canyon in 1896, at the request of a gentleman on the Wetherill Expedition (Wheat 1976:48). In 1897 Richard Wetherill had another rug woven that remained in the family's possession until at least 1913. The fate of these early rugs is unknown; since no photographs were taken, subject matter cannot be ascertained. The next sandpainting tapestries were not made for at least ten years and again their production was an exceptional event. A Whirling Logs sandpainting rug was made in Chaco Canyon in 1904 and Wheat discovered from trading post records that several rugs were made at Newcomb's Trading Post by an unidentified singer (*not* Hosteen Klah as has been reported) in 1903 and again between 1906 and 1911 while yet another rug was woven at Two Grey Hills in 1904. The fate of these rugs is also unknown. However, they caused quite a commotion in the area and again production ceased for a number of years.

Hosteen Klah (Lefthanded) was the best known and most prolific weaver of sandpainting rugs and for this reason has often been incorrectly identified as the first Navajo to produce the intricate rugs. Unlike most Navajo men, he wove ordinary rugs most of his life, completing his first at the World's Columbian Exposition in 1892–1893. He was constantly weaving rugs which were considered dangerous. For example, in 1910 he wove a copy of a rug fragment found by the Hyde Expedition in Chaco Canyon, a task which meant he could be contaminated by ghosts. In 1911 he secretly wove a blanket of yeibichai dancers, also dangerous because of por-

traying the sacred masks, but local Navajos and singers found out, and feeling even this weaving was sacrilegious, they demanded that Klah hold an "evil-expelling" rite and destroy the rug. However, the rug was sent to Washington, no ill effects were seen and the incident was forgotten (Newcomb 1964:115; Coolidge and Coolidge 1930:106). Klah waited until 1919, two years after he became an established Nightway singer, however, before he even attempted his first sandpainting or yei rug. This was a picture of the Whirling Logs from Nightway (Newcomb 1964:157–168). It took Franc Newcomb many years, therefore, to convince Klah that weaving the sacred designs, i.e. using a permanent medium in which he excelled, would be more appropriate than the strange method of ink on paper. Klah's initial reaction had been negative partly because he felt that while it might be wrong to make a permanent sandpainting, it would be even worse to put it in a rug on which people would walk. If hung in a museum or on a wall it would be acceptable. After lengthy consultation with his family (for his sister and mother would do the spinning and dyeing and would become ill if anything went wrong) he decided to start weaving.

Klah's first rug was purchased while still on the loom by Mrs. King C. Gillette. It was shown at the first Gallup ceremonial—the first time a sandpainting rug was ever shown publicly. It was woven so well that it won a blue ribbon for craftsmanship. His second rug, the Storm People and Corn from Hailway, was completed in 1921 and purchased by Mary Wheelwright. Every year Klah's rugs were shown at Indian craft fairs and expositions such as the Chicago Century of Progress in 1934. Klah began weaving one or two rugs a year in order to support himself (for weaving along with curing had always been his profession). While Klah made at least 25 rugs himself, his sister's daughters, Gladys and Irene, began helping him when he received an ever-increasing number of orders for the intricate rugs. Klah thought each sandpainting rug was the same as a sacred sandpainting in that it was capable of calling the gods; therefore, he would make sandpainting rugs based only on the chants he was qualified to sing—thus

the seventy sandpainting rugs Klah and his nieces made were from Nightway, Hailway, Shootingway, Mountainway and Eagleway.

Newcomb (1964:162) always thought that Klah and his nieces were the only ones to make complete sandpainting rugs because other Navajos in the area would not make copies. (They felt that one would go blind from constantly gazing on the sacred symbols as the rug was slowly woven and that one's arms would be paralyzed from weaving symbols.) A few Navajo did begin to make yei rugs or occasionally place isolated symbols in pictorial rugs after they saw that Klah and his family were prospering rather than ailing. However, a few women who had medicine men as close relatives were daring to produce sandpaintings rugs, but in secret. For example, weavers near Ganado had made several rugs by 1915, and in 1916 a weaver near Lukachukai daringly made a rug of the Wind People dressed in Snakes from the Navajo Windway. In the 1920s and 1930s, singers like Miguelito made detailed templates on paper for their female relations to follow and would criticize the rugs during construction to insure accuracy. Today most weavers use published reproductions and laywomen are not working directly under the supervision of singers. Most weavers of sandpainting tapestries live in the corridor between Shiprock and Two Grey Hills. This is the area directly north of Sheep Springs where commercial sandpainters are most numerous.

Sandpainting rugs were always rare, even though their monetary worth was great. They were difficult to make and required a great deal of skill. Coolidge and Coolidge (1930:104) stated that one trader who specialized in their sale received no more than six sandpainting tapestries a year. Kent (1961:26) estimated that only two or three women made them regularly in the 1950s. One reason is the huge loom required to incorporate necessary detail. Weavers must be very skillful as well as able to surmount religious issues. In 1961, these rugs were expensive collector's items, retailing for a minimum of $700. High prices have always been paid for sandpainting tapestries (Reichard 1936:158) and Klah's rugs in the 1920s and 1930s sold for $1,000 or more. Values in the 1970s doubled and tripled.

Sandpainting Designs
in Silver Jewelry

Navajo silversmiths occasionally place sandpainting motifs on jewelry sold to Anglo-Americans, but these pieces are extremely rare, and appear to be a post World War II development coinciding with the addition of motifs from petroglyphs and pictographs, animals, flowers and prehistoric Southwestern pottery designs to the repertoire of the silversmiths. However, several authors and individuals with only a superficial understanding of Navajo religion have hinted that this transition occurred in the 1920s or earlier. One example is the "swastika" pendants made around 1906. A common design used all over the world, this motif is similar to the central location symbol found in the Whirling Log sandpainting from Mountainway. Local traders began asking Navajos to use the geometric pattern and called it the "whirling logs design" even though it had absolutely no relationship to the sandpainting. Hegemann (1962:19) says that any resemblance to the whirling logs design was purely in the imagination of retailers and was concocted solely to please uninformed Anglo tourists. As with the weaving, the retailers found that "symbolic" jewelry sold better than pieces without meaning. According to several sources, the Navajo did not especially like the design which has not been seen since the 1940s when traders discouraged its use because of the design's association with Nazi Germany.

The only other possibilities of the early use of sandpainting designs in jewelry are the rare snake rings and bracelets, items which were definitely outside the mainstream of Navajo use (Bedinger 1973:88; Franciscan Fathers 1910:271). These pieces consisted of flexible narrow bands, flattened and elongated at one end with stamped eyes, mouth, scales, and rattles. Even though these snakes were realistic life forms rather than the standardized and symbolic forms used in sandpaintings, Adair (1944:104) found that most Navajos refused to make reproductions of snakes, even though traders encouraged them to do so since they were popular souvenirs. In general, the fear of the highly dangerous and unpredictable snakes outweighed the encouragement.

While isolated geometric motifs such as circles or squares were used in stamped and incised jewėlry, Navajo smiths did not see them as bearing any relation to isolated motifs used in sacred sandpaintings. Adair in the late 1930s conducted a small experiment, by showing a variety of commonly used designs to five smiths. These designs were ones which traders were saying had direct religious associations. The smiths, however, laughed when questioned as to the designs' symbolism and religious significance, stating that the "lightning" and "clouds" were only meaningless decoration.

There were few if any sandpainting designs in silver before World War II. This is probably due to religious principles as well as to the fact that silver jewelry was produced as much for Navajo consumption as for sale to Anglos. Geometric designs were definitely preferred in silver because smiths had the talent, equipment, and facilities to do highly detailed engraving which would have been required to make sandpainting designs in silver by 1900. But this would not have been worth their time and effort since smiths were paid primarily by the weight of the silver used in the piece rather than the amount of labor and workmanship. (Bonuses were sometimes paid for exceptional quality, but few traders followed this practice.) For example, a scale was fairly uniform over the Reservation in 1938—fifty cents per ounce worked, with ten to fifteen cents added for set stones (Adair 1944:114). Very complex designs like sandpainting designs would have required a great deal of silver and concentrated labor, and there would have been no economic incentive for such an effort. In addition, many smiths became singers as their eyesight failed. It would have been a very difficult medium in which to save the sacred sandpaintings, and few active smiths would have had the necessary knowledge to do this.

SANDPAINTINGS AS DECORATIVE ART

Wall Decoration

As attractive sources of motifs, Navajo sandpaintings were recognized as suitable for use on decorative art. The idea that

Navajo sandpaintings could be used as permanent wall decoration was quickly seen by an early collector of sandpainting reproductions, John Huckel. The Fred Harvey Co., was building hotels throughout the Southwest to serve passengers of the Santa Fe Railroad. Each hotel was designed to capture the scenic and cultural qualities of the region. For the El Navajo Hotel in Gallup, New Mexico, built in 1923, Huckel and Mary Jane Coulter (designer, architect and decorator for the Fred Harvey Co.) decided to use a Navajo theme, complete with Navajo rugs, pottery, and baskets for decoration. The walls were decorated with twelve large exact reproductions of Navajo sandpaintings furnished from the Sam Day, Jr., collection discussed earlier. This was the first use of Navajo sandpaintings as purely secular wall decorations in a public building.

The selection of the pictures was based on two considerations: the legend and subject matter, which would be of interest to Anglo travelers since they had been previously inaccessible; and the suitability of the designs to the spaces to be decorated. No efforts were made to change the designs so that they would fit an oddly shaped space, nor was realism introduced. The designers and artist Fred Geary did not want the paintings altered, but wanted them to serve as exact duplicates of ceremonial paintings. Like the individuals who were collecting reproductions, they felt that the wall murals would be historic records of a religious art form which was dying. With this in mind they hired Sam Day, Jr., to supervise the placement and even the orientation of the paintings on the walls and had several Navajo singers who were interested in preserving their culture evaluate and criticize the results. Some of their criticism was to Anglo eyes so minor as to be unimportant. To Navajo singers, however, it was extremely crucial. For example, one old singer was upset that the rainbow garters on the legs of Monster Slayer in the painting Monster Slayer Quartet from Shootingway had been eliminated (Anonymous 1923:175). It does not appear that there was any negative reaction to the permanent designs, at least not by the singers quoted in local newspapers. Whether other Navajo singers and laymen reacted as positively cannot be ascertained.

The opening of the El Navajo Hotel also marked an-
other important event, the first Navajo House Blessing cere-
mony conducted for a non-Navajo public structure (Frisbie
1968). A sandpainting, probably Pollen Boy and Cornbeetle
Girl, was made for the event, and in subsequent years,
museums and other public buildings which housed sand-
paintings would often be dedicated by similar ceremonies.
The dedication ceremony for the El Navajo Hotel was held
on May 25, 1923, conducted by Haquali Yazhe and Hashke-
Yazhe, Shootingway and Blessingway singers from Window
Rock. It was estimated at the time that at least 30
singers and their apprentices, including Miguelito, Hosteen
Bimenen, Hatale Yazzi, and Hosteen Bicha Tsohigi Begay
(all of whom had served as informants for Newcomb),
attended. It was one of the social events of the year and
many individuals from Albuquerque and Santa Fe attended.
Articles written about the ceremony and the hotel em-
phasized that the designs in the murals were eminently
suitable for wall decorations in any structure, public or pri-
vate. Newspaper articles, such as those which appeared in the
Albuquerque Herald on May 26, 1923, mentioned the beauty
of the structural composition and the mass, line, and colors.
Statements such as this helped create an interest in, and de-
mand for, permanent copies of Navajo sandpaintings.

Navajo drypainting designs have been used to deco-
rate the exteriors and interiors of other public buildings since
the 1920s (Fig. 2.6). Most were made by Anglo-Americans.
For example, Bruce Richards made a mural of the Whirling
Logs design from Nightway in an unidentified public building
in Arizona as part of a WPA project in 1937 (Anonymous
1938b:22). The first-class cocktail lounge of the luxury ocean
liner, the *S.S. United States,* was decorated by Peter Otsuni in
1952 with sandpaintings from Shootingway and Beadway,
using reproductions from Reichard (1939a), and highly ab-
stract and individual renditions of other sandpainting motifs.
These murals were made in vitreous enamel on copper as
mosaics on a sanded panel. Occasionally Navajos made
sandpainting wall decorations in off-reservation buildings. For
example, Sam Tilden made four Windway reproductions for
the Coronado building in Santa Fe (a private medical office

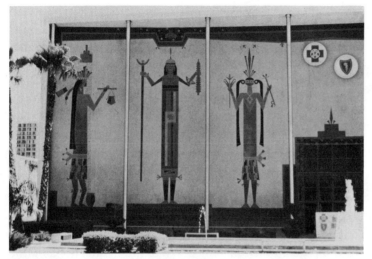

Fig. 2.6

Figure 2.6 This mural on the front of the Blue Cross-Blue Shield building, Phoenix, is the world's largest sandpainting, designed by Paul Coze. Made of crushed colored rocks cemented to the building front, the designs are a combination of Navajo, Hopi and Anasazi figures. The figure on the right is from the Magician's burial (see MacGregor 1943).

building) when he was working at the Museum of New Mexico in 1940. The owner, Henry Dendahl, thought that Navajo symbols of curing were appropriate subjects to decorate the lobby of an Anglo medical building, just as today many Anglo doctors and hospitals use commercial sandpaintings as the basis of their decorating schemes.

The use of Navajo sandpaintings as wall decoration was much slower in penetrating the reservation itself. Very few examples are seen today. A mosaic of the Skies from Shootingway can be found on the façade of the auditorium at the Navajo Tribal Fairgrounds in Window Rock, and the restaurant of the Holiday Inn at Kayenta contains modified, single figure murals copied from Newcomb and Reichard (1937). However, in the later case, the reaction to the paintings was negative and Navajos refused to work in the motel until a singer conducted a short Blessingway ceremony to counteract any possible negative effects from the designs.

Sandpainting Designs in Easel Art

Similar to wall murals utilizing sandpainting reproductions is easel art, designed to be hung on a wall for aesthetic and decorative purposes. While not a traditional art form, easel art

has become an important medium of expression for Southwest Indian artists. Many Navajo painters use sandpainting motifs in their work. One of the earliest recorded instances of this use of sandpainting figures is the work of Apie Begay (Wyman 1967:1; Dunn 1972:150). Begay, considered to be one of the first Navajo artists, lived west of Pueblo Bonito in Chaco Canyon. In 1901 he was visited by Kenneth Chapman of the School of American Research who gave him colored crayons, pencils, and paper so that he could complete sketches of isolated sandpainting figures which he had independently been attempting in two tones, red and black. His painting of the yeis from Nightway (see Tanner 1973: Fig. 4.4) show changes in stylization not seen in traditional sandpaintings. Arm placement is modified, decoration on the torsos has been changed, figures are less rigid, and there is a feeling of movement not found in sacred sandpaintings. While Begay was not an informant for any trader or anthropologist collecting sandpainting reproductions, it is not known whether he was a singer or layman. He did continue to paint yei figures into the 1940s.

There are few other examples of sandpainting designs in easel art until the 1920s, when paintings or line drawings of sandpaintings begin to appear in anthropological reports. Many were used to illustrate mythological stories. Other early painters, such as Big Lefthanded (early 1900s) from the Tuba City area and Choh (1885), painted religious symbolism in secular paintings as well as made reproductions. Big Lefthanded, for instance, made five paintings of Yeibichai dancers from Nightway as well as scenes from Enemyway (Fig. 2.7). However, the real impetus to the use of sandpaintings in easel árt came from Dorothy Dunn. Dunn, an art teacher at the Santa Fe Indian School from 1932 to 1937, encouraged students to paint pictures based on their traditional daily and ceremonial lives in "traditional" artistic styles. For Navajo students she suggested pastoral landscapes, subject matter which became the dominant Navajo theme in their easel art (Brody 1971: 134), but by at least 1933, students were adding sandpainting elements to these themes. For example, in 1934, Gerald Nailor and Stanley Mitchell (Chee Chilly Tsosie) produced a landscape of horses and men with three partial whirl-

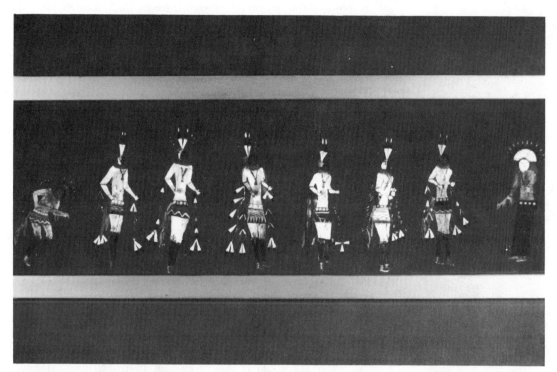

Fig. 2.7

ing rainbow figures in the sky. Andy Tsihnahjinnie added formalized plants rooted in rainbows to this early painting of horses. While the subject for these paintings is ceremonially derived, placement and action are not.

A few Navajo students began painting more complete, but still modified versions, of sandpaintings in watercolor in the early 1930s. The two most noted individuals were both women, Ruth Watchman and Mary Ellen. Neither woman cared for painting the pictorial aspects of Navajo life, according to Dunn (1968:301), but became engrossed in the technical task of creating a permanent technique for capturing the sandpainting designs. The paintings which these women produced were not accurate versions of sandpaintings as Dunn assumed, but still derived from the traditional subject matter. In fact, judging from published illustrations, complete sandpainting designs were rare. Dunn (1968:300) notes that the

Figure 2.7 Yeibichai Dancers by Big Lefthanded (Klah-so), Tuba City, made between 1905 and 1912. This is not a Navajo sandpainting reproduction but instead shows the early use of Navajo religion as a subject for easel art. The painting is made on light brown cloth using native pigments, opaque commercial watercolors and commercial oils, and like the yeibichai rug on p. 43, shows a group of men impersonating the Holy People. Photograph courtesy of the Smithsonian Institution. Neg. No. 82-1609.

reason for this is the religious nature of the complete designs and therefore, while the sandpaintings could not be the major basis for modern styles, they would provide a rich source of motifs which could be used in conjunction with Navajo subjects or included in abstract designs. The incorporation of the extremely conventionalized and stylized sandpainting motifs (i.e. sun, moon, rainbow or plant) as isolated items of decoration with realistic scenes from everyday life ˙became the basic compositional problem for Navajo students. While both Mary Ellen and Ruth Watchman appear to have painted very little after leaving the Santa Fe Indian School (Forbes 1950:249) other Navajo painters, such as James Wayne Yazzie, Gary Cohoe, R.C. Gorman, Carl N. Gorman, Mary Morez, Robert Chee, Richard Taliwood, Harry Walters, Stanley Battese, Ed Lee Nataly, and Boyd Warner, Jr., have used sandpainting designs in their work. Painters like Gerald Nailor have commonly used the sandpainting elements in flat, non-perspective style to add a new dimension to their more sculptured figures. Harrison Begay has even freely adapted the Slayer Twin Quartet with a continuous border, and regularly places a Rainbow Goddess and Cloud People in his paintings made in the 1960s and 1970s. In turn, Begay's paintings of women weaving, Indians riding horses, hunters and warriors, and realistic deer, antelope, and horses have served as the source of inspiration for several commercial sandpainters.

Earth Color Paintings

While influencing the development of design and subject matter, Dunn in 1933 taught her students at the Santa Fe Indian School to make earth color paintings in an effort to utilize the inexpensive materials found in the environment and reproduce colors traditionally used in painting pottery and ceremonial objects (Dunn 1952a:335). The technique, casein tempera, uses earth colors or pulverized dry organic pigments glued to a backing or to walls in a fresco technique. Tempera paintings are made with paints which can be diluted with water, but which when dry are insoluble since their adhesive base is an

emulsion which forms an opaque paint. Several kinds of emulsion bases were used by students including pure egg yolk diluted with water, melon-seed extract, glue, wax, resins, vegetable oil, and finally casein (a powdered protein made from milk). The palette came from pulverized clays, sandstones, and ores found throughout the Southwest; Dunn called them names based on the locality of origin, such as Laguna white, Hopi green, La Bajada yellow. These pigments were then combined with casein and other liquids to form a suspension and painted on a backing covered with sand. When finished, the painting was varnished, waxed, or overpainted with thin oil colors or glazes, a procedure which gave the painting a dull, lacquerlike sheen. Eventually these experiments in earth colors were combined into true fresco and fresco secco techniques for murals. The textural quality of the ground in these paintings and murals was like a sacred sandpainting, and hence Dunn considered the technique to be especially appropriate for Indian students who came from cultures which made religious sandpaintings. However, since the design is painted on in a liquid form it does not completely capture the rough texture of impermanent sandpaintings. While the closest technological innovation to commercial sandpaintings, earth color paintings differ from them because the color in commercial sandpaintings is sprinkled as a dry powder onto a wet adhesive base.

The technique quickly became popular with students from the Southwest, critics, and patrons. Pablita Velarde (Santa Clara), Andy Tsihnahjinnie (Navajo), C-Som-Ma-Thya (Santo Domingo), Lomayesva (Hopi), Vincent Mirable (Taos), Pai-Tu-Mu (Laguna), Ye-W-Te (Acoma), and Ruth Watchman (Navajo) all began using the medium extensively. In 1933 Watchman produced a Navajo "sandpainting" of Cloud People and Sun in earth colors which was exhibited at the Phillips Academy in Massachusette (see Dunn 1968:Plate vii). So successful were the experiments that the students held a critically acclaimed exhibit of earth color paintings in Paris in 1935. By 1940 many Indian artists were using the technique. However, since the 1950s, Pablita Velarde and Joe H. Herrera have been the foremost painters using this technique

Figure 2.8. The Exchange of Quivers from Beadway. A sandpainting can be the template for both commercial sandpaintings and earth color pictures. This comparison shows the similarities and differences in each type of painting. **a.** *A sacred reproduction of the Exchange of Quivers collected by Franc Newcomb. It is housed in the Museum of Northern Arizona, and it has been published by Gladys Reichard (1939b: Plate V).* **b.** *An earth color painting in casein tempera paint on a sand backing by Pablita Veralde of Santa Clara. Although derived from the Navajo sandpainting tradition and made by a technique which attempts to duplicate the textural quality of the sacred painting, the hunting animals (lynx, lion, wolf and wolverine) have been individualized and given greater mobility. Plants made partially in the Navajo sandpainting style have been added to balance the composition. The layout is greatly changed from the Navajo prototype. This painting is housed at the Arizona State Museum.* **c.** *Commercial sandpainting by Pearl Watchman, Sheep Springs, made about 1965. The Rainbow Goddess has been reversed and the bows being exchanged have moved from the hands of the hunting animals to a position above their heads. Size: 18" x 18".*

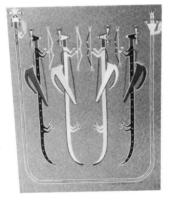

Fig. 2.8a

Fig. 2.8b

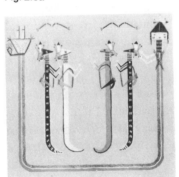

Fig. 2.8c

(Dunn 1952b) (Fig. 2.8). Both occasionally use Navajo sandpainting designs in addition to realistic depictions of Pueblo life and abstract motifs from Pueblo mythology. For example, the murals that Velarde completed in the late 1950s in the lobby of the Western Skies Hotel in Albuquerque were adaptations of Navajo sandpaintings in earth colors.

Casein tempera was used widely for murals in buildings around the nation (Dunn 1968:273). For example, murals commissioned in 1939 by architect John C. Meen for the façade and entry of Maurice Maisel's new trading post in Albuquerque were designed and executed by Anglo artist Olive Ruch and Indian painters Awa Tsireh, Popovi Da, Pablita Velarde, Pop-Chaltee, Ben Quintana, Ku-Pe-Ru, Joe H. Herrera, Wilson Dewey, Ignatius Palmer, Ha-S-De, and Harrison Begay. Dunn's students painted similar murals in the Department of Interior Building in Washington D.C. Gerald Nailor also decorated the Navajo Tribal Council chambers in the same techniques, while Andy Tsihnahjinnie painted a mural at the Westward Ho Hotel in Phoenix which consisted of abstract sandpainting motifs. In 1958 he used similar designs and techniques for the Harris Co., department store in Riverside, California (Dunn 1968:322–323).

No record exists of Navajo community reaction to the use of sandpainting designs in easel art of wall murals. It is likely that most Navajos, except close relatives of the artists, never saw these paintings since they were constructed and marketed primarily in areas far away from the reservation. As monographs containing illustrations of sacred sandpaintings made their way back into Navajo homes, books showing easel art probably did not, partly because of the cost. By the mid 1930s a technique of painting on a sand ground utilizing pigments of pulverized earth colors had been developed by an Anglo artist for Native American use. A few Navajos experimented with it for the purpose of capturing some of the textural qualities of sacred sandpaintings, but those who continued to use the technique were by and large not Navajo but Pueblo painters. Only two Navajo artists, Boyd Warner and David Paladin, produced both commercial sandpaintings and art in the casein tempera technique.

Miscellaneous Uses of Sandpainting Designs

Motifs and designs from Navajo ceremonial items have been used to decorate manufactured items such as clothing, draperies, bedspreads, towels, sheets, napkins, tablecloths,

dishes, mugs, salt and pepper shakers, teapots, coffeepots, lampshades, pillows, cushions, and sundry items. For example, a coffeepot would be decorated with "yei" figures or a tablecloth would have cornplants and Rainbow Goddesses woven into the fabric. These articles were being marketed extensively by 1930, but were probably first produced much earlier. Shops in Albuquerque and Denver sold these Anglo-made items primarily as tourist souvenirs. While most storeowners were honest, a few fraudently labeled them "Indian-made," leading to the establishment of protective laws designed to separate Indian from non-Indian-made goods. They did create a market for Indian-made items with sandpainting designs. Some Anglo artisans who used sandpainting designs, however, were interested in adapting traditional Indian designs to modern forms and uses. For example, Westlake (1930) studied the Fred Harvey Co., collection in the 1920s and altered the Native American designs seen on pottery, baskets and textiles to use in porcelain, home decoration schemes, and in modern costumes. In addition she encouraged Native Americans to use their designs (and often Hispanic designs as well) for new commercial purposes. Her endeavor, unsuccessful in the case of Navajo sandpaintings, is not unlike the attempts of Lois Field and Rhoda Thomas to adapt Rio Grande Pueblo weaving to modern Anglo-style dresses in the 1930s. As with the use of sandpainting motifs in silver, this attempt to use sandpainting designs in these various manufactured media was just too early to be accepted by the Navajo. Navajo pottery was almost always plain or incised prior to this, and manufacture was declining. When pottery again became more common on the western end of the reservation in the 1970s several men and women appliqued small corn plants or horned toads onto the finished pieces. Likewise Navajo costumes did not include this type of decoration traditionally nor did Navajo home furnishings. For example, paintings on lampshades were unknown. So along with the new media there was also no way to interpret these activities as a way of saving Navajo religion.

Sandpainting rugs and reproductions also were used by Anglo-Americans for postcards, greeting cards, calendars,

and posters. For example, Frashers Foto of Pomona, California, made a photo postcard from a photograph of two men making a sandpainting demonstration and the Museum of New Mexico issued a postcard depicting the Monster Slayer Quartet from Shootingway, the permanent but non-fixed sandpainting exhibit made by Sam Tilden. In addition to postcards museums have produced silk-screen prints of sandpainting designs as a means to raise revenue and to educate the public. For example, Anglo artist Robert S. Spray made a single figure Holy Person and two Long Bodies from Mountainway as part of a set sold by the Arizona State Museum. Originally these prints were made to illustrate Margaret Schevill's book *Beautiful on the Earth* (1947). Plates from monographs such as Newcomb and Reichard (1937) and Reichard (1939a) also have been enlarged and sold as separate portfolios suitable for framing.

In the 1970s sandpaintings had become so secularized that they were used for advertising campaigns. The Atlantic Richfield Company made posters showing Mother Earth and Father Sky drawn by Alfred Dihyja (or Dehiya). Dihyja, an art student from western New Mexico and an apprentice singer studying under his grandfather, demonstrated for the Navajo Tribal Museum in 1971 or 1972. A member of the board of the Atlantic Richfield Company saw him and engaged him to do a series of demonstrations which could be photographed and used by the company for an "educational" campaign. Needless to say, many Navajos were upset by this use of their sacred designs.

Sandpaintings have been used in Anglo-American art classes, both in public schools and in programs sponsored by Woodcraft Rangers, Boy Scouts, Girl Scouts, and similar organizations since the 1920s. Sandpainting designs are included in guidebooks and "how-to" booklets which include such things as how to build a fire "Indian-style" or make a Plains headdress. Early booklets were often inaccurate, misidentifying sandpainting figures and the cultural sources for the various designs (see Westlake 1930; Anonymous 1953:10). Other Anglo-Americans used the medium of drypainting for educational and entertainment purposes. G. Paul Smith, a Lyceum

bureau and Chautauqua entertainer in the early twentieth century, made "sand etchings" on a slanted velvet-covered surface to illustrate his lectures (Wyman 1983).

Finally Christian missionaries have not failed to utilize the symbolic and communicative medium of sandpainting in their mission to the Navajo. What better medium is there to express new religious ideas than one previously used by a culture to visualize and objectify supernatural beings? For example, Father H. Baxter Liebler, (1969:67–77), an Episcopal missionary at St. Christopher's Mission, Bluff, Utah, used impermanent sandpaintings to illustrate his sermons to Navajos in the 1950s and 1960s. According to local tales one of his drypaintings which included symbolic black clouds even brought much needed rain. The Franciscan missionaries at St. Michaels, Arizona, also began using sandpaintings permanently adhered to boards in the 1960s. The products of such efforts made by art classes at the mission school are Navajo adaptations of Christian symbols. One painting, "Navajo Madonna," shows a woman in traditional dress carrying a baby strapped to a cradleboard. Both heads are encircled by golden halos (Padres Trail 1968:8). This new use of drypaintings is analogous to the use of Navajo symbols (such as the sun to represent Jesus Christ) in oil paintings, or the construction of churches in the shape of hogans. While the mission art classes teach sandpainting construction techniques, none of the commercial sandpainters currently practicing learned the craft from this source. Most uses of Navajo sandpaintings in these miscellaneous types of media are still primarily Anglo uses rather than Navajo.

The diverse reactions of the Navajo community showed that few could have been ignorant of the existence of permanent and secular sandpaintings. It also seemed unlikely that they would all agree on whether sandpainting reproduction outside the ceremonial context and in permanent form was good or bad.

NAVAJO REACTION TO PERMANENT SANDPAINTINGS

ALTHOUGH SOME NAVAJOS WERE UPSET at first when indi-
viduals violated religious taboos by making sandpaintings in a
permanent form outside their ceremonial context, the Navajo
community was never totally united against their production.
By the late 1970s many Navajos recognized the existence of
both sacred and secular sandpaintings. But the road to accep-
tance of this dichotomy had many twists and turns. From the
first, reaction ranged from indifference to violent opposition.
Reasons for the opposition varied widely. Some felt that a
sacrilege was being committed and the paintings were being
treated irreverently; some feared supernatural repercussions,
for to break a rule is to disrupt harmonious relationships with
deity which would probably, but not necessarily, cause trou-
ble. Others did not fear for themselves but objected because
the uninitiated would see the paintings or would view them in
the wrong season. Still others feared for the Anglo recorders
who were unprotected but in continual contact with concen-
trated power.

In general, the consequences of misuse of sandpaint-
ings were believed to be blindness, insanity, paralysis, and
crippling for the singer, weaver, or painter, whether Anglo or
Navajo (Coolidge and Coolidge 1930:105; Wheat 1976:48).
Tales of the effects of this misuse are evident in Navajo litera-
ture. The illness of T's wife, an expert who wove beautiful

sandpainting rugs, was interpreted as a result of copying sacred designs (Reichard 1963:96). The first woman to make a yeibichai blanket supposedly went blind within eight years, and another who made a rug based on a painting used in Windway was punished by a cramp which drew up all her limbs (Coolidge and Coolidge 1930:105). A woman who made a Beadway rug in 1925, continuing in spite of the reprimands of elders, went blind. Her family then disposed of the rug (Watson 1968:24).

While Navajo morality is contextual rather than absolute so that rules vary with the situation and abstract ideals are rare, the community does act if the group feels it is in danger. Thus the possibility for violence existed. Arthur Newcomb hired a guard to protect Hosteen Klah's first rug since members of the community had attempted to destroy it. Another story is told about the first yei rug.

> ...it can well be understood with what shocked surprise, thrilled horror, and fierce condemnation the Navahos learned that a blanket, clearly of Navaho origin, was on exhibition at a certain trader's store into which was woven as the design the figure of one of the *yei.* It is almost impossible for a white man to comprehend the vast sensation this caused. Councils were held over the reservation to discuss the matter, and the trader was finally commanded to remove the blanket containing the offending emblems from the wall of his office. He refused, and for a time his life was deemed in jeopardy. But he was a fearless and obstinate man, and resisted all the pressure brought to bear upon him, though among themselves the Navahos still argued and discussed the sacrilege, and a shooting-scrape in which one man lost his life was the outcome (James 1974:139–140).

While one must question the trader's fearlessness, as well as his sensitivity to the feelings of his Navajo customers, the number of councils which were held and the extent of the opposition in this instance, it is clear that the potential for violence was real. Similar instances, while rare, were recorded by other traders. Lummis (quoted in Bedinger 1973:98) states that a silversmith was nearly beaten to death, and his hogan, equipment, and jewelry destroyed, for making a rattlesnake bracelet.

By far the most violent objections recorded were aimed at early weavers of sandpainting, yei, and yeibichai rugs, which by definition were blasphemous. Weavers were felt to be mercenary, producing an article for sale to benefit no one but themselves. Sale was seen as an illegitimate transfer of knowledge and in addition rugs would be walked on and hence the pictures of the Holy People soiled and defiled. Thus yei rugs were an extreme form of disrespect toward the Holy People. One reason was the weavers, as women, were weaker than men unless ceremonially protected. Many women who wove geometric designs would not even think of weaving a sandpainting rug. In 1942, Duclos tried unsuccessfully to commission La-Ba-He to weave a rug, but she even refused to talk about it for fear of offending the deities. She felt that as a layman and a woman she would not have been able to ward off the consequences. In contrast, singers, as the respected keepers of ceremonial knowledge who had the ability to control supernatural power, worked under the safe umbrella of preserving a disappearing culture. In addition, a Navajo singer owned his ceremonial knowledge. It was his to do with as he saw fit, and while laymen often disapproved, they recognized the singer's right to individual determinacy. Since most weavers were not singers, it was felt that they were using designs to which they had no right and over which they had no control. People thought weavers, unlike the singers, would bring disaster to the entire community. For these reasons, weavers experienced a great deal more pressure and vocal opposition than singers.

In time, however, more women began to produce yei rugs, and the violent reactions gave way to tolerance, or at worse, a general uneasiness. While older Navajos still voiced concern, yei rugs drew higher prices than other types of rugs and several traders actively encouraged production (Sapir 1935:609; Amsden 1934:106). This economic advantage was combined with the realization that very few weavers became ill. (Yana-pah never went blind and the suspense which the community experienced died down.) This reaction to outside pressures is similar to the pattern evident in the elimination of the spider hole in Navajo weaving: early blankets contained a

hole in the center to honor Spider Woman, the deity who taught Navajos to weave. Traders, however, refused to buy blankets with the centered hole, considering them unattractive. Weavers, meeting their customers' demands, gradually eliminated the hole and only those who became ill because they had failed to follow the mythological injunction would place a half concealed slit in subsequent blankets.

During the last twenty years, more yei and yeibichai rugs have been made, although the fact that some women still carry them rolled up tightly under their arms and will not show them to the merchant until all other Navajos have left the store shows that the opinion of others is still a factor to be dealt with. Since most demonstrations have been done off reservation most Navajos have not reacted either negatively or positively. Opponents, however, claim that the only singers who would demonstrate would be those not respected by the community or those to whom no one would go to lead a sing. By and large, however, decisions such as making a sand-painting out of context are felt to be the business of the individual and the immediate family, not the concern of the entire community. Within the familial context, mild criticism and expressions of apprehension are more common than violent opposition.

INDIVIDUAL APPREHENSION

Singers were often apprehensive about making rugs, reproductions, and demonstrations, because this difficult and weighty decision involved more than simply making a painting permanent. For example, Matthews states that singers were more concerned that the reproductions would be exposed at the wrong season than that they would be copied. In order to ease their consciences and offset negative repercussions singers developed methods to rationalize their actions. This involved a readjustment of the rules which allowed them to make permanent sandpaintings outside the ceremonial context without endangering the sacred paintings or calling basic beliefs into question. The example of the Navajo singer, Miguelito, producing sandpaintings for the Huckel collection in 1923 and

1924 shows the difficulty singers often experienced in rationalizing a break from traditional religion. In fact, Miguelito's even attempting to make reproductions is attributed by Gladys Reichard to his being brought up nontraditionally. He knew that the ancient rules were bound to break down under conditions of culture contact, but he had to be convinced, nevertheless, that it was his duty to preserve his ceremonial knowledge.

Miguelito pondered his decision for many days to overcome his fear and the problems of working without a patient. His misgivings were many even though he had already made reproductions for Sam Day, Jr., and Roman Hubbell in previous years. Each time he made a reproduction he had to overcome his fear of supernatural displeasure (Reichard 1939a:2). Day and Schweitzer worked many times to convince him of their rationale before he would complete the task.

By the time Miguelito began painting, however, there were already precedents for making the sandpaintings permanent. This was not true when Matthews first began collecting reproductions, but by the 1920s, many singers had heard that reproductions were made without mishap and had seen them or made copies themselves. Miguelito saw reproductions from Sam Day's collection. Even with this precedent the decision to follow suit remained: granted that one could make this knowledge permanent, how far could one go? What were the proper corrections once the taboo had been breached? When Miguelito overcame these problems, new ones arose, for by completing the task as rapidly as Schweitzer desired, he was "overdoing." Overdoing weakens the power of the chant because the painting is used too often. Another problem was that no singer ever revealed all his knowledge at any one time; when teaching, he always held something back, for to complete the instruction meant that the singer was through practicing. An apprentice had to obtain the information not provided by his teacher from another singer (Reichard 1936:6–7; Aberle 1967). Finally, he would consider a sketch finished at the end of one day, whether the painting was actually finished or not and he would often not work on it the next day. Reichard tells how Miguelito rationalized his decision. Since

he had promised to do the task, he felt compelled to complete it. To offset the possible ill effects he prayed and had a purification ceremony. He felt his knowledge was such that it could offset possible misfortune, partly by making the paintings without error. "He would trust in the power of his faith and the processes it prescribed to remove such harm as might ensue" (Reichard 1939a:7).

Singers also expressed anxiety for the safety of the individuals with whom they worked. Washington Matthews and his informant were both said to have been stricken with deafness, and later both died of paralysis (Coolidge and Coolidge 1930:105). Both illnesses are symptomatic of Mountainway, the first chant they recorded. (Using a chant incorrectly can result in acquiring the very illness which the chant is designed to cure.) When Mary Wheelwright asked Hosteen Klah to share his knowledge of this chant with her, he told her what had happened to Matthews. He offered to record his songs, prayers, paintings and origin myths from Mountainway only if Wheelwright was not afraid to take them. Although Klah believed his power was sufficient to protect them both, there was still an occupational risk (Wheelwright 1942:10–12). His fear for Wheelwright, as for Franc Newcomb who had caught flu in 1920, was that she was unprotected because she had not previously been a patient in a ceremony. Klah performed a short rite from the chant, along with Blessingway prayers when the task was finished. When no harm befell Wheelwright or the tribe, Klah continued to collaborate with her and teach her. He even gave a Hailway ceremony so that she could record the 440 songs and numerous sandpaintings contained therein. Franc Newcomb and Gladys Reichard were both given ceremonies for protection, as a Navajo apprentice and novice would be (Newcomb, Fishler and Wheelwright 1956:3). These rites gave these women free access to ceremonies all over the reservation.

All anthropologists faced problems when trying to study Navajo religion and record sandpaintings. Many were not permitted to witness the ceremonies firsthand, and singers were reluctant to discuss their knowledge with strangers. Sometimes, even if the singers allowed an Anglo to witness the ceremony, community reaction was such that the outsider

was asked to leave. The need for harmony took priority (Reichard 1939a:9).

In spite of a generally negative reaction on the part of the Navajo community, there was never a complete consensus that making permanent sandpaintings was wrong. Even in 1884 not all medicine men opposed reproduction of sandpaintings.

> After the writer made copies of these pictures, and it became known to the medicine-men that he had copies in his possession, it was not uncommon for the shamans, pending the performance of a ceremony, to bring young men who were to assist in the lodge, ask to see the paintings, and lecture on them to their pupils, pointing out the various important points and thus, no doubt, saving mistakes and corrections in the medicine-lodge. The water-color copies were always (as the shamans knew) kept hidden at the forbidden season, and never shown to the uninitiated of the tribe (Matthews 1897:45–46).

It does not appear that Matthews' possession of permanent copies was wrong as long as he agreed not to show the paintings during the summer when snakes and lightning were present, and not to show them to those who had not been sung over. It was thought that reproductions were either the same as, or very similar to, the real paintings.

Once a precedent had been set some anthropologists found it easier to persuade the next singer to record prayers and sandpaintings. Such was the experience of Newcomb and Wheelwright. Wheelwright (1942:12) writes:

> After I had recorded his great ceremonies and myths I went on to other Medicine Men and always found that when I told them of Klah and the idea of the Museum to keep the records safe for their people and mine, and of the ceremonies I had already seen, they were willing to tell their myths and show me what I needed to know. When they saw Mrs. Newcomb's sandpainting copies and found she also was really seeking for the absolutely correct version, they were anxious that their own sandpainting should be in her collection.

Klah's endorsement opened many doors. He persuaded other singers to tolerate Newcomb's presence, enabling her to record a number of paintings. Miguelito did the same for Reichard.

Even though many medicine men still did not approve of reproductions, most of them had at least become accustomed to the idea by the mid-1920s. Newcomb found that with time there was less need for secrecy about possessing reproductions and active criticism weakened. But even with increasing acceptance, most singers and laymen disliked note-taking during an actual ceremony. Most, however, did accept the fact that Newcomb memorized the compositions and immediately after the ceremony retired to reproduce them. They even corrected them for her. So accepting did they become of Newcomb that she often assisted in constructing the paintings during ceremonials, and singers would occasionally consult her paintings (Newcomb and Reichard 1937:4; Newcomb, Fishler and Wheelwright 1956:3). She never made reproductions without the knowledge and approval of the singer.

At least 195 Navajo singers and apprentices have assisted anthropologists and laymen in the recording of sacred sandpaintings. Enough opposition remained in the 1920s, however, that Wheelwright chose Santa Fe as the location for her Museum of Navajo Ceremonial Art because it was far enough removed from the reservation to allay the fear that constant viewing of the sacred portrayals by people who lacked ceremonial protection, as well as by nonbelievers, would lessen the power and efficacy of the rites. Yet at the same time, it was near enough so that those who sought the records could have access to them. Most Navajos probably did not know about the museum and later accepted it as an accomplished fact.

Commercial sandpainters who still believe in their old ways were initially apprehensive about their work, and several remain uneasy about the paintings being done by other Navajos. This was, and is, a problem mainly for those who began before 1969; later painters had precedents. An exception was Fred Stevens, Jr., one of the founders, and his maternal relatives who themselves had a precedent. They noted that their clan relative, Hosteen Klah, had successfully made and sold sandpaintings in permanent forms. If they followed in his footsteps and did exactly what he did, they could make permanent sandpaintings for commercial purposes. Like Klah, they

would become famous, respected, and wealthy because the gods approved their actions.

Some sandpainters who still believe in Navajo religion, particularly singers and their closest relatives, have been worried because most commercial sandpainters make paintings without thinking of the consequences. For example, one group of painters mentioned that several people from Sheep Springs were making Cyclone People from Windways. These unpredictable deities had become very angry because they had been called and as a consequence had brought tornadoes and extremely harsh dust storms to the area. Another painter stated that the disrespect shown by most commercial sandpainters is the reason there are so many deaths and so much drought in Sheep Springs. The fact that these individuals did not know what they were doing and that they neglected to say a prayer over their finished works meant all the people in the area would be punished.

COMMUNITY REACTION TO COMMERCIAL SANDPAINTINGS

Stories of opposition to commercial sandpaintings were common among Navajos. The majority of sandpainters, except for those under 20, had been told that commercial sandpaintings should not be made. Usually singers or older clan or affinal relatives were more upset about the sale of commercial sandpaintings than others. Singers were concerned for the welfare of the community and kinsmen for the health of their relatives. The fear was of supernatural repercussions rather than overuse of paintings or their being viewed in the wrong season.

One story which is fairly typical of Navajos' reactions to commercial sandpaintings was told by a young Navajo woman who bought a sandpainting of Crooked Big Snakes from Beautyway at the school in Many Farms where she was a teacher's aide. She intended to hang it in the living room of her home, but her mother refused to allow the painting to remain in the house. The older woman said it would call the unpredictable and dangerous snakes and would only bring disaster

and illness to the family. Although the young woman was unconvinced, rather than cause strife, she returned the painting to the artist.

Older Navajos did not consider buying or displaying commercial sandpaintings, even if they were not opposed to their manufacture. The only sandpaintings in most Navajo homes are those of non-Navajo dancers or symbols used by the Native American Church; these motifs are completely divorced from Navajo sacred sandpaintings. Eric Henderson (personal communication 1981), however, has noticed small single figures of Holy People in a few Navajo households.

Another characteristic attitude is illustrated by the father who told his children it was improper to make commercial sandpaintings and that they should think carefully about the possible consequences of their actions. A discussion mentioning that commercial sandpaintings are "wrong" was held in the presence of these painters, although they were not directly addressed or told to stop. In another instance, a singer came to the house of a young painter, accusing her of "causing" a recent tornado. He insisted that her paintings of Whirlwind People from Navajo Windway had called the violent dust storms to the community. Although the woman was upset, she continued to paint but more secretly. In fact, she was more upset that someone had told her what to do than with the remote possibility that she was doing something "wrong." Most painters were more angry that their right to individual choice had been challenged than with the possibility that their actions could cause disharmony. In fact, most sandpainters felt that such criticism was unfounded, resulting from ignorance or maliciousness. They blamed the accuser for causing trouble and bad feelings by initiating the encounter. No sandpainter would admit he was endangering himself or the tribe.

Disapproval was always verbal, often couched in terms that young people no longer had respect for elders or traditions. The situation was much less intense than for early weavers or sandpainting demonstrators. Their activities had gone on for so long without general or specific mishap that painters did not worry greatly about supernatural repercussions or community opposition. With time most relatives became

less concerned. What informal opposition existed almost always diminished after a sandpainter worked for a few years without negative consequences.

While reactions to permanent as well as commercial sandpaintings were usually on an individual basis, an organized effort to stop the production of commercial sandpaintings began in 1977. A bill to make production of commercial sandpaintings illegal was proposed and sponsored by the newly formed medicine man's association, *Dine Be Azee Iil' iini' yee' ahot'a*. Incorporated in 1979, this nonprofit, voluntary organization was formed to serve as a sponsoring agency for the use of health insurance funds and to preserve Navajo healing ceremonies. Their goals were to promote respect for native healers among Anglo health practitioners; to safeguard traditional paraphernalia so that it would not be sold; to assist members in handling insurance claims; to stop unlawful collection of sacred substances and antiquities; to train potential Navajo men as singers; and to establish standards for the performance of ceremonies and the conduct of practitioners. They did not wish to interfere with individual religious worship.

In their quest to retain the purity of ceremonies, members of the organization stipulated in their by-laws that there would be no camera, television, or recording equipment allowed inside a shelter where an actual healing ceremony is in progress; that the commercial sale or pawning of ceremonial paraphernalia by members was prohibited; and that a member not participate in any tourist activities (By-laws 1979). In the first draft the by-laws specified that members and all Navajo laymen not make and actively oppose the sale of permanent sandpaintings in any form. Because Fred Stevens, Jr., however, was one of the charter members, this rule was deleted. The association compromised and declared that it was acceptable for singers to demonstrate and make commercial sandpaintings because they know what to change, but that laymen, who do not, should not be allowed to do so.

Several members of the association were not satisfied with this compromise and continued to oppose the manufacture of commercial sandpaintings. A committee representing the new organization sent a petition to the tribal council in

1977 (with several members dissenting). A bill outlawing the production and sale of commercial sandpaintings was prepared but was never presented for final vote. A similar bill has been introduced for consideration to the tribal council every year through 1982, but even though the association lobbied for passage, it could not muster sufficient political support. While there have been no commercial sandpainters on the tribal council, councilmen realized that the law was impractical and unenforceable. Nor was everyone convinced that the council had a right to legislate such rules. The sale of commerical sandpaintings became a political as well as a religious issue.

Reaction to commercial sandpaintings resembled the original reaction to Tom Yazzie's carvings of yeibichai dancers. When they first appeared at the Navajo Arts and Crafts Guild, older medicine men said that they were "no good." They predicted that Yazzie would go blind and die. After a few years the negative reactions diminished and people no longer commented when they saw the carvings in shops. The carvings were accepted, no disaster befell the community, and Yazzie did not go blind. On the contrary, he prospered.

Nevertheless, the conflict created by the criticism of and apprehension about sandpainting reproduction did not subside without considerable effort on the part of individuals who pursued occupations as sandpainters and the singers who preceded them.

Chapter 4

THE PROCESS OF
RATIONALIZATION

IN RESPONSE TO CRITICISM, as well as to appease their own apprehension and fear of supernatural sanctions, Navajo singers and weavers altered their ideas about the use of sacred sandpaintings by gradually developing a rationalization which allowed them to break the prohibition against rendering the sacred designs in a permanent form. Simultaneously this allowed singers to continue using sandpaintings in their sacred context without questioning their efficacy. This involved intentionally changing or omitting at least one element in the design, color symbolism, or composition (Reichard 1963:160). This rationalization stemmed from the belief that completeness and accuracy were the crucial factors in the sanctification of sandpaintings. They argued that this simple device of changing details would prevent the Holy People from being called and impregnating the painting with power, since the paintings would no longer be exactly as the gods described. Since the painting could not be consecrated, therefore, it would remain a secular object. In addition, this rationale meant that supernatural power would not be taken out of the tribe and used by nonbelievers, an important consideration for several singers (Newcomb and Reichard 1937:16).

Ways of changing sandpaintings were many; all that was required was that the paintings were not perfect. Just as the decision to make ceremonial sandpaintings in a sacred

context was an individual choice, what would and could be changed remained an individual decision. Sam Chief, who was timid about being too accurate and worked in secret, experimented with color, among other things, as did Miguelito, who substituted green for blue when he reproduced sandpaintings in watercolors. His paintings were consistent in composition and all other details. These Navajo sandpainters reasoned that interchanging two colors destroyed the painting's functional significance by negating each color's symbolism in relation to position, and therefore kept it from entering the realm of the sacred. Reichard (1936:160) wrote:

> ...a god may be depicted with three feathers on his headdress instead of four; the colors of a bow may be interchanged, for example, a red one which should have blue markings may be decorated in black. The digressions made are usually, from our point of view, insignificant enough; in my opinion they are thoroughly justified.

Navajos also felt, however, that some details should not be changed or tampered with. Sandpaintings still had to be recognizable by chant, except in the yei rugs. In demonstrations, directionality was important and had to be observed.

> Medicine men strewing sand in a non-Navaho building have to decide upon an expedient set of directions. For example, the entrance to a museum or department store may be out of sight of the place where the painting is to be laid; east is arbitrarily determined and a prayer is offered to make the decision correct. On one occasion the chanter laid all the pictures on the floor of a warehouse just in front of the door, which opened to the south. He had, therefore, to choose whether the paintings should open at the east, which meant toward a wall, or at the direction corresponding with the entrance. His solution was simple: for the occasion, four days, he said the south would be east. The broken circle orientation superseded the absolute directional requirement (Reichard 1963:167).

Again, Navajos were not in agreement. Some felt a reproduction or a rug should not be changed but should be an exact replica of a sacred painting. Errors angered the gods, who would be called regardless of the accuracy of the painting, and their anger would be great if people produced incorrect paintings. Accuracy was a sign of respect. For instance, the singers

who officiated at the opening of the El Navajo Hotel, Gallup, were displeased because the wall murals were inaccurate in a number of minor details. These men, all of whom had previously helped Anglos make reproductions, were more concerned with accuracy than permanence.

While all singers agreed that ceremonial sandpaintings become holy, there was a lack of consensus as to the point at which neutral sands become sacred, and the mechanisms by which ceremonial sanctification takes place. To some it was simply making the painting in the first place, since a single figure of a Holy Person would be sacred even out of context. But to others the picture of a Holy Person would become sacred only if made in the ceremonial context. Again, for others it would not be sacred until it had been consecrated with sacred pollen. Newcomb (1936:3) supported the idea that the moment of control was after the sprinkling of corn pollen and intonation of the prayer. Some of Reichard's informants indicated that it was earlier, when the encircling guardian was begun. This was such an auspicious moment that even the chanter could not watch. An instance of this is recorded when Jim Smith, a singer, had not yet finished a figure in a sandpainting. His helpers had begun to make the guardian while he was still drawing. When he noticed what was happening he quickly left the hogan, had them erase the guardian, and begin again. He did not return until the guardian had been completed (Reichard 1963:161).

This lack of consensus and ambiguity have had an effect on all permanent sandpaintings. Those who think any figure, whether isolated or in a complete composition, is sacred would probably consider any type of permanent painting dangerous. These individuals rarely make any sort of permanent sandpainting. Those who can conceptualize secular and sacred paintings as two distinct types of phenomena would use rationalizations of incompleteness and inaccuracy in one of its several forms.

In actuality most demonstrators relied on the distinction that their paintings did not constitute exactly the same type of phenomenon as those used in ceremonies. All were incomplete, and as a result had no meaning. Demonstrators more often omitted parts of the composition than changed items in

it. Weavers and makers of reproductions were as likely to change things as to omit them. As Sapir states concerning weaving:

> The weaver has a simple expedient for warding off the curse which follows a tampering with holy things. By deliberately changing the sandpainting design here and there she feels that she absolves herself from the charge of blasphemy. The blanket decoration looks like a genuine sandpainting to the white man but to the gods and instructed Navajo the departures from ritualistic accuracy put the woven blanket into the class of profane objects. No curse need follow the weaving—at least, so it is hoped (Sapir 1935:609).

Sapir further listed thirty-four errors which Albert Sandoval, his interpreter, pointed out in a blanket based on a Shooting-way painting purchased in 1929. The errors were classified by Sapir as intentional, the result of a faulty memory, or due to unfamiliarity with sacred sandpaintings. Unfamiliarity accounted for alterations in minor details, but gross errors were intentional.

Another contention, which further illustrates the complexity of the problem of sacred versus secular in sandpaintings, was the existence of a gradient of sacredness: some objects and symbols were more sacred than others. Sapir found that omitting certain symbols could give rise to greater fear than merely copying them while others should under no circumstances be made outside the ceremonial context. A parallel belief about Hopi kachina dolls is that while the dolls are not sacred in themselves, certain extremely sacred symbols should never be carved or painted on them. It becomes evident that with this rationalization came a shift in the interpretation of the taboo. The new interpretation allowed for two kinds of sandpaintings: accurate and therefore sacred ones to which the rules applied and inaccurate paintings to which the supernatural sanction did not apply. Those who misused a sacred sandpainting would be cursed. This shift helped legitimize the production of permanent sandpaintings.

In time, changes that introduced inaccuracies became the norm, but at first other precautions were also taken. Except for the yei rugs, early demonstrations, reproductions, and

sandpainting rugs made by Navajos were made by singers or their immediate families under the singer's direction and protection. Singers were confident in their superior knowledge and power to control supernatural forces, their ability to rectify the mistakes which all humans make. They could afford to take risks. In fact, the ability to tempt fate was also interpreted as a mark of prestige. While the community watched transgressors for ill effects or misfortune, and ascribed any mishap to the error of disobeying the gods, the singer showed that he had more power than those who would not make a reproduction.

> The transition in the mind from an involuntary error to a voluntary one is not a great one and can be made easily by a good rationalizer. A medicine man clears himself first with the supernaturals by use of the medicine. He must then prove to his fellows that his behavior is justified. The supernaturals are more easily satisfied! If he continues to live successfully, if he and his family have no "bad luck" for a long time, he may convince his people to a degree. However, there will be some who, identifying obstinacy with orthodoxy, will consider success following tampering with the supernatural as witchcraft. If this happens, a singer will have to prove his intimacy and favoritism with the gods even further. Only fate can decide the issue. Practically it remains eternally undecided (Reichard 1936:159).

A singer can also use his powers to cure others who have suffered bad luck, just as he can exonerate himself.

> . . . if a woman who has woven a sandpainting becomes ill or incapacitated in any way, she may be cured by having a "sing." The fact that she needs one is, of course, the proof of the layman's orthodoxy. One of the most famous sandpainting weavers was dying of cancer. She had many sings to cure her offense in weaving the sandpaintings. After each one she became a little better. The cure continued as long as the disease allowed her to survive. Its final futility has proved the Navajo religion right (Reichard 1936:159–160).

Special protective or prophylactic sings were also held over some early weavers. For instance, Hosteen Klah performed a nine-night Nightway ceremony over his two nieces before they began to help him weave, supervised the women to eliminate offensive mistakes, and said a Blessingway prayer over each

when a rug was completed, just as he would do with a ceremonial sandpainting and the men who had made it. Likewise, Miguelito held a ceremony for a woman who wove a Shootingway rug in 1935. Just to be safe he repeated the ceremony several times in the next twelve years. Even some Anglos who were making reproductions were so protected (Newcomb 1964). This is similar to an apprentice singer's being sung over and the additional Blessingways held to consecrate each new piece of paraphernalia (Frisbie 1977a). The one sung over gains strength and immunity from etiological factors, so that continuous association with powerful symbols will not cause illness.

> A weaver of sandpainting tapestry may defend herself by having a complete nine-day "sing" of the chant she is weaving. When least elaborate it will cost from $200 to $400. This is an additional reason for the high price of a genuine sandpainting. Hastin Gani's wife, before she began to weave paintings from the Shootingway Chant, had that chant "sung over her." Since that time she is able to weave any one of the many symbolic compositions with a reasonable amount of safety (Reichard 1936:160).

Demonstrators also say brief Blessingway prayers after finishing their designs, even if they are single figures taken out of context. For example, Sam Tilden and his son-in-law and apprentice Alexander Anderson placed four sandpaintings from Female Shootingway on display at the Museum of New Mexico on the condition that the construction process be treated as a sacred affair. When the paintings were completed Tilden consecrated them and said covering Blessingway prayers, just as he would in a curing ceremony, so that if there were any unintentional mistakes in the paintings they would not bring misfortune on the place where they were housed.

With time it became apparent that the majority of painters and weavers did not become ill. In addition, it was evident that these individuals were earning good money for sandpainting rugs and for occasional demonstrations and economics began to supersede other values (Reichard 1936:160). These financial rewards were, in fact, interpreted as a sign of supernatural favor and were indicative of the success of the new rules.

Social precautions were much less common than artistic changes as a way to prevent supernatural repercussions for commercial sandpainters. The prophylactic ceremony was the first preventive measure to die out. It was rare by the late 1970s to find an individual who had had such a ceremony before learning to weave or make commercial sandpaintings. In fact, only a few of the oldest commercial sandpainters had ever heard of such a practice, and no one had heard of anyone's becoming really ill from making permanent sandpaintings and thus needing a curing ceremony. None of the painters had suffered any serious ill effects from sandpainting.

Women are especially restricted in their encounters with supernatural power, hence with sacred sandpaintings (McAllester 1954:81). Many singers do not like them to watch the making or erasure of the painting, because they are physically weaker then men. Once strengthened by ritual, however, a woman may undertake and withstand ceremonial power just like an initiated man (Reichard 1939a; 1963:172; Kluckhohn and Wyman 1940:62). Indications are that menstruating women are not allowed into the ceremonial hogan because menstrual blood is considered particularly damaging to religious power (McAllester 1954:81). Most restrictions on women have to do with pregnancy and the fear that a woman may unknowingly be pregnant (Kluckhohn and Wyman 1940:21), for an unborn child is definitely too weak and malleable to be near such concentrated supernatural power. Neither pregnant women nor their husbands should help make or witness the erasure of a painting. And this idea has not died out because, as one woman told Kaplan and Johnson (1964:209), the reason she faints is because her mother saw a sandpainting while pregnant. Even a singer may not officiate at some ceremonials if his wife is pregnant unless he is particularly sure of his power (J. Stevenson 1891: 235–236).

The fact that so many women are commercial sandpainters reflects one of the fundamental changes resulting from the secularization of sandpainting. Commercial sandpainters have never heard that women should not make sandpaintings that are acceptable for men to make, nor was it felt that women were more apt to become ill than men. This

idea has not completely died out, however, because several female painters felt they would become ill if they painted while pregnant. The fear of injury was as much for the unborn child as for the mother. One woman who paints regularly attributed her five-year-old son's speech problems to the fact that she painted pictures of Holy People while she was pregnant. She carefully avoided painting when she was pregnant with her next two children. Apprehension for the future welfare of her children superseded her need for money.

Almost all commercial sandpainters contend that as a distinct class of objects, the items they produce are not the same as sacred sandpaintings and that they are, therefore, safe to make. A few sandpainters, however, have maintained that commercial sandpaintings are not mundane but are living entities just like their sacred counterparts. These painters are blurring the line that others are trying to draw between sacred and commercial sandpaintings. They protect themselves by saying a prayer upon starting and completing each painting. This blesses the painting, making it a semi-sacred object, and at the same time it informs the Holy People that their likenesses have been drawn not out of disrespect but to bring blessings to the owner and maker. One painter reported sprinkling corn meal on the commercial paintings each morning, talking to the deities so that they would understand and approve, stressing that he was making the paintings correctly as taught by the forefathers. By and large, however, commercial sandpainters use artistic devices and methods analogous to those developed by singers at the turn of the century as the means to separate the two types of sandpaintings.

The changes which make commercial sandpaintings imperfect and hence different from sacred sandpaintings fall into a number of identifiable techniques. Each alteration is used by almost all artists, although several groups favor one or another. Several may be found simultaneously in the same painting. Unintentional mistakes are those made unconsciously due to lack of knowledge and may be found in the same sandpainting with intentional mistakes. They can be attributed to forgetfulness, carelessness, or trying to finish paintings too quickly. At any rate, it is generally accepted that any mistake or change violates the criterion of perfection

Fig. 4.1

Fig. 4.2

Figure 4.1 Move-Out-Mountain by Gladys Ben, Shiprock, 1978. This Mountainway painting was awarded third prize at the Gallup Ceremonial in 1978. Four colored circles have been substituted at the east (top) for the paired guardians. Sizes: 24" x 24". Price: $450.

Figure 4.2 Star People by Wilson Benally, Gamerco, 1977. This painting shows a change in layout in that the four Cloud People have been moved from their cardinal positions to the diagonal corner positions usually occupied by the four medicine plants. The painting has also been misidentified by the maker, perhaps intentionally as a means of making it secular. The correct identification is the Cloud People from Navajo Windway. Size: 24" x 24". Price: $75.

required to make a sandpainting holy. The following is a list of major changes identified by painters surveyed for this study and seen in the paintings themselves. Several painters mentioned that they do not have the specialized knowledge needed to judge the correctness of minor detail so that, like weavers, they feel safe only if they modify major elements.

One common pattern is *substitution* of a major or minor element found in the sacred template (Fig. 4.1); a new figure is added to take the place of an original element. Neither the layout nor the number of main figures changes. This may involve nothing more than changing the placement of two figures, without elimination of either type. Substitution may also involve a color which has directional symbolism. A special type of substitution involves transposing two colors— yellow for white or blue for red.

The directionality of the entire composition or the color symbolism may be changed as well. For example, while the composition may still open to the east, the figures riding the logs in a Whirling Logs painting derived from Nightway may travel counter-clockwise rather than in the proper clockwise or "sun-circuit" direction. Layout can also be changed. As shown in Figures 1.1 and 1.2, there are two basic layouts, linear and radial. While linear layouts are rarely changed due to lack of options, radial paintings are often altered. For example, main and subsidiary theme symbols are transposed (Fig. 4.2). Main theme symbols name the painting, state its

*Figure 4.3 Yellow, Blue, White
and Black Corn People by Keith
Begay, Shiprock, 1978. This
painting from Shootingway won
first prize at the New Mexico
State Fair, 1978. The painter
used Plate XXI from Newcomb
and Reichard's* Sandpaintings of
the Navajo Shooting Chant
(1975). *Colors, the numbers of
figures and placement are the
same as the original. Head-
dresses on the Corn People have
been elaborated to fill the space
left vacant by the elimination
of the paired guardians.
Size: 12" x 12". Price: $98.*

*Figure 4.4 Female Yei by Elsie
Y. Watchman, Sheep Springs,
1971. Simple single figures of
generalized Holy People are the
most common type of sand-
painting due to economic con-
siderations as well as religious
ones. This figure has the general
Shootingway headdress and is
whirling like a Whirling Rain-
bow Person, but lacks the sym-
bolism of a Rainbow Person.
Note that the maker has
neglected to put hands on the
figure. Size: 12" x 6". Price: $5.*

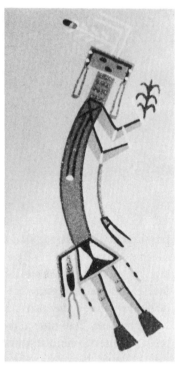

Fig. 4.3 Fig. 4.4

purpose and tend to be located in cardinal positions. Subsidiary symbols, no less important in Navajo thought, are placed in corners between the theme symbols (see Wyman 1970b). Also radial paintings which do not have linear version will be made as horizontal lines of figures in a commercial sandpainting, or parts of linear and radial paintings will be combined to produce totally new layouts.

Elimination and *simplification* are the most common changes, because they satisfy marketing demands and also are the safest changes to make. Major or minor figures, a minor detail, or an element which would appear to us to be insignificant, such as the red garter on the leg of a Holy Person, may be eliminated. Many paintings are so simplified that they can no longer be identified. Deletion of the paired guardians at the east (Fig. 4.3), followed by the guardian itself, is standard for commercial sandpaintings. Simplification has meant that the

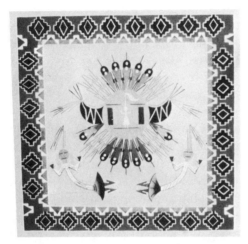

Fig. 4.5

Figure 4.5 Sun and Eagle by Cornelia Akee Yazzie, Tuba City, 1977. This sandpainting is completely enclosed in a border borrowed from a Navajo rug design so that it frames the painting and does not allow the power of any of the symbols to escape and call the Holy People. In addition, two isolated, generalized Whirling Holy People are placed below and to either side of the central figure of Pollen Boy on the Sun in a layout which would never be seen in a sacred sandpainting. Figures are extremely stylized. Size: 24" x 24". Price: $225.

mean number of figures as well as the number of different types of figures in each composition is less in commercial sandpaintings than in sacred sandpaintings. While main or theme figures remain in commercial sandpaintings, most subsidiary symbols and most secondary figures such as little birds or decoration not held in the hand of main figures have disappeared. Less than 10 percent of the commercial sandpaintings contain the detail found in sacred paintings. The result is that commercial sandpaintings are less complex than sacred sandpaintings (Fig. 4.4).

Enclosure is placement of paintings within a border which has no opening. This may take two forms. Either the painting is encircled by a new border which has no opening or the guardian figure (see Fig. 4.5) is made continuous so there is no eastern opening. In sacred sandpaintings, the guardian must remain open so that the healing power and the illness may be transferred.

Addition of new elements not found in the template on which a secular painting is based is also a frequent alteration. They may involve placing a figure from a Shootingway paintings onto a Mountainway composition, making up a new type of figure or design which is drawn in a sandpainting style, or combining two distinct sandpaintings into a single

piece. Since 1976 painters have added nonsandpainting designs and elements. For example, a Holy Person may have a Mexican serape thrown over an extended forearm (Fig. 4.6), or Monster Slayer on the Sun from Shootingway will be surrounded by peyote symbols. Painters have been extremely inventive in these additions and have concocted some extremely strange pictures.

Commercial sandpaintings have become more colorful than sacred sandpaintings through the inclusion of new colors. Navajos recognize five predominant colors in sacred sandpaintings: white, black, gold, blue-gray and red-brown. Brown, pink and variegated colors occur less frequently. All colors are solid and dominant, and there is no shading. While these colors are still common in commercial sandpaintings, bright turquoise blue, green, bright red, shades of brown, tan, and beige are regularly added to the painter's palette. Painters are increasingly distinguishing shades in sandstones and giving them distinct names. Gray is rarely used in sacred sandpaintings because it is associated with monsters and symbolizes evil, dirt, indefiniteness, and fear, but is found in commercial sandpaintings. Thus it appears that the colors are losing or have lost some of their symbolic significance.

Selection of neutral or benevolent beings (i.e., those which bring blessings and avoidance of unpredictable or essentially evil beings (which cause sickness) as subject matter for commercial sandpaintings is another way to avoid offending the Holy People. As pictures of etiological factors many sacred paintings depict evil and dangerous beings which are brought under ritual control, reversed, and eliminated. But commercial sandpainters lack the power to control this dangerous process because it is harder to drive off evil than attract good; therefore, they avoid reproduction of malevolent beings, which, unlike most of the Holy People, are not reasonable. All painters stated that there were figures they would not make and that it was dangerous even to mention the names of those which would easily take your life. The worst monsters, unpersuadable deities who cannot be controlled, and dangers conceived as deities are never seen in paintings. White Thunder, the most difficult and dangerous thunder, is never rendered, and even Navajo medicine men will rarely

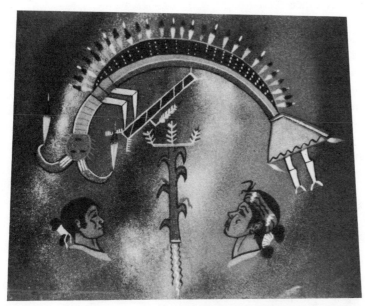

Fig. 4.6a

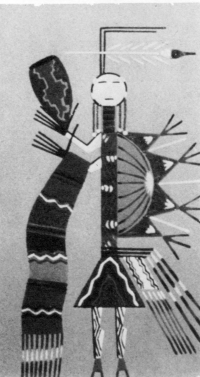

Fig. 4.6b

Figure 4.6 The addition of non-sandpainting elements alters any painting so that it does not have power to call the Holy People. **a.** *Entitled Yei by Kohoe, 1976. This nontraditional sandpainting shows a Humpback Yei figure and a traditional corn plant made in a style used in sacred sandpaintings. In an attempt to make sandpaintings resemble easel art, the painter has placed the corn plant and the Humpback Yei in space without reference to traditional symbols or placement. The artist has attempted to use shading in the painting which is done in a style reminiscent of that used by students of the Santa Fe Indian Art School in the 1930s. Size: 12" x 8". Price: $60.* **b.** *Entitled Hunchback by Walter Z. Watchman, Sheep Springs, 1977. This single figure of the Humpback Yei from Nightway has a unique hump for carrying seeds and a greatly elaborated body covered with meaningless decoration. Also, a nontraditional, brightly-colored Mexican serape has been thrown over the extended forearm of the figure (pictured on book jacket). This painting shows the inclusion of a sandpainting element which is never used with this figure: the planting stick of the Humpback Yei has been changed into a great war club. Size: 16" x 8". Price: $45.*

Figure 4.7 Unpredictable and malignant subjects rarely made by commercial sand-painters: **a.** *Big Black Horned Crooked Big Snake, by N.Y.B., Torreon, 1977. This painter did not sign his full name to the painting lest the Snake People discover who made it. The marking on the back of the snake means that it is used in a ceremony that emphasizes the expulsion of evil. Size: 16" x 8". Price: $15.* **b.** *Big Blue Thunder, by Patsy Miller, Sheep Springs, was made of sand and charcoal on plywood in the early 1960s before stencils were used. Many women will not make this painting while pregnant, and other painters will only make it during the summer so as not to disturb the Thunder's winter sleep. The headdress and the markings on the body have been changed. Size: 9½" x 7". Price: $21.* **c.** *Sandpainters are ambivalent about making pictures of Water Creature from Beautyway, an unpredictable being. This painting was made by James Joe, Shiprock, sometime before 1970. Most Navajos will not make this painting. Size: 11½" x 8". Price: unknown.*

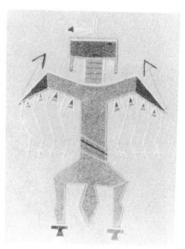

Fig. 4.7b

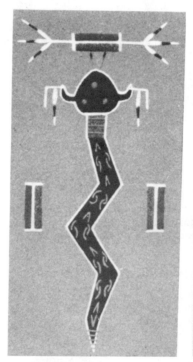

Fig. 4.7a

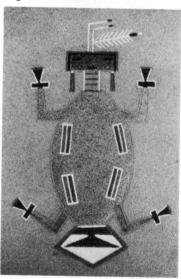

Fig. 4.7c

make him in a sacred sandpainting (Reichard 1944a:6). Most sandpainters also will not make a snake (Fig. 4.7) which is an unpredictable deity and the only ones who will are either fundamentalist Christians or singers. The consequences of depicting a snake are well known, and one story of how an early commercial sandpainter was killed in an automobile

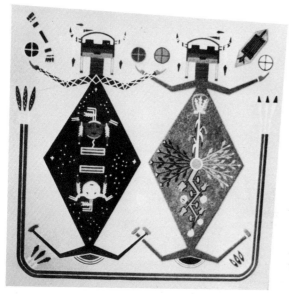

Fig. 4.8a

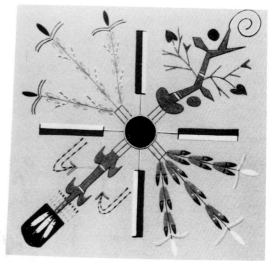

Fig. 4.8b

accident because he had made paintings of snakes is widely known. His paintings had called the snakes, and he had not had the power to counteract their anger. The few commercial sandpainters who did make paintings of snakes did not sign their names to the paintings, probably using the rationalization that the offended deities would not then be able to find them. Weavers who have made sandpainting rugs containing snakes have not had their names associated with their work. In fact, one woman in the 1960s even changed her name.

Occasionally pictures of unpredictable beings who may cause sickness are found (see Appendix 4). Examples are bears and bear tracks from Mountainway, Cyclone People and Big Whirlwind People, Storm People and Snake People. More common, though, are predictable animals which combat disease, such as Horned Toad (the predator in the Red Antway), the predator animals from Beadway and Eagleway, and neutral animals such as the game animals and birds.

Popular figures found in commercial sandpaintings are Sun and Mother Earth-Father Sky (Fig. 4.8). Rainbow People who protect the Navajo are also favorite subjects as are plants

Figure 4.8 Good subjects, showing deities, helpers, and heroes who act predictably and have always helped Earth people: **a.** *Mother Earth and Father Sky from Shootingway by Juanita Stevens, Chinle, 1978. This painter has used a design from Newcomb and Reichard (1975: Figure 5). In addition, the voice line connecting the two figures has been eliminated as has the line of Xs (XXXX) on the chest of Father Sky. Size: 24" x 24". Price: $150.* **b.** *The Four Sacred Plants, by David Lee, Shiprock, 1979. Subsidiary themes in many sacred sandpaintings, the four sacred domesticated plants— corn, beans, squash, and tobacco—are main themes in this painting. Size: 18" x 18". Price: $40.*

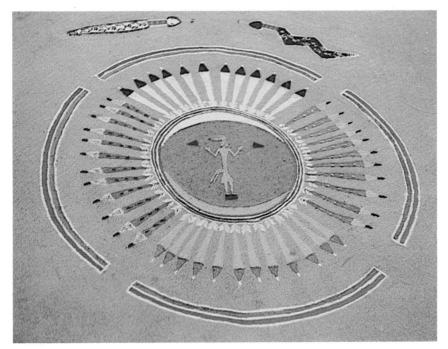

Fig. 4.9a

Figure 4.9 Sandpainters change many things in a sandpainting as can be seen from a comparison of a single sacred sandpainting. Pollen-Boy on the Sun-With-Feathers (above) used in both Navajo Windway and Chiricahua Windway is one of the most popular commercial sandpaintings because of its attractiveness and its good subject matter. It always bestows blessings. While painters have altered the sacred template in various ways to avoid offending the Holy People, everyone has left off the paired Big Straight and Big Crooked Snakes at the east and made the tips of the Eagle feathers black. Almost everyone eliminates some of the feathers surrounding the Sun, but the number used varies. This painting is commonly called "Sun and Eagle."
(Detailed descriptions continued on p. 92.)

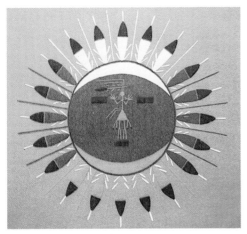

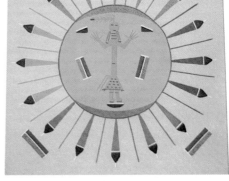

Fig. 4.9b Fig. 4.9c

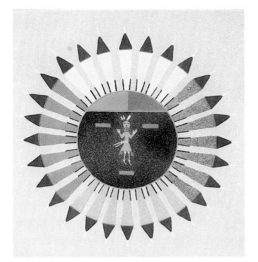

Fig. 4.9d

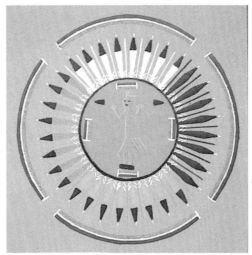

Fig. 4.9e

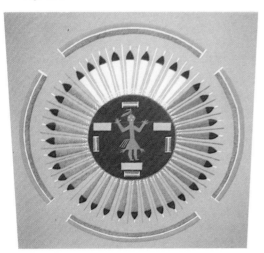

Fig. 4.9f

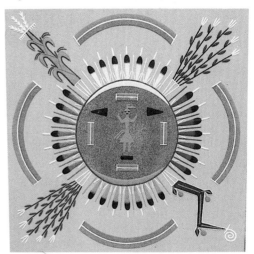

Fig. 4.9g

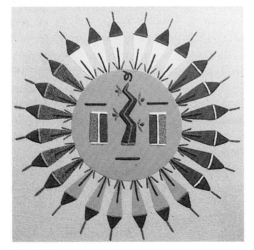

Fig. 4.9h

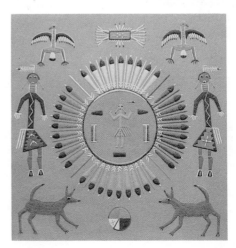

Fig. 4.9i

Legend for Figures 4.9a-i shown on pp. 90–91

Figure 4.9 **a.** *Sacred template: an actual sandpainting made by Chee Carroll of Chinle, Arizona (1961) and collected by Leland Wyman (see Wyman 1962: Fig. 38). The suṇ chin faces west and the sun face is blue with black eyes and mouth, white forehead (representing consciousness), and yellow chin (representing fertility). Four sets of twelve eagle feathers surround the sun face. The color sequence for the feathers from the east is white, blue, yellow, red. Feathers are tipped in black, yellow, blue and mottled white according to the quadrant. Pollen Boy is yellow. Four disconnected rainbow arcs guard the sun. Photo courtesy of the Taylor Museum.* **b.** *This painting by Notah H. Chee, Newcomb, 1975, shows elimination in the number of outlines surrounding the sun face and a change in the number of feathers per quadrant. Color symbolism has been reversed and the rainbow arcs have been eliminated.* **c.** *Alfredo Watchman, Sheep Springs, 1978, uses extensive color changes. Pollen Boy is now bright turquoise blue and the sun face is yellow. Feathers are blue, brown, tan and yellow. Arcs of consciousness and fertility on the sun face and the*

multiple outlines have been eliminated. Two rainbows have been added to the sun face, and the rainbow arcs have been changed to four rectangles placed at the corners of the pictures with the colors reversed. The number of feathers in each quadrant varies. **d.** *Wilson Price, Sheep Springs, 1979, uses new color hues and new materials. The sun face, now black, is made from carborundum grit which sparkles. Due to this change the eyes and mouth are now tan. The eyes have been changed to rectangles and the face has been altered to represent a Hopi sun face. Color symbolism in the feathers is constant, but the guardian arcs have been eliminated.* **e.** *Made by Chee McDonald, Sheep Springs and Torreon, 1972, this sandpainting is similar to that made by Watchman. Four rainbow bars have been added to the sun face which is now yellow. Consequently, Pollen Boy is turquoise blue.* **f.** *James Joe, Shiprock, a clan brother of McDonald and his teacher, made a very similar painting in 1978. The sun face has four rainbow bars but the colors have been reversed. Pollen Boy is blue-grey and the sun face is*

black. Eyes are rectangles rather than triangles and the color symbolism in the feathers has been partially retained— white, red-brown, yellow, blue grey. **g.** *Marian Herrera, Torreon, added depictions of the four sacred plants—corn, beans, squash, and tobacco—to this 1978 painting. Pollen Boy is now blue and his headdress and sash point in opposite directions, producing a conflicting directional message. Four rainbow bars have been added to the face, but the consciousness and fertility arcs have been retained.* **h.** *This 1977 painting, (maker unknown), shows that Pollen Boy has been replaced by a squash plant. Two rainbow bars have been added and the eyes and mouth of the sun are now thin lines. The guardian has been eliminated.* **i.** *Substitution and addition are the most striking features of this intricate painting by James Joe, Shiprock, 1978. In place of the rainbow arcs, Holy People and figures from Coyote Stealing Fire from Upward Reachingway are placed around the sun face. Seen here are Coyote, Eagles, the Sun's tobacco pouch, the emergence place, and Fire God.*

which benefit mankind. These Holy People are beings which Reichard (1963:50) calls ''persuadable,'' that is, beings which are easy to invoke and have no primordial meanness or evil intentions. They can also be readily placated because their offerings are well known. Seventy-seven percent of the commercial sandpaintings contain these persuadable deities (see Appendix 4). The rest are unpredictable deities. Thus commercial sandpaintings are minimizing the possibility of incurring supernatural disfavor. The same trend appears to be occurring with ceremonial paintings. Younger men are learning primarily safe paintings. Paintings are no longer used if they are believed to be too powerful or dangerous (see Newcomb and Reichard 1975: Plate XIII).

Commercial sandpainters are also drawing primarily on Holyway chants which stress the attraction of good (Appendices F and G). Of course, these are also the chants which contain the most sandpaintings, so they would be the common source of motifs. Most commercial sandpainters use Shootingway and Nightway, followed by Beautyway and the Windways (Fig. 4.9). They are used as the source of commercial sandpaintings because they are available to painters in published reproductions, and except for Hand Tremblingway and Nightway, they are also the most frequently performed chants (see Wyman and Kluckhohn 1938). Sandpainters who used these resources felt that if a reproduction had been published, it had been tested and found acceptable by the Holy People and hence could be safely used in a commercial sandpainting.

The final major artistic method sandpainters have used to overcome the prohibition against making permanent sandpaintings is to create new beings or depict subject matter which would never be seen in a sacred sandpainting. Almost everyone begins to paint by making simple pictures of Holy People. Sooner or later most experiment with non-traditional designs, layouts, and subject matter. Besides being safer, these motifs offer greater creative freedom. Some painters strive to develop a distinctive style which will give them a competitive edge.

Fig. 4.10a

Fig. 4.10b

Figure 4.10 Non-traditional sandpaintings: **a.** *Yeibichai dancer by Wilson Price, Sheep Springs, 1977, showing one of the masked impersonators who dances in Nightway and Big Godway ceremonies. This dancer is portraying Talking God or the leader of the dancers as can be seen from the white cape and mask. A background has been added to increase realism. Size: 16" x 16". Price: $45.* **b.** *Shiprock by the Johnson family, Sheep Springs, 1978. Landscapes, especially depictions of important features on the Navajo reservation, like Shiprock or mesas in Monument Valley, became popular in the late 1970s. They were an out-growth of the backgrounds first used in paintings of Navajo dancers. Size: 13" x 13". Price: $30.*

The first nontraditional sandpainting was made as early as 1965 by James Joe. Although the reason is not known, they were rarely made between 1965 and 1972. After 1972, they began to appear again and since 1975 have flourished. Yeibichai dancers, similar to those found in yeibichai rugs, reappeared first and became standardized in two forms placed in a limited number of poses, usually with one leg raised to indicate movement and an arm bent at the elbow and extended forward (Fig. 4.10a). They were still the most common type in the early 1980s, although new themes have appeared every year. Landscapes (Fig. 4.10b), portraits of people (Fig. 4.10c), romanticized pictures of Indian children which first appeared in 1975 (Fig. 4.10d), still lifes of Rio Grande pottery first made in 1974 (Fig. 4.10e), Navajo rugs (Fig. 4.10f), Zuñi fetishes (Fig. 4.10g), jewelry and even Hopi kachina dolls were a few examples. Many were based on photographs in *Arizona Highways* and other popular magazines. Painters also use other Indian themes, including Apache gans dancers, Pueblo eagle dancers (Fig. 4.10h) or Plains hoop dancers

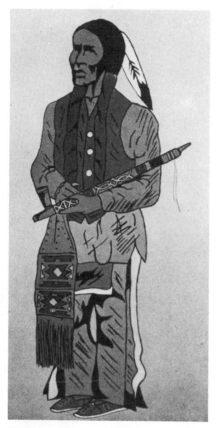

Fig. 4.10c

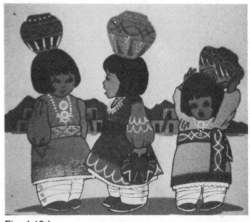

Fig. 4.10d

Fig. 4.10 (cont.) **c.** *"Indian Chief" by Mary Lou Peshlakai, Sheep Springs, 1977, is the artist's first attempt at portraiture. Sandpainting errors are difficult to correct. Here the artist began the composition at the top and ran out of room at the bottom; hence, the legs on the figure are proportionately too short. Size: 24" x 10". Price: $95.* **d.** *Pictures of children are especially popular with nurses and grandmothers. Zuni Children by Davis Peshlakai, Sheep Springs, 1977, shows three young girls in brightly colored costumes standing in front of a pueblo. This and similar paintings are adapted from a coloring book (Bartos and Bartos n.d.). Sioux children and Navajo children are also made. Size 12" x 12". Price: $30.*

copied directly from Bahti (1970). New religious elements have also entered in the form of peyote symbolism (Fig. 4.10i and 4.10j) and Christian designs (Fig. 4.10k) since approximately 1977. These either stand alone and constitute an entire composition or appear as isolated motifs in a traditional sandpainting framework. For example, Christ might appear as a separate painting, or a Latin cross rather than Mother Slayer might be placed on a sun face.

Action scenes have become more common as painters try to make their sandpaintings resemble easel art (Fig. 4.10l). Attempting to show perspective and using techniques like foreshortening in sandpaintings have met with varying degrees of success. Portraiture began in 1976. Even sandpaintings of Snoopy and Winnie the Pooh are to be found. Many other

Fig. 4.10e

Fig. 4.10f

Fig. 4.10 (cont.) **e.** *Still lifes depicting material objects of Navajo and Pueblo cultures are becoming increasingly common and are made by individuals who would like to see Navajo sandpainting become a fine art. Pueblo pots by Margaret Johns, Farmington, 1976, is a well-made example showing two Rio Grande Pueblo pots and a bear fetish. Sand is used to create the illusion of lighting from the left. Size: 24" x 18". Price: $500.* **f.** *Navajo Rug by Wilbert Sloan, Tohatchi, 1977, shows a Two Grey Hills style rug. Pictures of rugs only began in 1977 and still lifes in general have been made since 1976. Size: 16" x 14". Price: $60.*

forms defy classification such as the split paintings (half pot, half sun face) made by a family in Tuba City since 1978 (see Fig. 7.8). Designs in sandpaintings are limited only by the imagination of the painter; they are no longer a conservative form designed to save Navajo religion. Most sandpainters are confident that their techniques work. In fact, many feel that these new designs are so divorced from sacred sandpaintings that there is no possibility of comparison and hence no sacrilege. It is precisely because the rules requiring sandpaintings to be perfect no longer apply that new artistic innovations can be tried and the stylistic boundaries expanded.

While almost all commercial sandpainters feel that sacred and secular sandpaintings must be kept distinct, exactly what a painter changes and feels all painters should change is highly variable. Nor is there a consensus over which symbols should be protected and not placed in the hands of nonbelievers, or how many changes should be made in each painting. Again, this shows the flexibility of the Navajo religious system and the ambiguity concerning sanctification. In addition,

Fig. 4.10g

Fig. 4.10h

Fig. 4.10 (cont.) **g.** *Zuñi bear fetish by Gracie Dick, Two Grey Hills, 1978, shows the isolation of the pottery figurine and the use of traditional rainbow arcs. Size: 12" x 12". Price: $18.* **h.** *Eagle dancer by Susie Watchman, Sheep Springs, 1978. The eagle dancer is a Pueblo, not a Navajo dancer. All tend to be brightly colored, and many designs, like this one, are drawn from Bahti (1970). Two sun outlines are in the upper corners. Size: 12" x 12". Price: $75.*

it focuses on the question of whether the Holy People are still powerful. If one decides the Holy People are still powerful, one is faced with the dilemma of whether they are more upset with their portraits being drawn out of context than with them being drawn incorrectly. Patterns, however, were discernible by the religious affiliation of the maker, the types of paintings produced, and the reasons why a painter began. If a painter thinks that even with changes the permanent sandpaintings are potentially sacred and not just decorative entities, he tends to take more precautions than if he sees them as secular items. Traditionalists, those who paint in order to preserve Navajo religion, and those who mainly produce full reproductions are more cautious in their approach to their paintings. For example, one man feels that while colors can be altered, figures should not be changed. These men and women ask elders and singers about details so that each figure will carry the right paraphernalia and have the appropriate headdress. This care in execution is interpreted as a sign of respect for the Holy People.

Fig. 4.10i

Fig. 4.10j

Fig. 4.10 (cont.) **i.** *Paintings with subjects drawn from symbols used in the Native American Church are the only sandpaintings which Navajos will buy. "Deer" by Edward Jim, Shonto/Black Mesa, 1977, is one such painting. Although reminiscent of "Bambi," this is a sacred deer, with cloud symbols, a wand, and sacred hoof prints. The artist combines Navajo ceremonial symbolism—the Rainbow Goddess—with Peyote symbols. Size: 16" x 16". Price: $29.* **j.** *"Father Peyote" by Timothy Harvey, Lukachukai, 1977, shows an Indian warrior in Plains dress holding a peyote button (Father Peyote) toward the sky as he prays. An attempt at fine art, this painting contains a large amount of ground turquoise. Size: 24" x 24". Price: $125.*

Most sandpainters, however, regard commercial sandpaintings as completely secular and decorative items bearing little resemblance to sacred sandpaintings. These individuals change numerous aspects so that many of their paintings bear little resemblance to sacred templates. They also tend to use published illustrations of sandpaintings and will not copy a sandpainting seen in a ceremony. These artisans feel that omission is the safest course of action. The result is that they tend to produce simpler compositions designed for souvenirs and for decorating the home.

Finally, a few painters, primarily those who are confirmed fundamentalist Christians or those who only produce souvenir paintings, feel that there is no reason to change details or even to be concerned with such matters. To those who no longer believe in Navajo ways the figures are meaningless, just as a curvilinear line or a landscape is without spiritual significance. Therefore, they reason that supernatural sanctions will not occur. In other words, whether designs are correct or incorrect is purely coincidental.

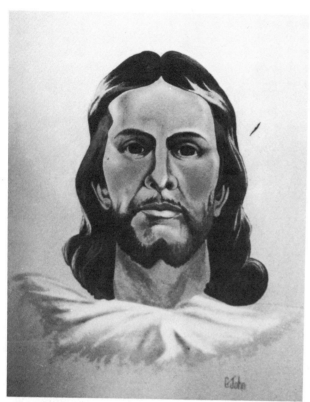

Fig. 4.10k

Fig. 4.10l

Fig. 4.10 (cont.) **k.** *Christianity is also becoming the subject matter for sandpaintings as shown by the painting of Christ by George Johns, Farmington, 1977. Commissioned from a reservation trader, this painting was constructed with sands laid almost grain by grain to produce the contours of the cheeks. Size: 30" x 24". Price: $150.* **l.** *Action shots and attempts at easel art are still rare because of the difficulty in making them. "Medicine Man" by Timothy Harvey, Lukachukai, 1977, is reminiscent of oil paintings by Navajo artists like Harrison Begay and Andy Tsihnahjinnie. A mask for a yeibichai dancer appears over the shoulder of the man constructing the sandpainting. Size 24" x 24". Price: $95.*

The distinctions made between sacred sandpaintings and permanent ones produced commercially contributed to a growing tolerance among the majority of Navajos for sandpaintings made for the purpose of making money. But overcoming the initial resistance was only one of the obstacles in the way of the full development of sandpainting into a craft. The other major problem had to do with the technical difficulties—how to make the sand adhere to a wood backing. The solution to the problem was complex, and involved the efforts of several people, oddly enough, most of whom were Anglos.

FOUNDING AND SPREAD OF COMMERCIAL SANDPAINTING

IN THE EARLY 1930s, and again, independently, in the late 1940s and early 1950s, Anglo-Americans and Navajos began to search for rapid, stable, and economical techniques to produce paintings which captured the textural qualities of sacred sandpaintings. A series of interrelated innovations can be traced directly to the work of Anglo artists, Mae de Ville Fleming, E. George de Ville, and Luther A. Douglas, and a Navajo singer, Fred Stevens, Jr. While there were earlier instances of the use of dry pigments as an artistic medium by American and European artists, it is improbable that the Navajos had any knowledge of their work. For instance, Georges Braque commonly used the technique in Europe and, closer to the Navajo community, artists and hobbyists in Arizona made horizontal pictures with sandpainting motifs using alcohol and collodium as an adhesive. The pigments had to be held in place by a glass top and the method, which was time consuming and unstable, was unsuitable for wall-hung paintings. Clifford Trafzer (1973:270) contends, however, that Sam Day, Jr., a trader at Chinle, Arizona, made permanent sandpaintings on wood backings before 1923. If true, this would have been the earliest instance of this use and an instance which would have been available to the Navajo. How-

ever, an examination of Trafzer's primary sources in the Sam Day, Jr., collection at Northern Arizona University failed to confirm Trafzer's statements. There is only one series of technological innovations which served as the direct basis for the craft of commercial sandpainting among the Navajo.

THE FIRST COMMERCIAL SANDPAINTERS

The development of sandpaintings by E. George de Ville (1888–1960) and his wife, Mae Allendale (1903–1977) was a direct result of the Depression. The de Villes, with their two young daughters traveled from town to town, primarily in California and Nevada during the late 1920s through early 1930s, painting signs and murals, redecorating movie theaters, and doing interior decorating for private homes while they tried to sell their oil paintings. Previously George had studied with Charles M. Russell in Montana and had painted lithographs for theater lobbies and made poster displays for Hollywood studios. After a brief stay in Cortez, Colorado (managing an auto court so that the girls could attend school), the family traveled south to Arizona and New Mexico in order to paint landscapes and record the daily life of local Indians and Anglo settlers. But in 1932, the family found themselves stranded in Gallup, New Mexico, where their car broke down. Without money to have it repaired, and recognizing that there was not much market for oil paintings or water colors at the time, the de Villes supported themselves with all types of odd jobs including making "food special" banners for grocery stores. Mae's interest in contemporary Native Americans, however, was kindled on this trip to Arizona, and soon her interest focused on Navajo ceremonialism. Making friends with a Navajo singer, she and her daughters were allowed to attend approximately a dozen ceremonies south of Gallup. Mae was allowed to sketch the intriguing designs (Fig. 5.1), which led her to experiment with what she believed would be an innovative, marketable medium—permanent sandpaintings.

Figure 5.1 One of the first sandpainting reproductions of Mae de Ville was made after attending a Beadway ceremony in 1932. The painting is made with tempera paint on construction paper and shows Scavenger in the Eagle's Nest.

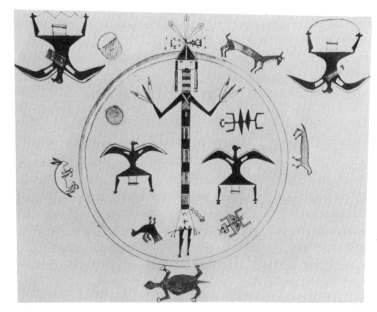

Fig. 5.1

Within a year Mae de Ville, a young woman with no formal art training who had grown up on a ranch in California, had perfected a technique for painting with sand. She chose weathered rocks and local materials, including cinnabar, turquoise, azurite, lapis, and sandstone so that the colors would not fade over time. These were laboriously ground into fine, evenly sized sands using a mano and metate and were then sifted twice through cheesecloth. Wallboard coated lightly with glue to seal the pores was used as a backing. When the glue dried, the design was lightly outlined on the sized board. Next, an adhesive of varnish, white lead, and raw oil was applied with a brush to a small section of the composition. (Two shades of adhesive were actually used: clear was used for light-colored pigments; for dark colors, gray sand was added to the adhesive.) Pigments were sprinkled gently through the artist's fingers onto the wet adhesive, somewhat like the method for making mosaics. Excess sand was gently tapped off, leaving a thin, uniform layer of color. Only fine lines of detail were placed on top of the single layer of colored sand (Fig. 5.2).

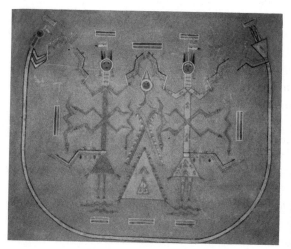

Fig. 5.2

Fig. 5.3

The unique sandpaintings were almost an instant success. By 1933, while there was still little interest in watercolors and oils, demand for sandpaintings was increasing. Mae de Ville decided to expand her repertoire even though her husband was skeptical of the project. He did not think it was possible to blend the colors subtly and feared that realistic paintings would be crude and garish. The number of colors at this point was limited, but by 1934 Mae, after numerous experiments, had perfected pleasing landscapes partly by broadening her palette which eventually included over 50 hues. The sands were finely and evenly ground. These little paintings she sold to Carmen's Curio Stores for 50 cents each. As inexpensive souvenirs which sold for $1.00 to $1.50 they sold quickly, especially to tourists and travelers on their way to California. Pleased with this success Mae began to produce Pueblo Indian scenes and gradually made fewer pictures based on Navajo ceremonial sandpainting (Fig. 5.3). By 1938 her time was so consumed with the small realistic sketches that she ceased making Navajo sandpaintings.

Figure 5.2 Permanent sandpainting made by Mae de Ville in the mid-1930s. Though considerably damaged, it shows Wind People Dressed in Snakes from Navajo Windway. The Holy People are partially armed.

Figure 5.3 This sandpainting of a Pueblo Indian Village by Mae de Ville in 1938 is characteristic of her later work. After her shift away from the stylized sandpainting reproductions she only produced realistic scenes. A greater variety of colors was used than in earlier paintings, but the backing is still used.

Meanwhile, George, encouraged by Mae's success, was convinced that there was a market for sandpaintings and that it was a sophisticated medium. He tried his hand at sandpainting. One of his first efforts, a replica of the Gallup railroad station in the early 1880s, was purchased by the Atchison, Topeka, and Santa Fe railroad and used for their 1944 calendar (photo in Underhill 1953:280). He also made landscapes, portraits, and character studies. In the late 1930s he was even commissioned by Mrs. Roosevelt to make a sand portrait of President Roosevelt, a painting which hung in the White House for many years. George de Ville painted realistic subjects, and never painted Navajo sandpainting designs. The only innovation that he added was framing and placing the paintings under glass as protection against Gallup's blowing dust and the soot and smoke from coal-burning stoves and steam locomotives. George never painted the small, souvenir landscapes that Mae began. Instead he focused on using the medium as an alternative to oil painting as fine art.

By 1938 the de Villes had become well known for their unique art medium. In the mid 1930s, Paramount Studios featured them in a short subject film on unusual occupations, showing them both working in the lobby of the El Rancho Hotel in Gallup, and various newspaper and magazine articles were penned. They became noted western artists. With increasing demand they ceased producing for curio shops and began to work mainly on a commission basis. Their paintings in sand had become gallery items. The de Villes were the first commercial sandpainters, earning a moderate and steady income from their ventures.

After the de Villes divorced in 1940, Mae stopped painting and turned to pottery restoration (a field in which she also made many innovations) and retailing in gift shops in eastern California and Arizona. In 1962 she moved to Flagstaff, Arizona, where she managed the gift shop at the Museum of Northern Arizona while continuing to pursue her interest in modern and ancient Native Americans. George de Ville continued to make sandpaintings until his death in 1960, but set up a studio in a small Mormon settlement near Springerville, Arizona (Fig. 5.4). In the 1950s, George had

Figure 5.4 Sandpainting of two Navajo Indians conversing by E. George de Ville, made in the late 1940s. Constructed on wall board, this painting is typical of the type of painting Fred Stevens, Jr., would have seen. De Ville never attempted Navajo sandpainting reproductions although he used a sand medium for his art work and called his compositions sandpaintings.

Fig. 5.4

several large exhibitions in Texas and New Mexico with paintings ranging in price from $75 to $1,500 and including landscapes, portraits, romanticized scenes of Navajo daily life, mountain scenes, and religious paintings. In 1953, de Ville estimated that he and his wife Mae had produced at least 4,000 sandpaintings. The de Villes legitimized the use of sandpaintings as fine art, showed that it could be a successful commercial craft, one that was of interest to Anglo-American customers, and one that would provide an adequate living to makers. Indirectly, they also provided the opportunity for Navajos to learn about the craft and adopt it as their own.

During the period when George de Ville set up his shop in the town of his second wife, Marguerite Morgan, he often visited the small town of Lupton on the Arizona-New Mexico border. Here he met his life-long friend, Fred Stevens, Jr. Stevens would often come home with de Ville and watch him work on his sandpaintings or travel with de Ville to towns like Holbrook or Gallup when he would make a sandpainting mural for a local store or deliver paintings. Although de Ville never actually taught Stevens, because he guarded his adhesive as a trade secret and enjoyed a

profitable monopoly, Stevens began to get the idea of making sandpaintings using Navajo ceremonial designs. (Stevens did not know of Mae de Ville's earlier work.) He thought that his friend's technique for making pictures of the painted desert using local materials could be adapted to ceremonial sandpaintings. Therefore, Stevens began experimenting with sandpainting techniques in 1946.

Born in Sheep Springs, New Mexico, in 1922, Stevens was a member of the *kiyaa'áanii* clan. His mother was a diagnostician (a Navajo religious specialist who determines the cause of a disease) and his father, Son of Late Old Talker (a clan grandson of Hosteen Klah), a Blessingway singer who began to teach his son the chant when he was six years old. Stevens conducted his first Blessingway ceremony at age 18, but his apprenticeship in other chants continued for many more years. A Nightway, Blessingway and Female Shootingway singer, Stevens decided to make sandpaintings in a permanent medium because he believed it was his duty to preserve Navajo culture, especially the rapidly disappearing ceremonies, for future generations of Navajos and Anglo-Americans. While the commercial sandpaintings would not be sacred, he felt that they would be symbolic and hence would illustrate religious mythology. In addition, Stevens, as a professional artist who earned his living demonstrating sandpaintings in a museum, saw the production of commercial sandpaintings as an extension of his occupation. He considered himself an artist, like de Ville, and he saw a demand for permanent replicas of his demonstrations. Stevens then strove to fulfill his customer's wishes. Like all good craftsmen, he experimented with his craft in order to sell the best product possible.

During World War II, after finishing high school at Fort Wingate and graduating from baking school (an unusual event for Navajos at the time), Stevens worked as pastry cook and kitchen helper in Leroy Atkinson's hotel and restaurant in Lupton. Near the hotel Atkinson ran a private museum built into an abandoned movie set where Native Americans demonstrated various crafts, including sandpainting. One day the sandpainter became ill. Blaming his ailments on his breaking

of ceremonial restrictions, he refused to return to the museum. Rex Boulin, manager of the small museum and gift shop (and brother of Mrs. Atkinson) had to quickly find a substitute since the demonstrations had been advertised and there were federal regulations against false advertising which were being strictly enforced at the time. No other sandpainter could be found, however, because of the general apprehension over the task. The fate of the previous sandpainter was widely known, and the owners often pressured the sandpainter to allow the demonstration paintings to remain overnight. Stevens, wanting to leave the tedium of the kitchen, and feeling he had the necessary skills and power to counteract any ill effects, offered to fill the position. Boulin, after briefly watching Stevens practice one day in the desert behind the trading post, made Stevens the permanent sandpainter. From then on Stevens would daily sit in the wooden pit making sandpaintings for the travelers along Route 66. Dressed in Navajo costume of a velvet shirt, white pants and silver and turquoise jewelry, he would often don in fun a Plains feather headdress because it was the symbol which Anglo-Americans associated with Indians. In between customers Stevens would remove the headdress, replace his glasses, and continue his education by reading newspapers, the encyclopedia, or other books. An extremely educated man, Stevens spent much time with Anglos while trying to retain his contacts with other Navajos. This was not always an easy task.

Stevens quickly gained a reputation as one of the finest professional sandpainting demonstrators, and, also as one of the most daring, for he was one of the few who would leave his demonstrations overnight. With his wife, Bertha, a master weaver and former housekeeper for the Atkinsons, Stevens began to tour fairs, art shows, and museums, where his demonstrations became permanent exhibits (Fig. 5.5). Stevens first demonstrated at the Arizona State Fair in 1950. He then toured for the State Department through the encouragement of Luther A. Douglas, the Gallup Ceremonial Association, and the Indian Arts and Crafts Board of the Department of the Interior. In 1967, the Stevenes toured Europe and demonstrated

*Figure 5.5 Fred Stevens, Jr.,
demonstrating sandpainting
techniques at the Arizona State
Museum in 1959. He is making
a single figure painting of
Monster Slayer in Armor as
used in Shootingway. The two
commercial sandpaintings in
the background, Sun, Moon,
Black and Yellow Winds from
Shootingway and the Humpback
Yei with Planting Stick from
Nightway were also made by
Stevens. These are early ex-
amples of the sandpainting
technique which Stevens
and Douglas perfected and
Stevens taught to other Navajos.
Arizona State Museum, photo
by Gil Bartell.*

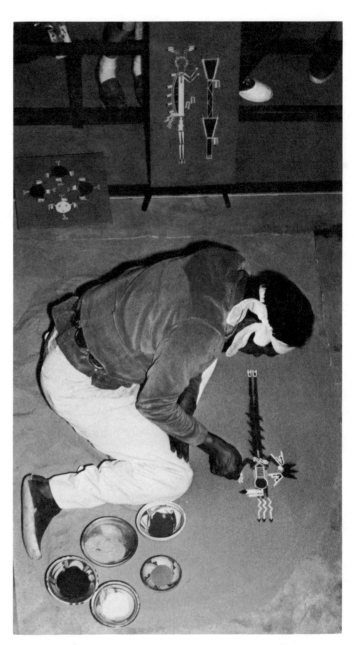

Fig. 5.5

at Buckingham Palace for Queen Elizabeth II. They also worked in Germany, Belgium, Turkey, Greece, Mexico, Japan, South America and Canada. In the United States Stevens demonstrated at the Arizona State Museum, the Hudson River Museum, the Denver Art Museum, and the Walcott Art Center in Minneapolis. Often his demonstrations were combined with dedication ceremonies, as in 1977 when Stevens chanted a Blessingway Ceremony at the new Plains Indian Center dedication ceremonies. As a result of these activities Stevens spent a great deal of time with foreigners and Anglo-Americans. In this way he is very atypical of most Navajos. This knowledge of a culture other than his own has been noted by other anthropologists as a characteristic of an innovator of ethnic and tourist art.

In 1946, after demonstrating for a couple years, Stevens decided to make permanent sandpaintings. He knew it was possible to make sand-on-sand paintings which could capture the textural qualities of sacred sandpaintings, a feature he felt was missing from reproductions of sandpaintings made on paper, but he did not know how to overcome the technical difficulties. De Ville did not show Stevens exactly how to make the paintings or what materials to use, especially the all-important adhesive. Stevens did not press de Ville for the knowledge nor did he try to copy de Ville's technique or use his methods without his permission. This would have been contrary to Navajo values. Instead, Stevens began intermittently to experiment with these technical problems on his own while continuing to work for the Atkinsons with whom he had a very close relationship. Although he sold a few sandpaintings at the urging of the Atkinsons and placed an occasional painting in the Shiprock Fair in the late 1940s, Stevens said his early efforts were mediocre at best. Designs were poor, colors spread, and the sands peeled off or disintegrated. Stevens would often give up his attempts. But despite his dissatisfaction, he was constantly urged by customers who saw his demonstrations and by his employers to make the paintings permanent. With such encouragement Stevens would renew his experiments, trying to perfect a technique for permanent sandpaintings which would last

and be economical. Stevens had by this time overcome his initial apprehensions about making permanent sandpaintings. He felt he could make permanent sandpaintings without incurring supernatural sanctions because he had been demonstrating without mishap, and indeed his financial reward from the task was interpreted as a sign of supernatural pleasure. In addition, he used Hosteen Klah, his father's clan brother, as his model, employing Klah's arguments and techniques to prevent supernatural displeasure. He would say prayers over the paintings, only make paintings which came from the chants which he knew, and would leave a sandpainting incomplete or change one small aspect in the completed painting so that it would not be exactly the same as a painting used for ceremonial purposes.

In 1952 the Atkinsons sold their Lupton establishment and moved to Tucson where they opened the Indian Village Trading Post. Stevens and his family came with them to demonstrate sandpainting in the store's front and side windows. Every day Stevens and his four children sang and danced for customers in the basement. The family also danced in parades, at rodeos and at powwows during the 1950s and 1960s forming one of the most famous dance teams in the country. Stevens even made 113 demonstration sandpaintings for live television commercials for the Atkinson company between 1956–1959. These popular activities drew large crowds; people were fascinated by the sandpaintings and many, like those in Lupton, would have been happy to have purchased a sandpainting to hang on the walls of their homes. But Stevens was still unable to sell many permanent sandpaintings because he could not overcome the technical difficulties which hindered steady production. The artistic and chemical knowledge of a new friend of Stevens, an Anglo painter and pilot in the U.S. Air Force, finally enabled him to make sandpainting a practical, profitable craft which could be made by other Navajos as well as himself.

Captain Luther A. Douglas (1919–1976), a native of Idaho, was a professional artist who had been interested in Navajo culture for many years. He was especially fascinated by Navajo ceremonies and sandpainting, just as Mae de Ville

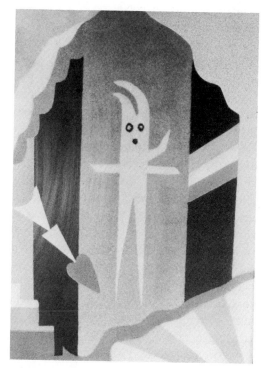

Fig. 5.6

Figure 5.6 This sandpainting by Red Robin is unusual in construction as well as subject matter. Produced before 1947 in Denver, it is made of ground glass and sandstone glued onto plaster which has been backed with cardboard. It is not based on a Navajo sandpainting design, although Red Robin did produce single figures of Holy People. It is housed at the Arizona State Museum, Tucson. Size: 23" x 15".

had been. As a child he saw his first sing on the Navajo Reservation and tried to make a sandpainting. When he was twelve years old, he managed to preserve his first small, single figure of a Holy Person. During his teens he continued to experiment and, satisfied with the results, showed his small composition to Yellow Hair, a Navajo singer demonstrating at a Chicago exposition in 1934. It does not appear that Douglas knew the de Villes although he probably had seen their early paintings on a vacation trip to the Southwest. While Mae de Ville did not teach Douglas how to make permanent sandpaintings, there is an indirect connection through an individual named Red Robin. An elusive figure, said to be a Zuni, Navajo, Acoma, or Anglo (Snodgrass 1968:156), Red Robin had watched Mae de Ville paint in 1932. Becoming a sandpainter himself, he went to the Denver Art Museum and

made eight replicas of Navajo Ceremonial paintings on boards for curator Fredrick Douglas as part of a WPA project. He would also regularly demonstrate at the museum, and Luther Douglas mentioned that Red Robin gave him his discarded sands. It seems safe to assume that Red Robin also helped Douglas with his preservation experiments. There is no evidence that Red Robin, who moved to New York City in the 1940s, ever taught any other Navajos to sandpaint.

Douglas's studies were abruptly interrupted when he joined the Royal Canadian Air Force in 1939. Transferring to the U.S. Army Air Corps, he eventually became a bomber pilot, stationed at various Southwestern bases until he went into combat in 1943. On his return he was stationed at Davis Monthan Air Force base in Tucson and by 1947 he had actively resumed his experimentation in Navajo sandpaintings and his studies of Navajo religion. It was during this period that Stevens became friends with Douglas although there is some question as to exactly when the two met. Stevens states that it was in Tucson in 1952, while Frederick Dockstader, recalling a conversation with Douglas, states that they became friends before 1950 when Douglas vacationed in Red Lake, Arizona, near Lupton. Sometime in the early 1950s, it is clear that Douglas and Stevens began to discuss the technical problems involved in making permanent sandpainting.

Douglas had worked out his basic "final preservation technique" between 1945 and 1950. Then in the early 1950s, collaborating with Stevens and using occasional suggestions from Rex Boulin, they improved and refined this method. The problem was to find a backing and an adhesive which could be combined with available sands in a practical and economical manner. The backing had to be sturdy and light enough to frame and hang on the wall without warping. After trying beaverboard, plasterboard, and other similar materials they found that three-ply plywood worked adequately. The adhesive proved to be more of a problem for it had to be slow drying, yet long lasting and strong. Stevens tried solutions of varnish and lacquer, but these proved too sticky. Commercial glues also proved inadequate for large scale production. Finally, Douglas successfully formulated a mixture of shellac, glue, and paste, but no one remembers the exact proportions.

Stevens and Douglas sold some of these early sandpaintings to tourists and residents of Tucson. One of Douglas's paintings, a linear variation of Holy Man and Holy Woman with Whirling Feathers from Male Shootingway was even sold to a physican from northern India! Both Stevens and Douglas, however, had misgivings about the quality of their paintings. Ultimately each man began to perfect his own technical variations and style: Stevens retained original colors from sacred sandpaintings while Douglas, like the de Villes, branched out into using hundreds of other shades. Besides sandstones Douglas used ground glass, gems, silver, lead, turquoise and malachite as well as plastics to add translucence to his paintings by the mid 1950s (Baird 1962). These materials, which were finely ground, sifted, and mixed with sand to give them body, have made Douglas's paintings much more colorful and vivid than anything that had been produced by Navajo sandpainters. Douglas used plywood or particle-board backing, later masonite; the sands were cemented in place, and the completed picture was sprayed with a clear varnish-type adhesive.

In the fall and winter of 1953–1954 Douglas began to successfully market his sandpaintings with the first of many one-man shows at the Contemporary Crafts Museum in New York City (Figs. 5.7 and 5.8). This was followed by shows in galleries around the country which was great publicity. These shows contained three types of paintings: modified replicas of Navajo sandpaintings from the Huckel collection at the Taylor Museum, and from published sources, such as Newcomb and Reichard (1934); interpretations of Navajo sandpaintings adapted to coordinate with Anglo-American decor; and original landscapes and abstracts, divorced entirely from Navajo subjects and taken from Douglas's own works in oils. The theme or purpose of these shows was to expose the American public to the artistic qualities of Navajo religious designs and to promote the use of colored sands as an artistic medium. Douglas also made a number of large paintings for museums such as the Cranbrook Institute of Science, the Fort Worth Children's Museum and the Arizona State Museum. Stevens would often demonstrate at the openings of these exhibitions.

Figure 5.7 This sandpainting by Luther A. Douglas is not representative of a specific Navajo sandpainting but is an interpretation based on elements from various chants. It was made in 1954 at the request of Dr. George Mills for the Taylor Museum. One of his earlier paintings, it is typical of the major stylistic changes which Douglas made when coyping Navajo sandpainting even though he considered his artistic experiments a means of preserving Navajo culture and religious history. The sands on this painting are rather coarse, but Douglas's craftsmanship greatly improved in later years. Size: 36" x 36" on masonite.

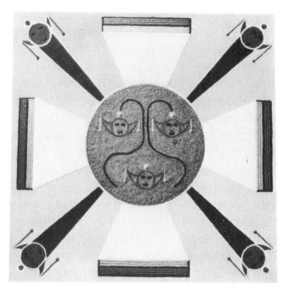

Fig. 5.7

After retiring from the Air Force, Douglas moved to Sun Valley, Idaho, and established the American House Creative Art Gallery in 1959. He continued to specialize in sandpainting but worked occasionally in other media. Unlike the de Villes, he always made Navajo sandpaintings and he continued to research Navajo religion. Numerous exhibitions and tours followed in the United States, Europe and India. Douglas did not teach any other young Navajos. His influence on the development of the new craft and its spread among the Navajos was, like the de Villes, mediated by Fred Stevens.

While Douglas was achieving success with his work and helping to create an active market for sandpaintings, Fred Stevens began to break his ties with his former employers, the Atkinsons. He moved back to the reservation and began to demonstrate for various storeowners in neighboring communities, like Gallup and Holbrook. Although Douglas still offered encouragement and suggestions, Stevens chose to strike out on his own, not wanting to copy another man's work or unintentionally steal his ideas. In 1958 he traveled to Jackson Hole, Wyoming, on his first major demonstration tour outside the Southwest. There, he states, he finally per-

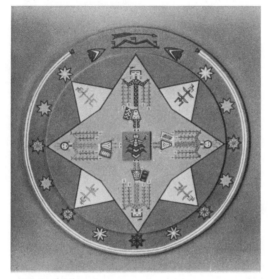

Figure 5.8 An adaptation of the Star People from Big Starway, this painting was made in the late 1960s by Luther A. Douglas. The multi-layering used here was Douglas' own innovation.

Fig. 5.8

fected his sandpainting technique after consulting Douglas. He decided to used a diluted solution of Duco™ cement which was lighter and thinner than the lacquer-based mixture he and Douglas had tried to use. His first successful painting using this technique was a nine-inch-by-five-inch picture of Fringed Mouth (Half Red Man), a yei from Nightway, which became one of Stevens's trademarks.

While selling sandpaintings more regularly, there were still problems with the new method. Two people were required to construct each painting because the glue dried too quickly. Late in 1959 or early 1960, while on a brief trip back to Tucson, Stevens began using a "white glue" which dried more slowly, enabling him to work without assistance. This technique, which he calls the white glue and paint brush method, is now used by almost all commercial sandpainters and consists of ten basic steps. First, colors picked up in the neighboring environment (sandstones, mudstones, slates, gypsum, charcoal) or obtained at retail establishments (carborundum grit) are ground with a mano and metate. After several poundings the colors are sifted to remove foreign substances. (Today, many painters mix the colors with riverbed sand to

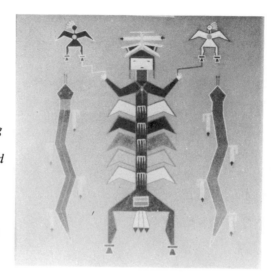

Fig. 5.9

Figure 5.9 In this 1961 sand-painting, Fred Stevens, Jr., depicts the Final Ascension of Scavenger attended by Lightning (represented by snakes) from Beadway. Stevens has eliminated the Rainbow Goddess which would have surrounded the drawing and the two small bats which would have served as the paired guardians of the east. He made easily noticeable changes in the paintings which were not drawn on the chants which he was trained to perform. Stevens began the process for obtaining a patent for the technique which he used to produce this painting, but the final papers were never filed. Size: 24" x 24" on plywood. Price: $50.

give it more body or mix the sands together to obtain new shades, but this was not part of Stevens' basic process.) The ground is then prepared: the board is cut to the required size and the edges are sanded. The binder, a white lactase-based glue, is prepared in a diluted form and is spread evenly over the backing. A generous amount of clean riverbed sand is sprinkled over the entire surface. After drying, the process is repeated.

After the background is complete, the painter lays on the design freehand or follows the contours of a stencil. The stencil is placed on top of the board, edges flush, and the painter draws a faint white line with a sharp instrument. The painter then begins to paint the solid areas of color: the binder is applied to a desired area with a small paint brush; then the pigment is immediately sprinkled over the wet area, patted into the glue, and the excess tapped off onto a piece of paper. Following each application of color, the adhesive must be allowed to dry and harden for up to two hours. Decoration is drawn in with a pencil to make faint guidelines for the glue and color. When the painting is finished and completely dry, the surface is sprayed with a light coat of clear artist's fixative, usually a clear varnish or plastic, which forms a protective coating. This method is like oil painting except that the artist

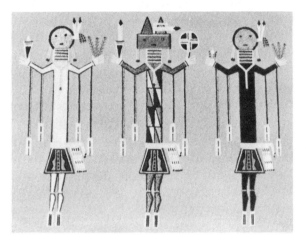

Fig. 5.10

Figure 5.10 This sandpainting also by Fred Stevens, Jr., done in 1979, is of Holy Woman and Two Protecting Yei from Big Godway. The two yei are variations of Talking God and his companion. The rainbows and lightning on which the Holy People travel have been eliminated. In this painting Stevens has used Douglas's technique. Size: 9" x 18" on masonite. Price: $50.

is painting thin lines with glue. It differs from the method discovered by Mae de Ville in that there is more than one layer of colored sand (Figs. 5.9). It differs from the construction of sacred sandpaintings in that there is no specified order of construction.

This is the method which most Navajo sandpainters use today. Like Douglas's method it was stable, rapid, allowed retention of detail and a reduction in the size of the composition while capturing the textural and low relief qualities of the sacred paintings. There have been very few technological changes on this basic technique. Most painters use either an epoxy glue or white lactase-based glue thinned with water. This is usually Elmer's Contact Cement™, made by the Borden Chemical Company. Several painters use additives, including pinyon gum although the exact nature of the glue is usually considered a trade secret. Precut stencils were used by 1964 and have become common since 1970 as more and more small-sized tourist paintings were made. Since 1967 painters have used particle board rather than plywood. Stevens continued to experiment with the basic technological aspects of sandpainting, and in 1976 he decided to switch back to Douglas's original techniques and materials. He now uses commercial casein glue, Casco™, and an adhesive with a masonite backing (Fig. 5.10).

Stevens continued to paint and demonstrate in the early 1960s, receiving active support from various retailers in the Southwest. In 1962 he returned to Sheep Springs and taught his brother, Leroy, and his sister, Minnie Stevens Foster, to sandpaint. According to Stevens, he formally showed his siblings how to make commercial sandpaintings because they were his brother and sister and one should help one's relatives. He also inspired a clan sister, Patsy Miller, and her husband Francis, to experiment on their own after they watched him paint on the table in Minnie's hogan. These four individuals then began to show others in the community how to make permanent sandpaintings. A new craft industry was born and began to spread.

As happens when an idea is ripe, several people discover it almost simultaneously. Several individuals have claimed to have discovered how to make permanent paintings in sand and have claimed credit for the numerous small technological innovations necessary for them to be a feasible craft and economic enterprise. One, David V. Villaseñor, has even asserted in several publications that he has taught, directly or indirectly, all Navajos who are currently making or have ever made commercial sandpaintings. Villaseñor, a professional artist living in California, was born in 1915 in Jalisco and raised in Sonora, Mexico, and migrated to the United States at age sixteen. While living in Tucson he accompanied a University of Arizona and Tucson Art Museum expedition on a sketching tour of northern Arizona and while on this trip attended a Navajo curing ceremony, experiencing what can only be described as a type of mystical conversion. He became fascinated with sacred sandpaintings and states that from that time on he began a life-long quest to produce permanent art in dry materials. Later, as a professional art counselor for organizations like the Woodcraft Rangers, Villaseñor often made impermanent sandpaintings for his students, and following World War II he began gluing the sands onto pieces of stiff paper. After several years of intermittent experimentation searching for a proper binder and backing materials, Villaseñor developed a "How-To-Do-Sandpainting" kit for the Fred Harvey Company in 1949 (over 2,500 kits were eventu-

· ally sold), and in 1951 he began exhibiting in galleries and museums in New York, California, and Arizona. His Navajo, Papago, and southern California sandpainting reproductions became a part of a permanent display on Navajo religion at the Southwest Museum in 1964. The designs were drawn from Monster Blessingway, Shootingway and Mountainway. Villaseñor purposely left each painting incomplete in order avoid offending native healers.

Villaseñor attempted unsuccessfully to teach his techniques to Native Americans, as he had to Anglo youth groups after 1949. He felt that he was perpetuating an ancient art form that was headed for extinction. Villseñor (1967:151) claims to have instructed Franklin and Mary Jane Kahn of Pine Springs, John and Mabel Burnside (of Pine Springs) and Vernon Mansfield, a Hopi. While Kahn and his brother, Chester, did learn sandpainting techniques in 1955 and 1956 from Villaseñor while attending a vocational high school in Nevada, both only made the sandpaintings commercially for a few months in 1956. Both stopped for economic and aesthetic reasons; they were beginning to pursue other already established crafts— silversmithing and easel art—at which they have become highly successful. While the close relatives of these men did watch them, none ever made or sold sandpaintings professionally. The Kahns never taught anyone to make sandpaintings. The same is true for the Burnsides. Although each made three or four pictures for fun in the mid 1950s, both were too busy with crafts at which they already were highly successful, namely silversmithing, and weaving and the construction of dye charts, to waste their time with a craft which was questionable. While Vernon Mansfield was not interviewed, there were no drypaintings by him in stores nor did retailers on or near the Hopi reservation know of any Hopi who has ever made commercial sandpaintings.

While Villaseñor probably has taught one or two other Native Americans, he is not responsible for the development and spread of Navajo commercial sandpaintings. He has, however, had an indirect influence on stylistic development through the publication of his two books, *Tapestries in Sand* (1963) and *How To Do Permanent Sandpainting*

Figure 5.11 "Seed Blessing Sandpainting" by Annie Tsosie, Sheep Springs, 1977. This painting does not exist in the Navajo sacred sandpainting repertoire. The painter has copied it directly from Villaseñor (1963) who created the painting himself. Commercial sandpainters often call it "Animals and Plants." Plants are all personified as Holy People. Size: 24" x 24" on particle board. Price: $90.

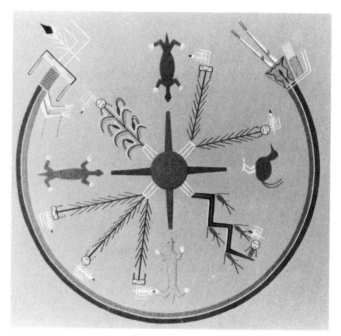

Fig. 5.11

(1972), the latter coauthored with his wife. Until approximately 1978, wholesalers of Navajo sandpaintings would give these books to promising young painters, indicating which pictures were popular and should therefore be copied. Since many of these young men and women are unfamiliar with the intricate details of their religion, Villaseñor's new names for the paintings have become common on the backs of the Navajo paintings. For instance, Villaseñor's version of Pollen Boy on the Sun surrounded by eagle feathers from the Chiricahua Apache Windway (see Fig. 4.9a, p. 90) is called "Sun and Eagle." Villaseñor's title for the sun painting from Plumeway is called "The Chiricahua Sun Sandpainting." Finally, the "Seed Blessing Chant" painting (Fig. 5.11), which has no counterpart in the sacred sandpainting repertoire of the Navajo, has been copied by many young Navajo sandpainters. Almost 14 percent of Navajo sandpaintings sold in 1977 and 1978 were drawn from Villaseñor's versions printed in his two books.

While several individuals claimed to have invented commercial sandpaintings, through only one person, Fred Stevens, Jr., did the techniques of the craft actually diffuse to the Navajo. Of the 451 sandpainters identified by name when this study was terminated in 1979, 302 can be traced directly back to Stevens as the ultimate learning source. Another 26 individuals (6 percent) could be placed in small learning clusters but when field work ended had not been definitely connected to the Stevens line. Only one other person was found to have acquired the knowledge in a school art class. Today, two sandpainters are teaching youngsters in formal art classes but none of their students have become commercial sandpainters. Few educational institutions, either public or BIA schools, have formally taught the technique of sandpainting. Since no other visible or viable learning sources were found, it is likely that most, if not all, of the remaining painters not interviewed learned indirectly from the Stevens source. Even so, data for this chapter are based only on the 302 sandpainters who were linked with Fred Stevens as the original learning source. Conclusions can, however, safely be extended to all other Navajo sandpainters.

THE SPREAD OF COMMERCIAL SANDPAINTING

With mastery of the technical skills and the completion of necessary technological innovations required to produce durable, permanent paintings in sand, the craft spread slowly among the Navajos during the 1960s and rapidly in the 1970s, beginning in the community of Sheep Springs, birthplace of the craft's founder. This diffusion process was a slow step-by-step affair, revolving around the interaction of two people at a given point in time and space. The mechanisms and manner by which this process occurred depended on two important factors: first, how each individual learned to make sandpaintings, and second, who each individual learned from and the relationship between the two individuals involved in this transfer of knowledge. These important factors, in turn, affected how the craft spread throughout Navajo culture.

Learning to Make Sandpaintings

As is common worldwide, the art of sandpainting was trans-
mitted by a variety of techniques which ranged from infor-
mal self-instruction to formal apprenticeships. However, like
most other Navajo crafts, training tended to be informal
and took place in the home of the already established artisan;
teaching was by showing, without explanation or generaliza-
tion. Often no instruction was given or, as one sandpainter
said, should it be, for "learning is in the environment; it is
never conscious." Most sandpainters do not think they have
been taught, because they associate the word "teach" with a
classroom situation.

For example, one girl, having watched her mother
paint for several years, began painting when she was thirteen.
She thought it would be fun to try, but her mother refused to let
her for fear she would "mess up" the work. One day, in her
mother's absence, the girl began to make a painting which she
finished before her mother returned. Although the composition
was crude, the mother was pleased with the effort and from
then on let her daughter use her materials to make sandpaint-
ings whenever she wished. The mother did not instruct her
daughter or criticize her efforts, but let the girl experiment
until she had mastered the basic technical skills. The mother's
reasoning was that it is better to watch than to be directed, for
to tell someone when and how to do something would stifle
creativity and assert authority in an inappropriate manner.

Other painters were taught, in that they were shown all
or some of the basic construction steps such as pounding the
sands, preparing boards or laying on the colors. This verbal
instruction occurred either in one intensive session or infor-
mally over an extended period of time. One woman felt that
one session was best, since more would only confuse the
pupil. This type of training usually occurred when the painter
had more orders than could be easily filled; the painter would
then ask younger relatives or wives for assistance. Instruction
in this case would be gradual: after mastering the basics of
preparing the materials, the helper would make backgrounds
or lay designs. In return, the apprentices would be given a

minimal wage. Eventually the new painter was skilled enough to make and market paintings on his own. More often, however, it was the budding artist who solicited help from an established painter. What was taught, the intensity of instruction, and the amount of criticism and verbal instruction varied tremendously. Usually this involved combination of observation and verbal instruction: the budding artist watched, experimented on his or her own, and received some formal verbal instruction or criticism when necessary. Some painters only went to their advisors when they had a problem, such as dripping glue or the sands not sticking in humid weather. Mentors would then show more efficient methods or suggest new designs. All new artisans, however, partly mastered the art of sandpainting by constant practice and trial and error.

TABLE 5.1
Mode of Instruction for Commercial Sandpainters By Sex of Student

Sex of Student						
Mode of Instruction	Men		Women		Total	
	N*	%**	N	%	N	%
Informal Methods						
Watch, then experiment (self-learning)	30	19.6	16	10.7	46	15.2
Watch, experiment, some criticism	33	21.6	38	25.5	71	23.5
Watch, some verbal instruction	35	22.9	32	21.5	67	22.5
Verbal instruction, intensive session	43	28.1	47	31.5	90	29.8
Formal Method						
Apprenticeship or helping situation	12	7.8	16	10.7	28	9.3
Totals	153	100.0	149	99.9	302	100.0

*N = actual number of respondents who gave each answer
** % = percentage of men, women, and all painters respectively who
answered each category.

Learning patterns differed little between men and women (Table 5.1). Informal methods with some verbal instruction were the dominant patterns for both sexes. Men, however, were slightly more apt to watch and then experiment

without any verbal instruction, just as men who had attended high school or lived off the reservation for a number of years tended to teach more formally than women. All mentors who taught more than one person used multiple methods of instruction. Children tended to learn the craft informally by observing their parents, while clan relatives or visitors were shown the process more formally. Those individuals who began at the request of the instructor tended to form an apprenticelike relationship. Thus individuals in daily contact with established painters tended to learn informally.

Regardless of how one learns the technical skills, excelling in the craft requires individual experimentation. An artist must discover the uses and textural qualities of each pigment; every painter begins with five or six basic colors and gradually expands his palette. A novice learns slowly to distinguish different types of rocks—which ones are too hard to pound or too soft and powdery to adhere to the board. Painters said it was very difficult to tell someone exactly what to look for in a rock, although it was possible to look at a rock and learn to judge whether it would grind properly and produce a pleasing shade. New figures and designs are also subjects for experimentation, and over the years a painter might expand his repertoire. Simple, small compositions such as single figures of Holy People were typical of early efforts because of the square bodies and straight edges.

The length of time it took to learn these technical skills varied according to the task and the type of painting produced. Outlining was the most difficult skill to learn, according to new painters, for it requires making lines thin and even, yet not so thin that the sands break off. Other skills hard to master included knowing how to make an even background, understanding how to grind the particles to an even, small size, and how to properly place the figures on the board so they are not off-center. Time is also required to create an individual style, although not everyone is interested in this task. These are all characteristics of sandpaintings which are made as fine art and very detailed and accurate reproductions of sacred sandpaintings, rather than of souvenir paintings which are by nature simple and basic. Painters who produce for the souvenir

market said that techniques were easy to learn and they had not essentially improved upon or expanded upon their initial efforts. While for these individuals the basics took them only a day or two to master, for those who aspired to more technically demanding compositions, the learning period might be anywhere from one to three or four years.

A special learning pattern characterized the efforts of a few sandpainters who considered both commercial and traditional sandpaintings to be sacred. They distinguished two learning processes—one for technical skills, and the other for the designs and symbolism, which included the lore or story which accompanied each painting and the prayers which they felt had to be intoned over every painting in order to appease the gods. For these deeply religious individuals the second process was the most important because figures must be portrayed as accurately as possible lest the Holy People become angry. These painters felt that new sandpainters must be apprenticed just like singers, and slowly expand their repertoire in light of this knowledge. They must be constantly corrected for minor errors and each painter, in consultation with his teacher, must discover what is right for him or her as an individual. This is a slow process because, according to one man, if an artisan learns too much at one time, he will forget and thus bring hardship upon himself and his family. A painter's work must mature as the painter matures and learns to comprehend the meaning of symbols. Small children are too young to understand these things. This specialized knowledge was acquired from fathers and fathers-in-law who had ceremonial knowledge.

Students also paid for this knowledge for without payment the designs and prayers would be ineffective and disaster would befall the painter. The similarity to learning ceremonial knowledge is, of course, striking. While men learning to make ceremonial sandpaintings did not pay to learn the construction techniques, ceremonial lore was almost always disseminated for at least a nominal fee. No sandpainter paid for instruction in technical skills, although several mentioned that they gave their teachers gifts as an expression of thanks. This included pieces of jewelry, produce, and sheep,

or finished paintings which could then be sold. In all instances the teachers were close relatives and the gifts were made to family and friends rather than teachers. This appears to be a different pattern from the payment given by apprentice silversmiths (Adair 1944:89–92) and singers (Aberle 1966, 1973:139; Kluckhohn 1939) who learn from nonrelatives. A silversmith does not pay a relative and learning ceremonial knowledge from a clansman or close relative greatly reduces the fee necessary to validate the transfer of knowledge. No sandpainter continued to give his or her instructor gifts, as singers do their mentors after each performance.

This duality in learning processes, with one focusing on the correctness of design resulting in formalized instruction, stems from the former religious nature of sandpaintings and the ambiguous position of permanent sandpaintings. It is not found in the instruction of secular crafts such as pottery-making, weaving, basket-making, or silversmithing. For Hopi, San Ildefonso, Zuñi and Acoma potters, formal intensive teaching dealt with technical excellence and, therefore, such tasks as clay preparation, molding, use of scraper, and finishing (Bunzel 1972:60–62). Choice of shape and decoration was left to the discretion of the student so as not to stifle creativity; acceptable designs and pleasing combinations of elements were informally learned by observation. Pressures to adhere to prevailing taste without actually copying were subtle and involved criticism, direct or indirect. Navajo weavers were taught both the technical processes and composition without explanation or generalization for experience is considered to be the best teacher. Experienced weavers occasionally gave no help whatsoever to neophytes but generally corrected mistakes and criticized results but did not make suggestions for future efforts (Reichard 1936:xv, 3, 18). In this instance, then, the small group of commercial sandpainters who insisted that formal guidance in design was the most crucial part of learning were unique among Southwest Indian artisans.

In accordance with Navajo rules governing ownership of knowledge, the technique of making commercial sandpaintings is the property of the individual and can be distributed as the owner sees fit. It is, therefore, at the discretion of the

owner that the knowledge is shared. This does not mean, however, that the diffusion of sandpainting construction techniques was without strife. One painter was angry with his brother for teaching "his" technique to others, because it was not the brother's to give away. An accusation of stealing was brought by one woman against her sister's husband because he had not asked her permission to paint. He had watched her and then begun selling paintings himself, definitely encroaching on her market. For this reason, many sandpainters do not like to have non-relatives watch them paint. Designs, rock sources, and glue formulas are examples of individual knowledge or property that are subject to theft. Several painters stated they would not have begun painting if their "teacher" had disapproved.

Similarly it is considered dishonest for a man to watch a silversmith with the intention of learning the craft without informing him (Adair 1944:91). In fact, smiths felt the craft had spread through stealing and many, like several sandpainters, did not like others to watch them work for fear the onlookers would steal their successful techniques and designs. This concern expressed by artisans is reminiscent of Navajo ownership and transmission of knowledge of a certain kind, specifically private lore, songs, and prayers performed by a man to benefit the herds and economic activities of his family (Aberle 1973:140). For example, Old Man Hat, concerned that he might die soon and that his son would not be given the proper songs by other relatives, taught him ritual songs which would protect his livestock and increase his herd's size (Dyk 1938:258). Conversely, farming songs concerned with subsistence activities were not guarded but were taught freely without remuneration (Hill 1938:61). Aberle suggests that the songs dealing with wealth (i.e. livestock) were not freely transmitted, while those concerning subsistence activities (i.e. farming) were. Commercial sandpaintings and silver sold to Anglos can be viewed as means to increase wealth. While not portable wealth in themselves like livestock, sandpaintings are means by which wealth can be accumulated. They are made for money, unlike agricultural produce, which yielded very little surplus except in

a few locations. To the Navajo knowledge is wealth. Just as a singer can always earn a livelihood through his ceremonial knowledge, so can a commercial sandpainter through his secular knowledge.

Navajo Social Organization

Thus technical aspects of the art of commercial sandpainting were learned, by and large, in informal situations, that is, within the households of relatives and friends. But in order to fully understand the mechanisms by which the art of commercial sandpainting spread it is necessary to review briefly Navajo social organization. Navajo society is organized on the basis of kinship, composed of approximately 60 equal, dispersed, exogamous units which are part of a matrilineal clan system. Membership in these egalitarian and unorganized clans is ascribed by birth; everyone is "born into" his or her mother's clan, and likewise "born for" the father's (Aberle 1973:110). Clans hold no property and have never constituted a residential or political entity, but instead function to regulate marriage, establish social identity and provide networks for hospitality and assistance. Clan members assume economic obligations in terms of mutual aid in ceremonial expenditures. These functions, especially the extension of hospitality and assistance through kinship ties, extend to one's father's clan, but in an attenuated form.

Because of the clan's dispersed nature, Aberle (1973:113–119) suggests that the "local clan element," consisting of members of a clan who reside in a given area, is an important entity for daily interaction. This loosely organized group is the major unit of aid outside the family and acts as an agent in disputes which cannot be handled by individuals. [This concept is roughly analogous to the "outfit" or "cooperating unit" (Lamphere 1977:5).] At the local level however, the extended family is the major cooperating unit, although the nuclear family is common. All members of an extended family live near one another but in separate hogans. Composition of the group varies but is based on consanguineal ties and has usually three or more generations. Those who "live within shouting distance" (Kluckhohn and Leighton

1962) tend to cooperate regularly, and it is with members of this group that one has the most interaction. While economic cooperation varies, as a residence group the extended family is the maximum subsistence unit and tends to cooperate in herding, farming, and pooling labor.

These scattered nuclear or extended household clusters typify Navajo settlements, in contrast to the compact villages of the Pueblos. Typically, a cluster of hogans is a quarter of a mile to several miles away from similar units. Ideally they are matrilocal, but neolocal and patrilocal residence are acceptable alternatives. The prevalence of each type varies by region, environmental conditions, economic opportunities, culture-contact situations, and factionalism (Aberle 1973:187, 188; Henderson and Levy 1975:114). Residence is much more variable in the eastern part of the reservation and Lamphere (1977:78–81) found that in Sheep Springs, the community with the largest number of sandpainters, young people are just as likely to reside patrilocally (with the husband's parents and kin group) as matrilocally (with the wife's parents and kin group), although when couples of all ages were considered almost twice as many people resided matrilocally. These settlement patterns are shifting slightly today, due partly to the introduction of federally sponsored housing units. Non-relatives may live side-by-side in the larger communities, and incipient in several communities is a pattern of houses clustered around trading posts, chapter houses, or Christian churches. Consequently, like the rest of Navajo culture, residence patterns are, and have always been, flexible. However, almost everyone in a Navajo community can establish some sort of consanguineal relationship with everyone else.

Residential units are also always in a state of flux. Someone is always absent, performing necessary economic tasks or visiting. Women are more likely to be at home than men because of their domestic duties. The composition of the household, incremented by visiting relatives, will differ by season and also the day of the week.

The nuclear family, composed of a man, his wife and unmarried children, is the minimum unit of residence and subsistence in Navajo society, and represented the majority of

hogans in Sheep Springs, at least (Lamphere 1977:75). However, unmarried and divorced individuals would attach themselves to these basic units, for individuals, especially a woman and her children, would rarely live alone. Thus almost any combination of relatives is possible in a Navajo household.

The type of kinship relationship which ideally and actually exists between any two people affects the opportunity to potentially learn a new craft in a society based on kinship. Navajo relationships in general are "face to face" and "multiplex" (Lamphere 1977:4). Interaction occurs mainly with close relatives, in terms of both genealogical and physical distance; other relatives are rarely visited. The same is true for residence groupings which do not contain relatives; unrelated groups rarely know much about the activities of the other.

Aberle (1973:158) identifies two types of relationships with relatives, bashful and non-bashful (see Appendix 6). With those with whom one is bashful, one is hesitant to ask favors. One is also hesitant to request aid from elders and those with whom one must show deep respect, such as a mother-in-law, and to a lesser extent a father-in-law. The behavior patterns between bashful relatives ranges from avoidance to respect, while for non-bashful relationships, joking, open affection, and aid are expected. Behavior also depends on sex and relative age. Behavior toward relatives outside the extended family is less intense and characterized by joking. The strongest bonds in Navajo society are between mother-child, sister-sister, and brother-sister. Less intense bonds exist between husband and wife, father and child, brother and brother (Aberle 1973:164).

Who One Learns From

As expected, due to the non-institutionalized learning patterns, most new sandpainters learned from relatives, especially members of their nuclear families (see Appendix 7). Only six percent of all new sandpainters were taught by non-relatives. Sixty-five percent of the learning relationships occurred in the home where the neophyte was taught by siblings, parents, or spouses. (No daughters and only three sons served as teachers;

people learn from their elders or peers). This reliance on the family was more evident for women than men, although it was the dominant pattern for both. Women often learned from spouses while helping their husbands with their work, while men frequently learned from clan brothers. When learning occurred outside the immediate household of the neophyte, the focus for both sexes was on one's own clan relatives and affines rather than on one's father's clan relatives or miscellaneous relatives, those who did not belong to either clan but to whom a relationship could be traced. Learning from affines was especially important for women, second only to the importance of the spouse and family of orientation as sources of this technical knowledge.

The kin-based student-teacher relationships reflect the importance of the nuclear family and the dominant matrilineal pattern of Navajo social organization, as well as its variability. One still calls upon and visits members of one's own clan before turning to others for assistance and companionship (Lamphere 1977). All women who learned from an affine other than their husbands were either living with the husband's kin group, visiting, or being visited by an affine who was considered a close friend. The dominant pattern though is for men to visit other clan-related households and then return home to teach male and female members of their own home.

While both men and women learned primarily from male teachers (male painters taught 64 percent of all new sandpainters), just as Navajo silversmiths do, there was no significant relationship between the sex of the teacher and the sex of the student (Table 5.2). Among commercial sandpainters "cross-sex teaching" in which a man teaches a woman, or a woman a man, was almost as common as "same-sex teaching," in which a man teaches a man and a woman teaches a woman. This is a unique finding for Southwest Indian arts and crafts; teaching in other crafts tends to be woman to woman or man to man, reflecting the sexual division of labor in each society and the tendency for a craft to be produced by one sex. For example, weaving among the Navajos is a female craft; women teach women to weave, and, while a man will occasionally learn to weave, he will

TABLE 5.2
**Comparison of Sex of Teachers and
Students for Commercial Sandpainters**

A. Sex of teacher by sex of student for all sandpainters

Teacher	Student		Total
	Male	**Female**	**Total**
Male	102	91	193
Female	51	58	109
Total	153	149	302

$(x^2 = 1.02, df = 1, p = .30)$

B. Sex of teacher by sex of student for sandpainters omitting individuals
who learned from spouse

Teacher	Student		Total
	Male	**Female**	**Total**
Male	102	60	162
Female	33	58	91
Total	135	118	253

$(x^2 = 17.31, fd = 1, p = .001)$

(Each cell shows the number of men who taught male students, the number
of men who taught women students, the number of women who taught
men students, and the number of women who taught women students
respectively.)

rarely become a teacher of this craft. Unlike most other crafts, Navajo commercial sandpaintings are produced almost equally by both sexes, and have been since the founding of the craft. There was a very slight tendency for men to predominate in the first years, especially from 1962 to 1967, but women rapidly made up this slight lag by 1969. Since the early 1970s the number of new male and new female painters has been remarkably even. This is a new pattern in the Navajo sexual division of labor and for the development of a Navajo craft, and is particularly interesting because there are still few women who will make sacred sandpaintings.

This production by both sexes partly explains the new pattern of teaching without regard to sex. The marital relationship was also an extremely important variable, because if spouses are not considered, the relationship between students and teachers by gender becomes more like that for traditional crafts, especially for men. The importance of this marital rela-

tionship is particularly apparent if the teacher had taught only one other person; in such cases, this was almost always a spouse.

When a teacher taught more than one other person this pattern changed. Twice as many men as women were master teachers, or those who had taught eight or more sandpainters. By 1978, these masters (3 percent of all Navajo sandpainters), all of whom began to paint before 1970, had taught 37 percent of all sandpainters. These masters were often involved in apprenticeship situations and would primarily teach young clan relatives and affines, but also non-relatives and household members. Those men and women who taught fewer individuals tended to teach only siblings, regardless of sex. Women tended to teach siblings and children. In short, the more pupils a teacher had, the more likely the pupils were to include all kinds of kin, regardless of sex, and the greater impact this individual would have on the spread of the craft to new households and new communities.

Most painters (200 individuals or 66 percent) had not taught anyone when interviewing was completed in 1979. Fifty-nine painters taught two or more people of whom nine taught more than eight new painters each. This large number of non-teachers is partly a factor of time. While non-teachers began to paint in 1962, they tended to have later learning dates than those who had taught, peaking in the 1974–1976 period, while sandpainters who are teachers peaked two years earlier. Therefore, it is possible that many non-teachers will begin teaching. There were, however, no other special characteristics, such as education, age, or previous art training, which helped to explain why some painters became teachers and others did not. We can expect that more men who have not yet taught will become teachers than women.

The time lag between a sandpainter's learning to paint and beginning to teach the skill to others was on the average one year and four months, reflecting the initial practice period required to gain control over the medium. Those who taught others soon after starting always taught either a spouse or a child. In general, men tended to wait slightly longer than women before becoming teachers as did those painters who

began to paint between 1962 and 1969. On the average, for sandpainters between 1962 and 1969, a period of 19 months elapsed between the time they began to sandpaint and the time they taught; the time lapse for those who learned after 1970 was only a year. Actually the difference between the sexes and the difference between the time periods reflects the same pattern. Following 1970 the market for commercial sandpaintings changed; prior to this the paintings were sold primarily for home decorations and as fine art and after 1970 a market for souvenirs was created. Women who became teachers and began after 1970 tended to produce for the souvenir market. Male teachers, on the other hand, tended to be those who had learned between 1962 and 1969, and they also produced more demanding paintings, that is, those with more detail which took longer to master.

Sandpainting is not clan specific, just as no other Navajo craft is clan owned or controlled. Painters belong to at least ten clans. However, due to historical accident, the spread of the craft through clans, and the clan composition of Sheep Springs two clans are dominant: *kiyaa'áani* and *táchii' nǚ* (62 percent). The earliest sandpainters were *kiyaa'áani,* which is also the largest clan in Sheep Springs (Lamphere 1977:96–97). In addition, there is no tendency for either joking or respect kin relationships to dominate learning patterns (see Appendix 6). More than three-quarters of the new sandpainters, however, had a relationship with their mentors traditionally defined as nonbashful. Excluding those relationships which are human universals (such as parent-child, husband-wife) lowers this predominance so that only slightly more sandpainters learned from kin with whom they are nonbashful than bashful, regardless of sex. Many of the bashful relationships (in which one is hesitant to request aid or favors) are characterized by similar age. Thereby, bashful lines are being overridden; the greatest difference is seen in that a few men are learning from their mothers-in-law. Therefore, even though kinship relationships dominate learning dyads, kinship is not completely used in the traditional manner.

To date learning has been primarily horizontal rather than lineal, that is, primarily expanding through both sexes rather than having passed down from generation to generation

in established family lines. This is, of course, due to the fact that the craft is still so young, only having begun to spread in 1962. At the most seven individuals separate any sandpainter from Fred Stevens, the original source of the knowledge, and by far the majority of sandpainters are separated by five or fewer learning dyads. It is still too early to tell whether the craft will stabilize into family lines and produce a more linear pattern of learning or will continue to expand horizontally.

One final aspect of teaching patterns should be mentioned: friendship and visiting patterns. Many of the kinship patterns, especially those involving several links, actually reflect friendships. Since painting is a home industry, seen by all who enter a hogan, visiting patterns are crucial. These visiting patterns are important in the spread of the knowledge to new communities as well.

The learning patterns and the teacher-student relations characteristic of commercial sandpainters differed from those involved in the learning of ceremonial knowledge but were extemely similar to those characteristic of silversmithing, for example. Kluckhohn (1939), with a sample of 30 singers from Ramah, New Mexico, found that 18 men learned from consanguineal kinsmen, one from a stepfather, five from affinal relatives, and six from non-relatives. Unlike commercial sandpainters, a Navajo singer was more likely to learn from a paternal kinsman than from a matrilineal kinsman or an affine. While kinship is important (Aberle 1966:45), there is little evidence that clan is an important factor in the teacher-learner relationship. The rationale for the selection of relatives of any kind over non-relatives is partly economic: every ceremonial performance requires a ''fee,'' and in the lengthy, formal process of learning a ceremonial the apprentice must pay a ''fee'' to his teacher. Students likewise must give presents and other tokens of appreciation to a non-relative teacher on other occasions (Aberle 1967). If the teacher is a close kinsman, the only payment a student gives may be the remuneration at the end of the apprenticeship when he is sung over, a practice which validates the singer's new status. The more remote the kinship bond, the more remuneration the established singer may demand. Apprentice singers, therefore, tend to select kinfolk as teachers.

While commercial sandpainters primarily learn from relatives rather than non-relatives, reasons for this choice differ. For commercial sandpainters there was no learning fee, as stated earlier, so that economic considerations were immaterial. Patterns of residence and daily contact were the crucial factors.

While the methods of learning to work silver followed a pattern similar to that of the transmission of ceremonial knowledge, teacher-student dyads in silversmithing were more like those for commercial sandpainters. The first Navajo smith to work in iron and silver, Atsidi Sani (Old Smith) of Crystal, learned from a Mexican acquaintance in the 1840s. After teaching his four sons, he became a paid teacher with at least six pupils. Big Lipped Mexican, an itinerant Mexican smith, came to Crystal in 1870 and taught two brothers, Slim-Old-Smith and Very-Slender-Maker-of-Silver, clan brothers of Atsidi Sani. The latter had a shop where he paid ten apprentice-workers. Bedinger (1973:22) estimates that by the turn of the century 25 to 40 smiths lived in the vicinity and, that while all of them knew one another, it is not known whether they were members of the same clan or affinally related. Adair's data (1944:89–92, Table 1) shows that for contemporary smiths, 60 percent learned in the context of the domestic household, 14 percent learned from matrilineal kinsmen, 2 percent from father's clan relatives, 6 percent from miscellaneous relatives, 15 percent from affines, and 4 percent from non-relatives. The main difference in relation to sandpainters is that women smiths did not teach in the 1930s. Thus, emphasis on the immediate family rather than the clan, the dominance of male teachers and entrepreneurs, friendship patterns, and convenience all affect the learning patterns of commercial crafts among the Navajos. These factors, in turn, affected how the new idea to make commercial sandpaintings spread across the reservation.

The Spread of Sandpainting in Time and Space

As in many crafts, the art of commercial sandpaintings spread slowly at first. Early painters had to learn the technical fea-

sibility of the medium and expand the small market. The beginning period was from 1962 to 1969. In 1970, a dramatic increase began. Commercial sandpainting had become an established craft which could support many painters. The number of new painters beginning each year rose until 1973 and remained almost constant until 1977, when the numbers began to decrease (Fig. 5.12). In all, 74 percent of all commercial sandpainters known in 1978 had learned their craft between 1970 and 1978 (Figs. 5.13, 5.14, 5.15, 5.16).

There was nothing unique about the location of the founding and spread of the craft of sandpainting. Although there was more likelihood that the craft would start to spread from a community on the eastern half of the reservation because of the marketing distribution of Indian art, the longer and more intense contact with Anglos, and the main north-south transportation route, it was pure historical accident that

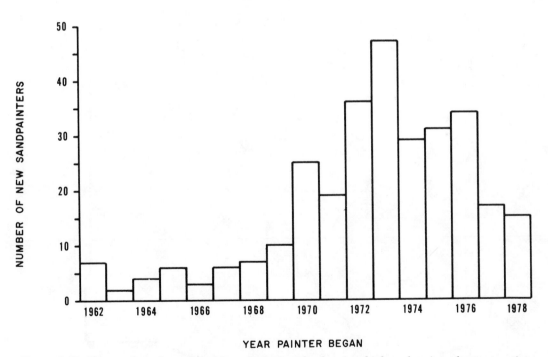

Figure 5.12. The number of commercial sandpaintings by date in which each painter began to paint.

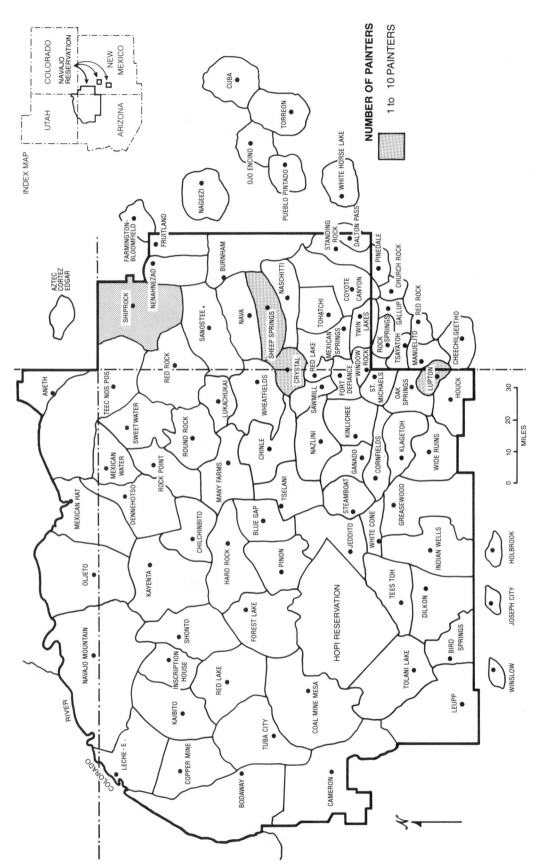

Figure 5.13 The Spread of Commercial Sandpainting: The number of sandpainters living in each Chapter Area in 1962. One painter lived off reservation.

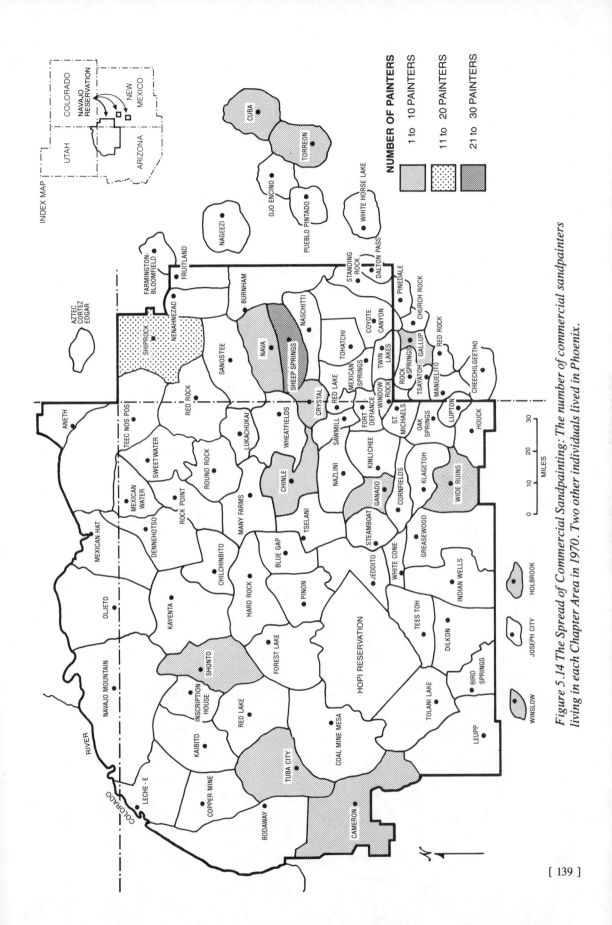

Figure 5.14 The Spread of Commercial Sandpainting: The number of commercial sandpainters living in each Chapter Area in 1970. Two other individuals lived in Phoenix.

NUMBER OF PAINTERS

1 to 10 PAINTERS

11 to 20 PAINTERS

21 to 30 PAINTERS

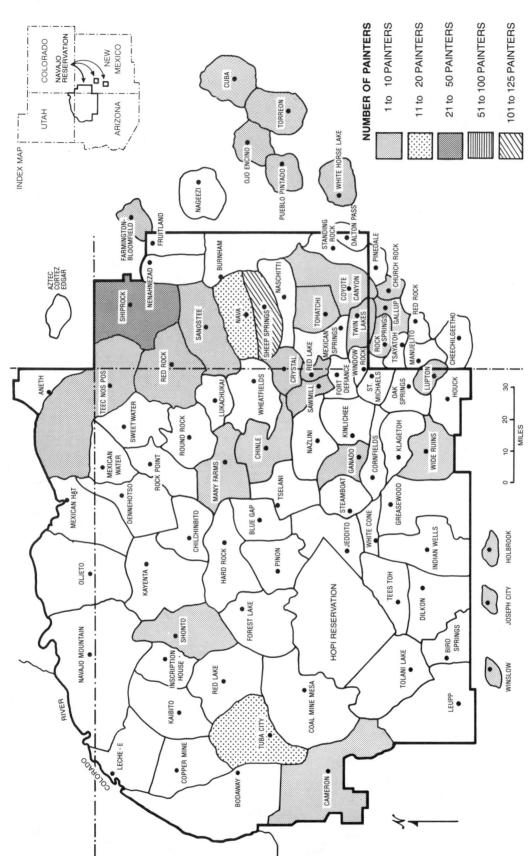

Figure 5.15 The Spread of Commercial Sandpainting: The number of commercial sandpainters living in each Chapter Area in 1975. Eight additional people lived in Phoenix.

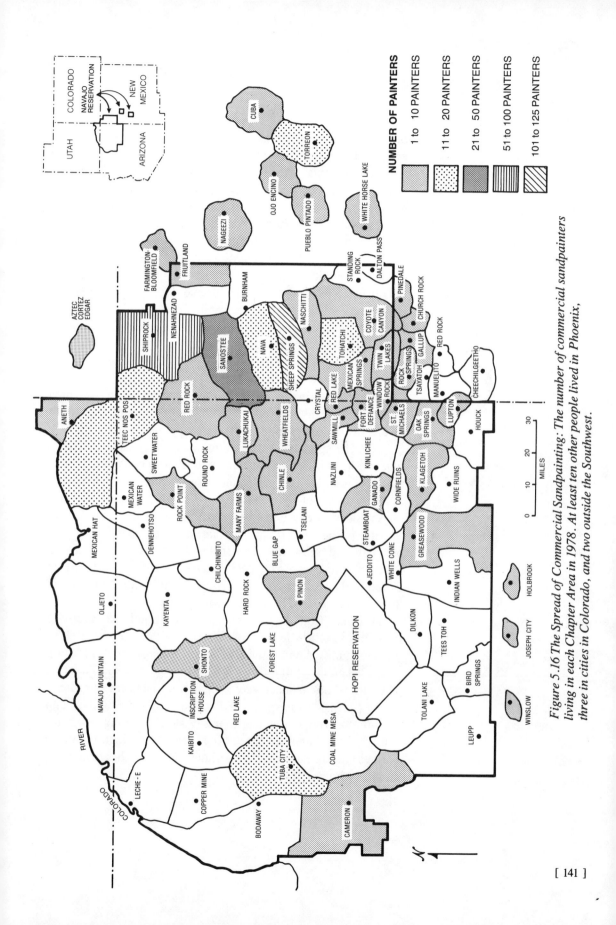

Figure 5.16 *The Spread of Commercial Sandpainting: The number of commercial sandpainters living in each Chapter Area in 1978. At least ten other people lived in Phoenix, three in cities in Colorado, and two outside the Southwest.*

NUMBER OF PAINTERS

1 to 10 PAINTERS
11 to 20 PAINTERS
21 to 50 PAINTERS
51 to 100 PAINTERS
101 to 125 PAINTERS

Sheep Springs was the initial community. It was certainly not because there were more singers than anywhere else on the reservation. It was only because this was the natal community of the founder. In 1978, Sheep Springs was still the home of more commercial sandpainters than any other community on the reservation, accounting for approximately one-third of all known painters. Another 30 individuals, who had grown up in Sheep Springs and learned how to paint there, had moved to other communities; their movements have been important in the diffusion of the craft. By 1978, two-fifths of all reservation communities had at least one sandpainter, another third had from two to six, while only 4 percent had twenty-five or more painters. These communities were located primarily in the east and southeast of the reservation as predicted. Since men tend to bring the craft into the home and it spreads from there, one can expect that in five years those communities represented will each have higher totals and that more communities both on and off the reservation will have sandpainters.

The spread of sandpainting has been spatially discontinuous: it is not geographical proximity between communities that accounts for this diffusion. Communities next to Sheep Springs were not the next ones to adopt the craft. Rather, dispersion was caused by the movements of individuals, reflecting primarily kinship and marriage ties, and secondarily occupational mobility. For instance, many individuals in Sheep Springs were related by marriage to people living in Torreon, New Mexico, an off-reservation community about 80 miles due east. The craft spread to this community in 1967 when a man from Sheep Springs married and moved to the home of his new wife in Torreon; it did not spread to Naschiti, the community directly south of Sheep Springs, however, until 1972. When the skill did reach Naschiti, it came via Phoenix. The earliest movements were primarily to the north and east of Sheep Springs along a major highway toward Shiprock and Farmington (important marketing centers) and not south toward Gallup (another marketing center), reflecting Sheep Springs' recent kinship and marriage patterns rather than proximity to wholesalers.

Commercial sandpainters moved off the reservation early (by 1965), but again via kinship relations. Very few moved, however, because they saw living in Anglo communities as an unavoidable necessity if they wanted to practice their craft. Thirteen percent of all sandpainters were found in 21 off-reservation communities in 1978. Almost half of these communities are composed exclusively of Navajos; the rest are settlements numerically dominated by Anglo-Americans. Since this percentage is slightly less than that for the tribe as a whole, the craft of sandpainting does not encourage out-migration. In fact, one of its major features is that it can be produced in the home so that producers can remain on the reservation. This is seen as an advantage by many sand-painters.

The dominant diffusion pattern, however, has been all over or haphazard geographically speaking, rather than along direct, radial lines. For example, by 1965, just through Leroy Stevens's teaching of a clan sister and her husband, the art moved off-reservation, to Phoenix, and later back onto the reservation at Cameron. From here, this one learning line went to Shonto-Black Mesa, then back to the eastern reservation at Tohatchi, proceeded to Shonto, and finally north to Mexican Water. Sometimes the knowledge would even come back to Sheep Springs so that a person did not learn from someone already living in Sheep Springs but from an acquaintance living elsewhere. For example, one learning line began in Sheep Springs when relatives visited, then traveled to Shiprock, went back to Sheep Springs and then east to Crownpoint. This pattern of dispersal has remained the same since the craft began and it, and the mechanisms which produced it, will remain the same in the future. Since learning is overwhelmingly informal and relaxed, and one can pick up the fundamental techniques rapidly, learning in the future will exemplify existing interaction patterns. Thus, while one can predict that the idea of making commercial sandpaintings will continue to spread, one cannot predict which community will be the next to borrow the art unless one knows the kinship and visiting patterns of the individual artisans involved.

Chapter 6

REASONS FOR LEARNING TO SANDPAINT

WHY PEOPLE DECIDE TO PRODUCE ART is a subject about which we have little knowledge. All too often researchers have focused only on the motivations of innovators, ignoring the majority of artisans, by assuming that the reasons for developing an art form are the same as the reasons for subsequently learning the craft through diffusion. For Navajo sandpainters this is definitely not the case. Motivations for becoming a sandpainter depend on when the artist began to paint—that is, whether the individual founded the craft, discovered it in its developmental stage, or started only after it had become firmly established. In addition, age and sex have a definite bearing on painter's motivations, as do such factors as education, recent employment history, religious affiliation, and previous art experience. Finally since all commercial sandpainters had been told that what they were doing or proposing to do was dangerous, their decisions were weighty. The reasons for becoming a commercial sandpainter were not trivial. These reasons are rational in both Navajo and Anglo-American value systems.

WHY NAVAJOS SANDPAINT

Although each sandpainter had distinctly personal reasons for beginning to paint, these reasons can be grouped into five basic categories—economic, social-cultural, aesthetic, pre-

servation of Navajo heritage and education of Anglos, and ease in production. In addition there were idiosyncratic reasons such as disability, liking to travel or using a gift of Mother Earth. These basic categories often overlap and are distinguished partially for heuristic purposes. While one third of all sandpainters gave numerous reasons for beginning to paint, economic considerations were overwhelmingly the dominant stimuli for beginning sandpainters (96 percent). Production of commercial sandpaintings is considered by Navajo painters to be a job which produces income much like any other occupation; rarely is it seen as a vocation. No sandpainter would continue to paint if he or she did not make money from the investment of time and effort.

The rubric economic motivations covered a great variety of reasons. The specific reason given by a painter correlated with the severity of his or her family's economic need. More than half the men and women surveyed began to paint because of critical economic necessity (see Appendix 8). Sandpainting became a main source of income for those who could not find work or whose jobs yielded extremely low wages. For example, one 22-year-old auto mechanic was making about $6,000 a year. He was also a competent easel artist in his spare time. At the urging of a retailer in Farmington, he tried sandpainting. By his second year he made a $10,000 profit that has increased as he has continued painting. Many mentioned as a reason for beginning to sandpaint an inability to compete with Anglos; others mentioned a lack of permanent employment. One man, caught in the typical Navajo pattern of a succession of temporary or seasonal, unskilled jobs interspersed with periods of unemployment, thought the extra money he could make from sandpainting would be his "security blanket," that is, his way of making a living the next time he was laid off.

For other Navajos sandpainting was seen as a potential income supplement rather than a means of earning a living. The most common reason for beginning to sandpaint was lack of spending money. Among others this group included individuals who were out of work but living in extended families. Some of these family members were steadily employed. Because of the strong sense of family as an economic unit, the

unemployed individuals were more likely to give reasons other than unemployment or acute need for beginning to make sandpaintings; the fact that they were unemployed might not surface until asked directly about unemployment. While others thought sandpainting income would be useful to pay utility bills, for example, more than one couple began in order to buy a pickup truck, while several young people viewed sandpainting as a means of saving money to finance college educations. Still others began because after watching their relatives earn good money from the craft, they felt there was nothing to lose by giving sandpainting a try. Others, living in families which existed at the poverty level, began making commercial art in order to purchase some of the luxuries and services available in the Anglo-American world.

Sheepherders were another group who viewed sandpainting as supplemental income. Whereas children were once the primary sheepherders, adults took over the responsibility when all children were required to attend school. Adult sheepherders found sandpainting an activity in which they could engage while the sheep were grazing. While an antidote to boredom, it was also a profitable pastime, and it offset to some extent the loss of an adult in the wage labor force.

Various social and cultural considerations were involved in many peoples' decisions to commence sandpainting. These were largely reflections of the general socio-economic situation on the Navajo Reservation, a desire to adhere to traditional social patterns, or more personal considerations such as liking to travel and a desire for independence, both reflections of important Navajo cultural values.

Some individuals found sandpainting an almost ideal occupation because of social reasons. Parents who want to stay home with their children and not rely on off-reservation employment which requires them to live without their families are one such group; the craft can even become a family project, with children enlisted to do simpler tasks. In fact, such social obligations were a quite common motive for beginning to paint. Wives often helped husbands who had too many orders to fill, as did some clan relatives and siblings. While the request was usually instigated by an overextended painter who needed assistance, altruistic motives also occurred. In one

case, a man feeling an obligation to help his unemployed brother-in-law regain his dignity offered to show him the technique. The brother-in-law started out helping grind sand, became a partner, and eventually set up his own business.

For those who were disabled or who found it necessary to remain in the home, sandpainting was also attractive. Young mothers with pre-school children who lacked alternative methods of child care and whose husbands pressured them to remain home and not seek outside employment found sandpainting to be an acceptable compromise. They could fulfill their obligations as mothers, minimize disharmony in the home, and still earn extra money.

For at least one woman sandpainting fulfilled an important social value—showing generosity and helping relatives. She specifically began to make sandpaintings in order to help her brother's family, thereby allowing her to meet kinship obligations. Another application of this same social value is manifested by young people who gave their reason for sandpainting as the wherewithal to take a brother to a movie or buy a present for a friend.

Sandpainting also allows many people to remain with relatives and friends in the area where they grew up and not have to compete in the Anglo-dominated world by themselves. This highly valued daily support and contact would be lost if a person was forced to go off the reservation for work. Sandpainters felt it an advantage not to have to face the hardships, discrimination, and lack of respect for their cultural values which living within Anglo communities often seems to entail.

Sandpainting allows people a great deal of independence. Married women who wanted more independence from their husbands could have their own cars and savings accounts. As one painter stated, no woman should be forced to rely on a man, for they are too unpredictable. In addition, both men and women see self-determinacy as an important cultural value and therefore find the idea of being self-employed and thus self-sufficient very attractive. For those who dislike having a foreman supervise them or who feel uncomfortable adhering to an eight-to-five work schedule, sandpainting provides freedom and the opportunity for the individual to control his time and productivity.

The pleasure and challenge derived from the act of creating a work of art are factors in the decision to continue painting, as well as a reason for starting. While to some it is a boring, necessary job, to others sandpainting is an art with its own aesthetic rewards. Artists find the challenge of making each new sandpainting better than the last includes not only improving one's technique in a difficult medium, but achieving a sense of self-expression and raising a positive emotional response in the buyer. Others wanted to be known as famous artists and saw the new field as one in which there would be minimal competition. The act of creating and the desire for aesthetic satisfaction was a very necessary part of becoming a sandpainter.

Sandpainting was also viewed as a pastime, something which would be fun to do when no other activities were available on a summer afternoon. Several painters also regarded it as a potentially relaxing hobby since the more mechanical steps would require little concentration. One man saw it as a means of escaping from everyday worries, while for others it was a profitable way to spend leisure time.

One advantage of commercial sandpainting is that it is easy to learn the basic techniques, and its practitioners quickly realize positive results. Extensive art training or acquisition of complex technical skills are not required to paint the most basic picture, not true for other skills such as pottery-making, for example. Ease of construction and neatness of the medium attract some painters. Initial expenses are minimal, since the only materials necessary are a small bottle of glue, a paint brush, and a piece of particle board, all of which could be purchased for about five dollars in the 1970s. Every painter sells his first painting and within weeks makes a small profit, an important consideration for individuals without a great deal of money.

Preservation of Navajo culture was a reason offered by founders and a few of the earliest sandpainters who were interviewed. These men and women saw permanent sandpainting as a way to actively preserve, explain and visualize Navajo culture. Storeowners mentioned that in the 1960s this concern was expressed fairly regularly by sandpainters so that it was a more widespread motivation than is indicated by figures in

Appendix 8. Early painters were often warned that their work was wrong and potentially dangerous. Several felt a strong need to justify their actions, both to themselves and to others, just as singers had done earlier in the century. Therefore, preservation was also a rationalization for actions which drew criticism. Of course, the painters who felt this way also painted because of the interest Anglo customers expressed in sandpaintings and Navajo religion. Although they wanted Navajos to buy their sandpaintings, Navajos were not interested in owning sandpaintings, even though many sandpainters tried to persuade their neighbors of the paintings' historic value. Ironically, this cultural knowledge will be left only with Anglos, and, if Navajos ever use it, it will have been filtered through Anglos.

None of the young sandpainters or those who began to paint after 1970 expressed this interest in saving Navajo religion. They thought so many sacred sandpaintings had been saved through museum collections and publication in anthropological books that the idea of preserving the religion as a conscious rationale for making the art and as a reason for starting to sandpaint was unnecessary. In fact, it was only because these books were available that many Navajos felt they could sandpaint since their attendance at curing ceremonials and familiarity with sandpaintings used in this traditional way was rare if not nonexistent. Moreover, one woman believed that she could become a sandpainter only because Navajo religion had already been preserved, using the same rationale expressed by sandpainters who would only make paintings copied from published reproductions (see Chapter 4 for discussion). These men and women would save their ethnic heritage but by other means. However, some noted that sandpaintings did teach Anglos about Navajo ways.

Several other sandpainters hoped that by making sandpaintings they could correct inaccuracies about Navajo religion found in the Anglo literature. In addition, it was seen as the duty of the sandpainter to help Anglos understand the concepts behind sacred sandpaintings or as one man said, "to let others see the beauty I see and understand." The belief behind this conviction lies in their ideas about the next world; that is, their concern that if only Anglos ascend to the next

world they must bear the sandpaintings and myths with them and their knowledge should be as accurate as possible. Permanent sandpaintings show what the gods look like, and produce emotions which convey the essence of Navajo world view. One woman believes this so strongly that her mission in life is to insure that this happens by producing sandpaintings to sell to Anglos. Meanwhile she hopes that by doing this she will also teach Anglos how to live in harmony with Mother Earth. This is an important goal in light of the belief that the end of the world may be brought about by the disregard of Anglos for Mother Earth and the laws of the universe. Her paintings, by blessing the homes in which they will hang, will automatically create a beautiful condition (i.e. hóẓǫ́) and hence, reestablish harmony.

A related but more general reason for starting to sandpaint is to express the "Indianness" of the painter. For one young man, painting showed what it meant to be a Navajo, as well as a Native American with a unique perspective on life based on his heritage. This was the closest any sandpainter came to expressing what can be interpreted as a concern for ethnic identity although all painters realized that their work sold well because it was handmade and produced by a Native American and hence by definition was exotic. Contrary to what had happened in many other groups, no painter began because sandpaintings were interpreted as a potential means to graphically display political or symbolic statements of the artists' right to a continued existence on earth. Neither did any sandpainter focus on the economic plight of the Navajos, as T. C. Cannon, for example, has often done in his easel art. Instead, using the traditional medium of sand, these men and women would show what it was like to be an idealized Indian. The resulting paintings depicted noncontroversial scenes from Navajo life such as men and women herding sheep or homogenized and romanticized creations of small, happy children in idyllic situations. The paintings were seen as an avenue for expressing the artist's feelings about the past, especially the fondest memories from childhood and were made, therefore, to give continuity to the past, present, and future.

ANALYSIS OF NAVAJOS' RESPONSES

Navajo sandpainters can be divided into those who took up the craft in an initial, developmental period from 1962 to 1969 (47 individuals), and those who learned after 1970 (246) when, following the success of earlier painters, a demand for the craft had been established. This division influenced the patterning of the reasons for beginning to paint as will be seen below (see Table 6.1). A single economic reason

TABLE 6.1
Reasons for Starting to Sandpaint by Time Period

Reasons for Starting	Developmental (Pre-1969)		Time Period Established (after 1970)		Total	
	N	%	N	%	N	%
Economics only	16	35.6	176	71.5	192	66.0
Economic and social only	16	35.6	40	16.3	56	19.2
Economic and other reasons*	11	24.4	21	8.5	32	11.0
Social only	1	2.2	7	2.8	8	2.7
Social and other reasons**	1	2.2	1	0.4	2	0.7
Aesthetics only	—		1	0.4	1	0.3
Totals	45	100.0	246	99.9	291	99.9

No data on time period, Men: 3 have economic reasons only, one has social only, 1 has economic and other combined.
Women: 2 have economics only, 4 have economics and social.
 * Other reasons include ethnic heritage, aesthetics, ease, and/or social combined with economic motivations.
** Other reasons include ethnic heritage, ease and/or aesthetics combined with social motivations.

was twice as likely to be given by painters who started in the established period as by those who began in the developmental period. An economic reason combined with other reasons was, conversely, more common in the earlier period. The reason for this change can be found in the attitude of other Navajos

toward permanent sandpaintings. As mentioned above, peer pressure was more vocal in the early period than the established period. Early painters needed more than one reason for becoming a sandpainter in order to justify their actions to themselves and their neighbors. The developmental period was also necessarily less stable than the post-1970 era because early painters had to create or expand an unpredictable market. They had to ascertain customers' preferences and modify their designs to meet variable demands. Many early painters had to persuade the owners of curio shops and Indian arts and crafts stores even to stock sandpaintings. In fact, traders (the individuals who had always bought rugs and silver jewelry) refused to buy sandpaintings, fearing that other Navajos would refuse to buy from the store if they saw the sandpaintings. Thus, while economic necessity was always an important reason for becoming a sandpainter, by itself it was unacceptable and was, therefore, often cushioned with social or aesthetic motivations as well as with the expressed desire to save Navajo culture and educate Anglos. This is not to imply that early painters were insincere; rather it points to the various kinds of pressures which gave rise to the need of the pioneers in the craft to rationalize.

Within ten years, this situation had changed, and sandpainting had become a success. It was thoroughly established in Sheep Springs and Shiprock and was moving rapidly to other parts of the reservation. Demand was steady and expanding, and new types of markets were being tapped. The number of sandpainters was increasing, and a major factor that had restrained people from pursuing the craft—threats of sickness and supernatural wrath—was lessening. Although people occasionally were told that it was wrong to reproduce sacred sandpaintings, the pressure had eased tremendously. Perhaps because of this, the additional reasons for beginning to paint, especially that of saving Navajo religion, were no longer mentioned. It became acceptable to say that one began to sandpaint simply because one needed money. Thus economic necessity, which had been evident from the beginning, now became prominent with no mask of other motivations to hide it.

The kinds of economic reasons painters gave were fairly similar in both the developmental and established periods (see Appendix 8), although a few more people in the later period said that they needed spending money or had a general need for money. The percentage of those stating unemployment as the immediate catalyst for starting to paint was the same in both periods, as was the number of those who desired to save money for education, to purchase cars, appliances or other costly items, or to have more money than a present job paid. The idea that "good money" could be made was unexpectedly higher in the developmental period than in the later period. The explanation lies, perhaps, in the fact that early painters were producing large, complex and detailed works of ceremonial sandpaintings which netted them more money per painting than souvenir art. Finally, competition also may have been keener as the number of painters increased in the 1970s so that while painters made money it may not have been considered good money; several painters mentioned that after 1970 they did not make as much per painting as they did earlier because storeowners could control prices.

Social reasons (often coupled with economics) were more prevalent in the developmental period, primarily because many more people began painting to help an established painter. Other social considerations were fairly equally represented in both periods, but the desire for independence was expressed more often in the earlier than later period. Feelings of not wanting to travel off the reservation, however, were mentioned only by painters who began after 1970, a shift not readily explainable. Social and aesthetic considerations as sole reasons were equally rare in both periods, while a concern with ease of manufacture, ethnic heritage, and education did not occur independently in either.

Aesthetic considerations, combined with other rationales for starting to paint, diminished as the craft of sandpainting matured. Within the category an interesting shift occurred which reflects marketing developments. All the painters who started between 1962 and 1969 and mentioned aesthetic reasons produced complex and detailed reproduc-

tions. For those making souvenirs aesthetics was not an impor-
tant consideration. Likewise those who began because of a
wish for fame or because they had an artistic gift from Mother
Earth began in the earlier period. Conversely, all those who
started to paint because they needed a relaxing hobby or sim-
ply a fun way to fill leisure hours began in the second period;
none of these individuals made technically demanding art.

Reasons for starting, therefore, changed with time. In
the developmental period the number of reasons given by any
one person and the number of different kinds of reasons was
much more extensive than in the established period. As the art
form evolved, supplemental reasons were eliminated and
economics gradually became the main reason for sandpainting,
a trend which is likely to persist in the coming years.

Just as the time when an artisan adopts a craft is a
crucial variable in understanding why Navajos became sand-
painters, sex of the sandpainter also had a subtle influence.
The driving force of economic necessity was the same for
men and women (Table 6.2). Men, however, secondarily

TABLE 6.2.
Reasons for Starting to Sandpaint by Sex of Maker

| | Sex of Maker | | | | | |
| | Male | | Female | | Total | |
Reasons for Starting	N	%	N	%	N	%
Economics only	101	68.2	91	63.6	192	66.0
Economics and social only	18	12.2	38	26.6	56	19.2
Economic and other reasons*	25	16.9	7	4.9	32	11.0
Social only	3	2.0	5	3.5	8	2.7
Social and other reasons**	—		2	1.4	2	0.7
Aesthetics only	1	0.7	—		1	0.3
Totals	148	100.0	143	100.0	291	99.9

 * Other reasons include ethnic heritage, aesthetics, ease, and/or social
 combined with economic motivations.
** Other reasons include ethnic heritage, ease, and/or aesthetics combined
 with social motivations.

mentioned aesthetic considerations while women's reasons were more often colored by social concerns, especially an expressed need to stay home and care for children. Women also wanted to help relatives and to have greater independence. Interestingly, other social reasons such as disability, boredom, or a desire to stay on the reservation were similar for both sexes.

Aesthetic satisfaction, a desire for fame, and ease of manufacture were also reasons mentioned equally by both sexes. The idea that sandpainting was fun was stated slightly more often by women than men, while the notion that painting would make an interesting, relaxing hobby was more often a motivator for men. It is not surprising that more men than women mentioned that they were concerned with saving Navajo religion. These men all saw themselves as carrying on in a modified form the traditional role of an elder male as the keeper of ceremonial and historical knowledge. Within the general category of economic motivation women were more likely to express needs for supplemental sources of money and a need to pay basic household expenses while men were more likely to start painting because of unemployment.

Looking at the responses of men and women with regard to when they started to paint, it becomes apparent that differences due to sex diminished as the craft became established. While men were always more likely to have an isolated economic reason and women were more likely to combine social and economic causes, the percentage difference between the two sexes has decreased. This subtle pattern of an increase in similarity with time is more evident when the individual reasons listed in Appendix 8 are compared. Because of the great disparity in sample sizes between the established and developmental periods, however, it cannot be asserted conclusively that this trend toward agreement *is* occurring. A strong basis exists, however, to predict that if the study had continued and included the next new group of sandpainters, this would be the case.

This prediction is based partly on the theory that the reasons given by painters for becoming artisans are stabilizing with the growing prevalence of only economic necessity as a

motivating force. For both sexes, economics as the sole reason for beginning to paint increased dramatically, nearly doubling from the developmental to the established period, while other combinations of reasons fell for both sexes. Whether this trend will continue into the future will require time and further study. What this study accomplished is to establish a trend for both men and women and a rate of change.

Still another variable which should be considered is age. Navajo sandpainters, in general, are a young population, suggesting that the craft has a potentially promising future. The majority of painters of both sexes and both time periods learned to sandpaint in their twenties and thirties; rarely were painters under ten years of age or over fifty. Table 6.3 summarizes data on the age of the painter when he or she began to paint and reasons for starting. Ages have been grouped into

TABLE 6.3
Reasons for Starting to Sandpaint by Age of Painter

Reason for Starting	Age Group								
	8–18 N	%	19–29 N	%	30–39 N	%	40+ N	%	Total N
Economics only	40	(45.5)	65	(70.7)	31	(70.5)	21	(65.6)	157
Social only	4	(4.5)	3	(3.3)	1	(2.3)	—		8
Aesthetic only	—		—		1	(2.3)	—		1
Economic and social	27	(30.7)	17	(18.5)	7	(15.9)	6	(18.8)	57
Economic and other	16	(18.2)	7	(7.6)	3	(6.8)	5	(15.6)	31
Social and other	1	(1.1)	—		1	(2.3)	—		2
Total	88	(100)	92	(100)	44	(100)	32	(100)	256

roughly ten-year intervals with the first period ending at the age of high school graduation. As would be expected, not until painters are out of school does economic necessity dominate as the sole reason for painting. Before this, neophytes are more concerned with having extra spending money and help-

ing relatives, especially parents, paint, than having to support themselves and a family. (As would be expected 76 percent of painters under 18 were taught by parents and older siblings.) Aesthetics combined with economic motivations also are prominent for young painters who thought sandpainting would be a pleasant way to spend an afternoon. Upon completion of high school, these young painters would either use sand-painting as a productive hobby or opt for it as a full-time occupation.

Men and women who started to paint in their twenties and thirties gave similar reasons for taking up the craft—economic necessity being the most important, of course. If any supplementary reasons were given, they were social considerations. This is the period in life when women most often stay home and raise children while men begin to come to grips with problems of under- and unemployment. Helping a spouse was also a common reason given by this age group, whereas it was noted only twice by individuals over forty. For these older painters, having to care for sheep and wanting to remain on the reservation replaced other social considerations. Also, the painters of this age group, especially men, were concerned with saving Navajo religion.

In addition, other factors such as level of education, recent employment history, previous art experience and train-ing, and religious affiliation were correlated with reasons for starting to sandpaint and showed, simultaneously, that the decision to become a sandpainter was a carefully thought out one and rational given the socio-economic conditions on the reservation.

As expected, religious beliefs and affiliations affected how sandpainters viewed their craft as well as their motiva-tions for becoming a sandpainter. Navajos are becoming in-creasingly heterogeneous in terms of religious beliefs. Navajo religion still endures, and belief in witches and ghosts does not appear to be lessening, but many Navajos belong to Christian churches or the Native American Church (peyotism). While early attempts to convert Navajos to Christianity did not meet with great success, by the 1950s seventeen different Christian churches and sects were actively proselytizing in more than 76

missions (Young 1961:525). Today there are five basic religious orientations available to Navajos: traditional (defined as adherence to Navajo beliefs and attendance at Navajo curing ceremonies), major Christian churches, Mormonism, fundamentalist or evangelical Christian sects, and the Native American Church (a nativistic religion introduced in the 1930s). The major Christian churches and Mormons do not require rejection of traditional religious beliefs, but the Fundamentalists, who emphasize conversion experiences, do. Fundamentalist meetings are in many ways reminiscent of traditional ceremonies and emphasize curing in the idea of salvation through supernatural visitation. The Native American Church also emphasizes curing but does not require repudiation of traditional or Christian religions. Religious orientations tend to follow family and residential lines, but the Navajos' emphasis on individuals and freedom of choice means that members of a household may be quite independent.

Like most Navajos, sandpainters ranged between traditionalists and fundamentalists (see Appendix 9), but most did not identify themselves as dedicated solely to and participating exclusively in traditional religious practices. Most painters had become affiliated with Christian churches or the Native American Church before beginning to paint. Frequently, painters stated that they were affiliated with two religions, for example, traditional combined with Catholicism. Half of all sandpainters felt that they were solely Christian, and several who were fundamentalists vehemently opposed Navajo traditional beliefs, calling them superstitions. These men and women were offended when asked if they attended curing ceremonies and felt that the old gods were "dead." They felt no affinity with the figures they produced on particle board and saw sandpaintings in a completely pragmatic light. These extreme anti-traditionalists primarily began in the established period, and became painters for purely economic reasons.

Other sandpainters were more tolerant. While professing a basic Christian orientation, they were either indifferent to traditional beliefs or tried to combine the two systems feeling that the systems were not mutually exclusive but expressed

different types of power and knowledge. According to these men and women what one believed was an individual decision. These painters were represented in both the developmental and established periods and their religious affiliation did not have an immediately apparent effect on the reasons they gave for becoming sandpainters. Traditionalists, on the other hand, usually began in the developmental period rather than the established period. It was these traditionalists who were more likely to feel they began to paint in order to save Navajo religion. No one who did not believe at least partly in traditional ways saw preservation of Navajo culture as a reason for making sandpaintings.

Another measure of religious behavior was attendance at a Navajo curing ceremony in the recent years. Only 10 percent of commercial sandpainters interviewed had attended a curing ceremony between 1976 and 1978. Several other sandpainters had attended ceremonies earlier in their lives, but not in the last ten or fifteen years. A few men had helped make sacred sandpaintings in the past but most had not helped since they had converted to fundamentalist sects. Most young sandpainters as well as several of the adults had never seen a sandpainting used in a curing ceremony. In short, few commercial sandpainters had extensive ceremonial knowledge, almost none had close relatives who were singers, and only eight besides those who were singers ever had been a patient at a ceremony. These were mainly girls' puberty ceremonies, Blessingways, or Enemyways. This lack of intimacy with sacred sandpaintings means that most commercial sandpainters must rely on published sources for their motifs.

There was a basic dichotomy between those few Navajos with ceremonial knowledge and those without in the reasons given for becoming sandpainters. Those without traditional knowledge were much more likely to give only a single economic reason for starting while those with ceremonial knowledge were more likely to give multiple social, aesthetic and preservation reasons combined with economic necessity.

Navajo sandpainters are not a unique group. Sandpainters are keeping pace with other Navajos in terms of increased familiarity with Anglo life styles and higher levels of formalized education. Just as Sheep Springs was a typical

Navajo community without any exceptional traits such as a high concentration of singers to make it a more likely birthplace for the craft, neither were there any demographic features which distinguished sandpainters as a special group from the general Navajo population.

Only three of the oldest sandpainters did not have an excellent command of English, and several of those who had spent their adolescent years in schools far away from the reservation often had trouble speaking Navajo. While the number of sandpainters graduating from high school is slightly higher than for the Navajo tribe as a whole (Appendix 10) the median level of attainment is the same. Thus sandpainters, like other Navajos, do not have the formal academic credentials or skills necessary to compete for high-paying jobs. Younger sandpainters, like younger Navajos in general (i.e., those under 25 years of age), are completing more years of formal education than their elders. This means that younger painters are choosing sandpainting as an occupation for its relative economic advantage and for social reasons, rather than because they are unemployed or qualified only for manual labor.

Few Navajo sandpainters, in any age category, have formal training in skilled occupations, including formal art training. Those few who had such training began to paint as a paying hobby or for aesthetic reasons rather than because of economic necessity.

Interestingly, regardless of age, painters who began before 1969 were slightly more highly educated than those who began after 1970. This coincides with the finding that the oldest painters in terms of age began in the established period, and helps explain why painters in the established period were more often unemployed than early painters, a fact discussed later in the chapter. All groups, however, spent at least one year in off-reservation schools and all of those who graduated from high school went off-reservation for their education. Thus sandpainters have all had a fair amount of contact with Anglos, pointing to the fact that sandpainters are not the most conservative or the most isolated Navajos. Nevertheless, painters with more education spent more time in the Anglo world, gaining firsthand experience of Anglo tastes. Thus it is

reasonable that the painters in the developmental period—that time which required ingenuity and intimate knowledge of potential customers—were more highly educated than later painters. It may well be that those who develop crafts which are intended for customers not belonging to the maker's culture will have to have spent some time in the customer's society. Those who start only after the craft is established do not necessarily need this type of acquaintance but can ride on the success of others if they so choose. The difference in levels of educational attainment by Navajo sandpainters is a reflection of this idea.

Reasons people give for their actions, like cultural ideals, do not always coincide with their behavior or the reality of their situations. However, with Navajo sandpainters this is not the case. The kinds of jobs (or lack of them) that painters held the year before they began to paint, clearly showed why economic motivations were the most common reasons for beginning to paint (Appendix 11). Sandpainting was an alternative to unemployment rather than an alternative occupation. Only one quarter of all sandpainters held any type of job some time during the year they began to paint, and even eliminating from the sample those who are under 18 and still in school raises the figure to just over one third. This unemployment rate among sandpainters is roughly similar to that for Navajos in general. In the 1970 census, 68 percent of all Navajos 16 years of age or older lacked a means of producing income (U.S. Bureau of Census 1973: Table 13). In addition, for sandpainters this bleak situation worsened with time; there were more unemployed men and women who began painting after 1970 than there were in the developmental era. This fact helps explain why single economic motivations became the predominant reason for becoming sandpainters in the established period. Motivations were a reflection of reality; men and women had to find new economic alternatives.

Those who were employed before they began to paint generally had very low-paying jobs; only eight held skilled jobs. Several individuals were actively engaged in sheep herding, but none had a large enough herd to ensure self-sufficiency. Navajo sandpainters differed from the general

Navajo population in that none were employed by the federal government in bureaucratic, white collar, or supervisory jobs and the only sandpainters employed by the tribal government were lumberjacks. One can theorize that those who were employed by the government did not need the money which could be made by becoming a sandpainter because they had steady well-paying jobs and hence they had no need to become sandpainters.

By 1978 only five sandpainters still received any type of welfare payments, showing what a successful economic venture sandpaintings had become. Some painters had become so prosperous that several had earned over $20,000 a year for several years and one had earned over $60,000. While most painters do not earn nearly this much, income figures (Table 6.4) do show unequivocally that sandpainters were able to earn a good wage. Sandpainting is a worthwhile occupation.

TABLE 6.4
Income Levels for Contemporary Sandpainters* in 1976

Income Level	Full-time Painters		Part-time Painters		Total
	N	%	N	%	N
Less than $500	—	—	12	33.3	12
$501–1000	—	—	7	19.4	7
$1,001–5,000	12	27.9	10	27.8	22
$5,001–10,000	9	20.9	3	8.3	12
$10,001–15,000	15	34.9	3	8.3	18
$15,001 or more	7	16.3	1	2.8	8
Totals	43	100.0	36	99.9	79

Mean income before expenses for all sandpainters = $6845.
Median income before expenses for all sandpainters = $2500.
Mean income before expenses for full-time painters = $9659.
Median income before expense for part-time painters = $3307.

*All figures are for individuals. Some families make sandpaintings as a family operation and do not distinguish how much each person makes. The figures given by families were divided by the number of people who were actively painting and counted only once. Since most Navajos do not keep records of how much they make in a given year, nor is this an important concern, figures given were only estimates. These estimates were checked against the number of paintings produced by these individuals in 1977 and 1978. Since the sandpainting market is variable from year to year, and the quantity of paintings produced by any one individual varies annually as well as seasonally, these figures would not necessarily be the same in any other year. The general range is, however, representative.

The amount of income a painter receives from sandpainting is primarily dependent on whether the painter choose full- or part-time production. This is equally true for both men and women. A slight correlation exists, however, between the time period in which a painter began to paint and the income level of the individual, partly because as already mentioned, earlier painters tended to produce large and complex compositions. These painters earned more on the average than those who made only souvenirs. Teenagers tended to produce on a part-time basis due to school requirements as did men and women who retained seasonal jobs in addition to their painting. Many painters did not want to paint on a full-time basis because they felt the market too precarious. They would rather retain the flexibility which could be found in several part-time or seasonal jobs which they could combine with sandpainting.

Potential income from the sale of arts and crafts was thus seen as an important economic advantage to the household of Navajo sandpainters. However, sandpainters had previously not utilized this option of craft production, even though it was an accepted cog in the Navajo economic system. Those who had engaged in other crafts, such as silversmithing, oil painting, pottery-making, weaving or producing cedar bead necklaces, had generally ceased for various reasons several years before they became sandpainters. Thus sandpainters were adding a new strategy to their mixed economic base rather than replacing one craft with a more profitable one. Once again, they were increasing their flexibility, a very rational move as the Navajo sandpainters saw it. The emphasis on flexibility was also important in the overall economic development of the craft.

Chapter 7

THE ECONOMIC DEVELOPMENT OF COMMERCIAL SANDPAINTING

SANDPAINTINGS NOW FUNCTIONED as a cottage industry, a basic or supplemental source of income for Navajo households, and as a part of the international market in luxury items and ethnic art. Their development was partly a response to a market economy by peoples who had few resources besides raw materials, unskilled labor, and ethnic art to give to the larger society in exchange for goods and services. The success of commercial sandpaintings was a result of the increasing demand by Anglo-Americans, Europeans, and others for exotic and handmade art forms and of the flexibility and ingenuity of Navajo sandpainters in their marketing practices.

DEVELOPMENT OF SUBMARKETS

As sales of commercial sandpaintings were rising in the 1960s and early 1970s, into even the international realm, three submarkets developed within the general ethnic art market which can be delineated, albeit somewhat arbitrarily, by the size, price, and artistic qualities of the sandpainting. They are the tourist and souvenir market, the gift and home-decoration market, and the fine-art and reproduction market.

The souvenir market consists of small, inexpensive paintings usually purchased by middle-class Anglos as remembrances of a trip to the Southwest (Fig. 7.1). These paintings generally cost from 2 to 15 dollars and range in size from

Fig. 7.1

Figure 7.1 "Mesa" by Jonah Yazzie, Sanostee. This painting made in 1978 is representative of tourist and souvenir art. Earth tones have been used to capture the colors of the mesa country at sunset. Size: 4" x 6". Price: $4.

2 x 2 to 8 x 8 inches (see Appendix 1). Painters mass produce these and can make as many as sixty paintings in a day. The designs are highly stylized and standardized by using stencils; decoration is minimal and rapidly drawn, lacking intricate detail. A few rocks such as turquoise, which must be purchased, are rarely used so these paintings are much truer to the subdued, earthtone colors of sacred sandpaintings. This simplicity is due not to religious purism but to economics and size limitations; painters do not make enough per painting to justify the time and expense needed to make more complex paintings.

The simple designs overwhelmingly consist of single-figure Holy People, usually so generalized as to be impossible to identify with any specific figure from a chant. A basic Shootingway headdress is commonly used, and if any objects are held in the hand they are the standard round rattle or three evergreen boughs (see Fig. 4.4). Slight changes in color are the only distinguishing characteristics. This basic composition shows the isolation of the most typical aspect of sacred sandpaintings. Other sacred sandpainting motifs seen in tourist and souvenir paintings include single figure plants, depictions of the sun and moon, animals, and anthropomorphic figures of Thunder, Mother Earth and Father Sky. Subject matter taken from nonsandpainting sources is rare.

The tourist and souvenir market is a recent phenomenon, a product of the 1970s and of the rapid rise in popularity of Indian arts and crafts in the national luxury item market (Table 7.1). As the price of rugs and jewelry increased phenomenally when it was discovered that they were an investment, a vacuum was left for medium- and low-priced goods. A

TABLE 7.1
Submarket Specialization by Sex of Painter and Date of Starting

| | Sex of Painter | | | | Time Period | | | | |
| | Males | | Females | | 1962–1969 | | 1970–1978 | | Total |
Submarket	N	%	N	%	N	%	N	%	
Tourist and Souvenirs	24	(19.5)	39	(37.1)	1	(2.6)	62	(32.6)	63
Gift-home decoration	74	(60.2)	51	(48.6)	22	(57.9)	103	(54.2)	125
Reproductions-Fine art	25	(20.3)	15	(14.3)	15	(39.5)	25	(13.2)	40
Total	123	(100)	105	(100)	38	(100)	190	(100)	228

number of crafts including ojos, beadwork, cedar beads, pottery, yarn baskets, and saindpainting began to be made by Navajos in a response to this new demand. Commercial sandpaintings partially filled this vacuum; because they were easily scaled down and durable, they proved especially suitable for tourist souvenirs. While customers did not understand the symbolism, the sandpaintings met their concepts of Indian art in that they were standardized, lacked perspective, were static, and had dull colors without shading.

Nearly one-third of the sandpainters specialized in souvenir art, although some occasionally made larger and more complex paintings aimed at the other two submarkets. More women than men produced souvenir art.

The sale of souvenir sandpainting varies with the tourist season and location of the shop. In Scottsdale and Tucson, summer is extremely slow, but it is the most active sales season at places like Santa Fe, Taos and the Grand

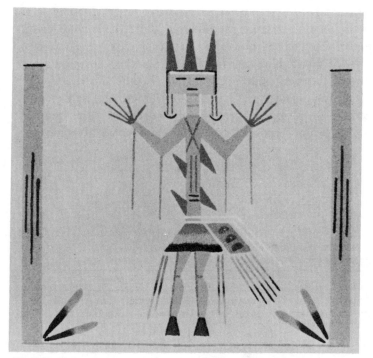

Fig. 7.2

Figure 7.2 "Holy Person in Armor" by Harry A. Begay, Sheep Springs, 1977. This painting of a generalized Holy Person in armor (the triangles projecting from the sides of the torso) is characteristic of sandpaintings made for the gift and home decoration market. The guardian which has been placed around the central figure (based on the Flint-armored Holy People from Female Shootingway) has been made in muted earth tones rather than as a specific figure. Size: 12" x 12". Price: $24.

Canyon. While tourists of all age groups and from all parts of the country are the major buyers of souvenir paintings, some retailers felt that the tourists interested in sandpainting were more likely to be knowledgeable about the Southwest than the average tourist and better understood the sandpaintings' basic meanings.

Further along the continuum toward larger, slightly more expensive and complex paintings are those produced for the gift and home-decoration market (Fig. 7.2). The largest market, it has the widest appeal to potential buyers because it has the greatest potential uses. Gift and home-decoration paintings are usually either 6 x 12 or 12 x 12 inches, although other sizes are made. They contain varying degrees of decoration, generally more than tourist and souvenir paintings, and sell

from 15 to 125 dollars, depending on size. While designs are standardized (stencils are used), they do contain more variety and detail. Most painters can make five to ten paintings a day in this medium-size range. Paintings tend to have muted colors to complement a Southwest decor.

While three-fourths of these paintings have traditional designs, fewer single-figure Holy People are drawn than in souvenir paintings (Appendix 1). More full sandpainting compositions appear, primarily because in a larger painting there is more room for detail. This factor also leads to more experimentation with nonsandpainting subjects, such as yeibichai dancers, human figures, plants, animals and pottery (Table 7.2). Painters have recently begun experimenting with color.

TABLE 7.2
Type of Subject Matter by Submarket for Commercial sandpainters

Type of Subject Matter Made by Sandpainters	**Type of Submarket**						
	Tourist and Souvenir		**Gift and Home Decoration**		**Fine Art and Reproductions**		**Total**
	N	%	N	%	N	%	
Traditional only	73	(56.6)	101	(47.7)	43	(66.2)	217
Both types	45	(34.9)	82	(38.5)	8	(12.3)	135
Non-traditional only	11	(8.5)	30	(14.1)	14	(21.5)	55
Totals	129		213		65		407

Customers of this size painting are as likely to be local Anglo residents as tourists. The peak season for local residents is Christmas, although these paintings are also bought during the rest of the year as decorator items. Businesses and interior decorators have tapped this mid-range market since the early 1960s as well.

The majority of sandpainters produce for the gift and home-decoration market. More men than women tend to produce these medium-sized paintings. The period in which a person began to paint (either pre- or post-1970) did not have a bearing on how many painters produced for this market.

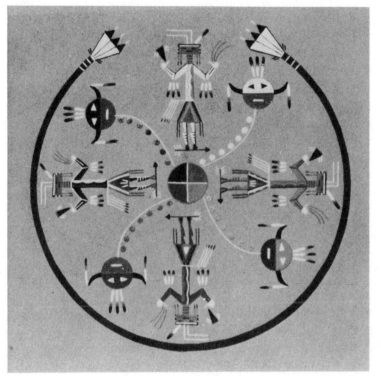

Figure 7.3 "People Bringing Down the Sun from Shooting- way" by Joe A. Begay, Sheep Springs, 1979. This is an ex- ample of a full sandpainting reproduction. While there are changes in the composition for religious, economic and aesthe- tic reasons, the painting is easily named and identified by chant. Few figures have been elimi- nated and the layout and style have remained the same. This painting was adapted from Newcomb and Reichard (1975). Size: 24" x 24". Price: $95.

Fig. 7.3

At the other extreme from the tourist market in size, complexity, and price is the fine art and sandpainting repro- duction market. This category includes large, highly deco- rated, elaborate reproductions of ceremonial sandpaintings (Fig. 7.3). In addition, some of the work, because of subject matter, layout, and artistic devices, is conceptualized as "art," using sand as its medium. While reproductions were the first type of paintings to be made, it was only after 1976 that sandpainters tried to produce fine art. The individuals producing for this market in 1978 were primarily the first sandpainters and their offspring.

Reproductions can be identified by chant, with the commercial paintings' composition and general layout the same as in the sacred sandpainting associated with that chant.

Figures are more specific than in the tourist and home-decoration markets, with great emphasis on accuracy. The simplified designs found in the first two submarkets are not found in these paintings. The most common size is 24 x 24 inches, although some are as large as 48 x 48 inches.

Those paintings that are considered fine art, while they still reflect Indian themes, embody European-based aesthetic concepts and artistic methods. Still lifes (Fig. 7.4), portraits, landscapes, and more symbolic subject matter are to be found in these well-crafted, more creative pieces, often combined with traditional motifs (Table 7.2). They take much longer to produce (from three days to four or five weeks) because painters often do not use stencils, do take extra care with craftsmanship and many times experiment with shading. Consequently they are higher priced, ranging from 150 to 1000 dollars, with a few selling for up to 3200 dollars. Fewer men and women make these complex compositions and reproductions because of the greater skill required. In 1978 most were still producing reproductions, reflecting the continued importance of traditional sandpainting subject matter. The growing number of painters who make only nontraditional paintings reflects the increasing use of sandpaintings as a creative art medium in this market. It is also an indication that some painters are tired of producing paintings which stress accuracy and standardization rather than creativity. As this redefinition of sandpainting as a fine art occurs, it is likely that more painters who produce for this submarket will turn to using sandpainting as an artistic medium rather than as a reproduction technique. Because of the different skills needed to make fine art as opposed to sandpainting reproductions, it is very likely that painters will increasingly specialize in the future.

Even though sandpainting has been edging into the fine art market since 1976, sandpainters are having a difficult time crossing the boundary between craft and art. Sandpainting has not been a form that enjoyed high demand among art collectors; only two people have collected sandpaintings and have done so in order to have examples from different chants as much as for the aesthetic appeal of the medium. A number of factors explain this. First, sandpainting is still considered

Figure 7.4 "Still Life" by Eugene Joe, Shiprock, 1978. Shown at the New Mexico State Fair, this painting is an example of the attempts made by some sandpainters to move Navajo sandpaintings into the realm of fine art. Still life figures are often drawn from the crafts of Navajo, Apache, and neighboring Pueblo groups. Here a Zuni bear fetish is placed on top of a Tony Da pot and a Hopi-style sun. A piece of turquoise has been placed in the matte finish section of the pot. Size: 18" x 12". Price: $675.

Fig. 7.4

a craft by the majority of customers, merchants, and even artisans themselves. It has been seen as a preservation technique rather than an art. No accepted criteria exist to evaluate sandpainting as art. Commercial sandpainting is still rarely judged at Native American art shows, and organizers of juried shows will not let the sandpainters enter the fine art divisions. As yet there are few named artists, a situation acceptable by western standards for a craft, in which anonymity

of the maker is expected, but not for fine art. Paradoxically, it is the nature of sandpaintings themselves that keep them from becoming collector's items. Their power and appeal is in static repetition and correctness. Authenticity rather than creativity is their trademark; on first glance commercial sandpaintings look remarkably alike, and the western concept of art, based on uniqueness and ability to evoke an emotional response, is simply not applicable in sandpaintings based on a sacred prototype. Sandpainters who make non-traditional paintings in sand will more easily break through this barrier.

Art collectors have looked upon sandpaintings as a dubious investment. This is partly due to the newness of the craft; unlike some rugs or pottery sandpaintings have no value as antiques. Sandpaintings have not risen strikingly in price, although inflation has changed the situation since 1978. An average 24" x 24" painting sold for $100 in 1965 and 1975 and in 1979 had risen to $150. In 1981 sandpaintings were sold for the first time at a major art auction, but owners had little upon which to base the resale value of the paintings and most did not settle for the estimated price. Another problem is that so many sandpaintings are sold for the gift and home-decoration and souvenir submarkets that this has kept prices of all sandpaintings down, including those which are one-of-a-kind compositions. Thus the established marketing structure for sandpaintings hinders this quest to tap the art market; sandpaintings are only now beginning to catch up with established crafts which saw a dramatic rise in price in the 1970s. In addition, most retailers view sandpaintings as items which turn a quick profit and several have even discouraged customers from collecting sandpaintings. They insisted that owning more than one of the decorator paintings would overpower a room and that more extensive technical improvements were required before sandpainting could become collector's items. Merchants do not advertise, therefore, or promote sandpaintings as they do easel art. In short, as an investment it is much safer to collect established crafts.

Finally, practicality prevents sandpaintings from being collector's items. Their particle board backing makes them heavy, bulky, and unwieldy, and they must be stored carefully

so they are not scratched. They are also expensive to frame. With these difficulties added to the other uncertainties, it is evident why Navajo commercial sandpaintings have not become collector's items.

MARKETING TECHNIQUES

Navajo sandpainters have always sold their work whenever and wherever they could. They will try to sell directly to individuals on the street or to people camping at local campgrounds as well as to storeowners. For Navajo sandpainters, flexibility is the key to their success in selling their work, just as flexibility was the key for Navajo households in their attempts to have a stable economic and income base. No one relies solely on any one method of selling because unlike Anglo artisans, who often have an exclusive selling arrangement with a shop, Navajo sandpainters see such contracts as confining. Because of the unpredictability of marketing directly to customers, however, using a middleman for the majority of transactions is more common.

Whenever new painters begin first to sell their work, they use a middleman and retail outlets. For painters who started in the developmental period this presented a problem for they often had to find merchants who were willing to give the new art form a try. In the 1950s Stevens sporadically sold paintings in Tucson, Gallup, Saunders, and Lupton in shops near his home or where he was doing sandpainting demonstrations. In the 1960s, many painters began to go from shop to shop in reservation border towns and nearby cities, establishing contacts with owners of Indian arts and crafts stores. Major wholesalers quickly emerged, and painters soon saw their work was going to sell well in tourist areas and in the established marketing centers for Indian crafts such as Gallup and Farmington. By the late 1960s stores outside the Southwest began to carry sandpaintings. Painters would occasionally travel to Texas and California, but more often wholesalers began including a few sandpaintings in the regular orders of rugs and jewelry they shipped to retailers both inside and outside the Southwest.

Another indication of the acceptance of sandpaintings in the arts and crafts market was the interest jobbers showed in sandpainting in the late 1960s and early 1970s. A jobber was a special middleman who traveled around the Southwest to various artisans, picking up items and taking them to a wholesaler. The jobber charged 10 to 20 percent for his services which were necessary given the great distances between towns on the reservation. The wholesaler, who sold the art to a retailer, adding a commission, did not have time to search for artisans on the reservation. As the number of Indian artists who owned cars increased, the need for jobbers lessened, and gradually, the primary responsibility for delivering sandpaintings to wholesalers came to rest on the artisan himself.

Painters who began after 1970 took advantage of these contacts by selling first to stores that had shown the most support for their teachers. Later they began trying to build up an independent clientele. In the early and mid-1970s this was easy, for in a bandwagon trend, stores all over the Southwest, even in towns which were dying, began to stock sandpaintings. It was no longer only Indian arts and crafts stores which sold sandpaintings. By 1975, sandpainters could sell at least one sandpainting to any shop they entered. They always took several paintings with them whenever they went to town to buy groceries or have the car serviced; rarely would they fail to sell enough paintings to pay for the trip. In fact, some painters never made it to the store with their filled order. The mother of one Navajo family from Sheep Springs explained how her son would take the paintings into gas stations, restaurants or stores where they stopped en route from Sheep Springs to Page and could manage to sell all their paintings before they passed Flagstaff! On such occasions they had to turn around, go home and make more paintings, much to the disgruntlement of the waiting storeowners in Page.

By the late 1970s sandpaintings were being sold in almost every type of retail establishment in the Southwest—from Indian arts and crafts stores to auto parts shops. The stores catered basically to the three major submarkets. Painters who produced primarily for the souvenir market headed for the curio shops located at resorts and along major highways, like

Interstate 40. While curio shops occasionally sold quality items, they tended to market inexpensive Indian crafts, tourist trinkets, and foreign-made imitations of Indian crafts. Sandpainters brought to these outlets small, assembly-line items, and paintings made in eccentric shapes, on backings like sandstone slabs, in wooden bowls, and even on cattle scapulae. Painters producing tourist art also sold to restaurant and motel gift shops and occasionally to other gift shops. Most of these latter types of shops, however, usually acquired paintings through major wholesalers.

The most important outlets for makers of gift and home-decoration paintings, fine art, and reproductions of ceremonial sandpaintings are Indian arts and crafts stores. These stores specialize in art and handcrafted items made by Native Americans. Owners of several of these shops are the major wholesalers of sandpaintings; some manage an inventory of several thousand paintings.

Museum gift shops and art galleries which present and market one-of-a-kind works of art rarely sell Navajo sandpaintings. When they do, they usually sell those considered fine art. Most sandpainters do not like to work on a consignment basis, nor do they wish to establish long-term agreements which most art galleries require. Very few sandpainters are even striving to tap this potential market.

The trading post, that frontier-era retail establishment where the Navajo traded sheep, wool, blankets, juniper berries and silver jewelry for manufactured goods and food, was not used by Navajo sandpainters as an outlet for their work. Fewer than five percent of the sandpaintings seen in 1977 through 1979 were found in trading posts. This was totally contrary to what was expected, for the trader has always been important as the initial middleman in the marketing of Navajo crafts. Trading took the form of barter and credit advances; that is, traders extended credit until the rugs and unprocessed wool were brought in and the accounts balanced. In addition, silver jewelry which was made for other Navajos was pawned. The trading post even served as a bank vault, for jewelry was a portable form of wealth for the Navajos. Some traders would hold onto the pawn even after it could have been officially

declared dead, for they valued the trust of, and wished to insure the future patronage of, their exclusively Navajo customers. Traders also helped turn objects of Navajo material culture into items which could be sold to Anglos. For example, they helped turn blankets into heavy rugs, and suggested color schemes and designs. They would bring catalogs in to the trading post and show weavers pictures which would convey their ideas on how to make the rugs fit into Victorian households. Traders helped develop regional styles which became identified with each trading post, such as Ganado or Teec Nos Pos rugs. Traders also helped establish eastern retail markets for the goods, and served as jobbers and wholesalers. Artisans would take their wares to the trading post nearest their home because physical distances made it uneconomical for them to travel regularly to a number of posts in search of the highest price for their goods. Artists formed close personal ties with the traders.

Traders refused, however, to buy sandpaintings for two reasons. First, most were located in remote and inaccessible places and very few tourists ever entered their doors. Sandpaintings are only sold in places like Hubbell's trading post which is now a national monument or at Canyon de Chelly because of their heavy tourist traffic; sandpaintings, unlike rugs, are commodities with such a small margin of profit per item that many have to be sold in order for the merchant to make any profit. Secondly, traders would not allow the paintings in their stores because they thought they were sacrilegious and feared that the paintings would offend their Navajo customers who would then refuse to trade at the stores.

Navajo sandpainters, therefore, have not followed the established marketing practices of weavers and silversmiths. They learned quickly that the trading posts nearest their homes would not buy sandpaintings. Indeed the few trading posts which do carry sandpaintings all purchased them from off-reservation wholesalers rather than the painters. Instead sandpainters had to market in off-reservation areas and travel at least forty to fifty miles before they could sell the bulk of their paintings. This was possible because sandpainting as a

craft developed after roads had been improved and auto-
mobiles were readily available. This has meant that sand-
painters bypass the trading post; they sell their art in towns
and then purchase groceries and other goods from merchants
there. Traders have thus not had the stylistic and eco-
nomic influence on sandpaintings that they have had on other
Navajo crafts.

This change in marketing patterns for sandpainters
may signal a decrease in the influence of traders over other
crafts as well. As many trading posts turn into grocery stores,
as pawn and credit systems are increasingly controlled by regu-
lations issued by the federal government, as more artisans
acquire trucks, and as roads continually improve, weavers and
silversmiths will sell less often to local traders. It will be much
easier to travel to border towns, take their wares to a number of
shops and sell to the merchant who offers the best price. Only
in cases in which the artisan does not have funds to purchase
raw materials and needs to borrow on credit will the trader
continue to have an important influence.

After a few years of relying only upon wholesalers,
many sandpainters shifted to selling directly to customers.
That they felt they were being exploited by middlemen shows
in part a lack of understanding of the structure of the Anglo art
market and the role of the middleman. Like many American
artisans, sandpainters felt that storeowners were making more
than the value of their services, and they resented the fact that
retailers were selling their paintings at double or triple the
amount the painter had been paid.

In addition, as the painters became established, they
tended to make more direct sales, especially if the paintings
were produced for the fine art and ceremonial reproduction
market or the gift and home decoration market. These direct
sales methods varied with the type of painting. Makers of gifts
and home decoration paintings regularly visited hospitals and
schools, a practice common also to Hopi kachina doll carvers
and Ute basketmakers. Painters found that curing symbolism
was a strong selling point for doctors and nurses. Roadside
stands along routes such as Highway 89 between Flagstaff and
Page or at the Four Corners Monument were used in summer

months by painters selling souvenirs to tourists. The most common method for makers of gift-home decoration and fine art and ceremonial-reproduction paintings was participation in arts and crafts shows. Here the artist set up a display booth in which he often made an impermanent sandpainting. Simultaneous demonstrations drew people interested in the stylistic origins of the art. Painters also attended state and county fairs, annual pow wows, flea markets, and had tables in shopping malls and department stores where there were large concentrations of potential buyers. Increased competition with other Indian and Anglo artisans was, however, somewhat a disadvantage.

Because of the inaccessibility of the scattered Navajo houses, most sandpainters will always have to search out their customers. Most buyers would not take the time and effort to find them. However, although rare, a few well-known painters work out of their homes if they are in the more populous Navajo communities, and one painter and his family moved to Phoenix. Individual commissions for fine art and ceremonial reproductions have often been handled by mail or telephone orders, although as of 1980 no painter had established a mail order business. Most artisans are wary of this method, having had problems with payments in the past; others have often not followed through on initial contacts by customers.

Because painters work primarily when they need ready cash, indirect sales methods are likely to remain most important outlets. Although direct sales will probably grow as dissatisfaction with middlemen increases, sandpainters cannot afford the time and effort to go out and sell to individual customers exclusively.

Of the four basic arrangements by which art is marketed in the United States—auction, consignment, guaranteed sale, and outright purchase—only the latter has been used in sandpainting sales. This means that the store buys the sandpainting from a supplier, adds a selling cost and profit, and arrives at a retail price. The store then owns the item and the painter has no say in how the purchaser displays or markets the art work. In fact, most sandpainters had no idea what happened to their paintings after they were sold, nor did they express much interest.

Sandpainters tend to specialize in one type of painting; that is, they tend to produce either tourist paintings or fine art paintings, but rarely both. The skills needed to make each type of painting differ. Specialization seems to be uniform for members of the same household, although each painter may produce and market his works individually (Table 7.3). In only ten percent of households with more than one sandpainter were

TABLE 7.3
**Households With More Than One Sandpainter
by Focus of Submarket Production**

Submarket Focus	Number of Households	Percentage
Households which specialize		
Everyone produces souvenir art	13	15.7
Everyone produces gift-home decoration	35	42.2
Everyone produces commercial fine art	8	9.6
Subtotal	56	67.5
Households which do not specalize		
Combinations of souvenir and gifts	13	15.7
Combination of gifts and commercial fine art	9	10.8
Combination of souvenirs and commercial fine art	3	3.6
Combination of all three	2	2.4
Subtotal	27	32.5
Total	83	100.0

*Paintings seen for only one member of production unit or household = 6.

surnames alone placed on the backs of paintings, because construction had been a joint effort. New painters tend to continue making the size and type of painting made by their teachers. The size of the household also had no effect on this tradition. Larger households.were actually more likely to specialize than households containing only two or three sandpainters.

MARKETING INFLUENCES

Most merchants have not wanted actively to guide the stylistic development of Navajo sandpaintings, but half a dozen large wholesalers in Farmington, Gallup, and Shiprock have taken

on the responsibility. They have interpreted the demands of their Anglo customers and relayed this information to Navajo sandpainters by suggestion, encouragement or criticism, and monetary incentives for superior workmanship. In response sandpainters have modified their work in several ways. This has not always been an easy task, however, because Navajo and Anglo values and aesthetic concepts are not always the same. For example, one merchant had a lovely sandpainting from Coyoteway of four butterflies and their homes prominently displayed in his shop. Many Anglo customers were captivated by the painting and wanted to purchase copies. The merchant tried to convince several sandpainters, including the man who had made the picture for him as a personal favor, to produce more copies of the painting, but was unsuccessful because in Navajo culture the butterfly is associated with love magic, insanity and incest. He is a creature which tries to get people into trouble.

Navajos have been most responsive to suggestions dealing with craftsmanship and technical aspects of construction. They have standardized the size of commercial paintings so they would fit manufactured frames.

Merchants have been especially successful with small- and medium-sized paintings. When ordering paintings, they would specify size and would pay less for oddly shaped or irregular-sized paintings. In bringing about this desired uniformity they were assisted by lumber yards that provided particle board precut in popular sizes. Storeowners also encouraged families and individuals to make only those sizes that the merchant felt were most appropriate to each artist's ability or talent. This system was beginning to break down in the late 1970s, although merchants still have a great deal of control over souvenir paintings.

Next to standardization of sizes, craftsmanship and quality have been merchants' main concerns. Early wholesalers believed that while the first sandpaintings were crudely fashioned, they improved over the years (Fig. 7.5). Others disagreed, feeling that the craft has been degraded by the later development of souvenir paintings. Economically, well-constructed crafts mean a steady increase in sales, and merchants try to convince painters that it is more profitable in the

Fig. 7.5a

Figure 7.5 A comparison of two sandpaintings shows why an improvement in craftsmanship was encouraged by retailers. **a.** Talking God (called by the painter Corn Man) bringing a green corn plant rooted in a rainbow to Earth people. It is one of the later works of James Wayne Yazzie, Sheep Springs, 1971. Lines are not perfectly straight, many areas are not filled in adequately or are smudged, and edges are fuzzy. Size: 11" x 11". Price: unknown. In contrast, **b.** is a detail from a large, complex painting made in 1978 by Francis Miller, Sheep Springs. Lines are extremely thin and clean, there is no smudging, and detail is more intricate. Size: 24" x 24" (illustration is detail from painting). Cost: $525.

Fig. 7.5b

Figure 7.6 "Healing God" by the Myersons, a husband and wife team, Shiprock, 1979. This sandpainting of a single Holy Person flanked by two herb plants shows standardization in size (12" x 12") and the use of elaborate decoration on the figure which has no particular significance. It has been included to make the figure more complex and fill up blank areas. Many people find this style too fussy. It is mainly used by a large kin group centering in Shiprock. Price: $50.00

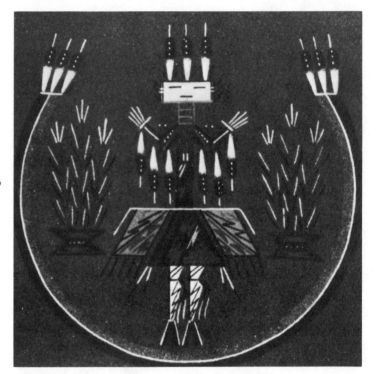

Fig. 7.6

long run to aim for quality rather than quantity. However, the usual practice of buying large numbers of paintings in a lot based on size rather than by the quality of each painting has hindered the quest for improved workmanship.

Merchants stressed that paintings should have clean areas (i.e. flecks of one color should not be found in another color which results from not allowing one area of color to dry before putting on the next); colors should not be smudged; lines should be straight; outlines thin; sands finely ground; and background sands completely covering the board. The glues should be carefully applied to prevent lumps and streaks and enough should be used so that colors will not fall off. Figures should be centered and colors pleasingly placed. In addition to these construction requirements, some merchants also asked painters to increase detail and decoration (Fig. 7.6). Personal

Figure 7.7 "Mesa With Spirits" by Timothy Harvey, Lukachukai, 1977. In response to retailer's requests Harvey placed his name and the date of manufacture on the front of this painting. This request is especially important for painters who are producing easel art. While this painting tries to convey religious sentiments, the symbols are not from any sacred sandpainting. Size: 24" x 24". Price: $120.

Fig. 7.7

preference was at work here, however, since other sellers felt excessive detail marred the simplicity of the figures and composition. These opposite poles of thought illustrate the two forces pulling at sandpainters—one trying to make paintings a less static art form, the other attempting to keep them as close to their sacred prototype as possible.

Retailers quickly realized that sandpaintings sold better if signed and if a brief legend was affixed to it, for it made them more individualized and thus more like art than a craft (Fig. 7.7). The story identifying the sandpainting origin as well as the signature had to be handwritten on the back of the painting; when sandpainters began to use rubber stamps, customers accused merchants of selling mass-produced items. The stamp violated an Anglo concept of handmade art, whereas Navajo sandpainters saw it as a way of making the

Fig. 7.8

Figure 7.8 "Split Painting" by Danny Akee, Tuba City, 1978. Few paintings show this much experimentation in color or design. In trying to combine traditional and nontraditional subject matter Akee has developed split paintings. Only he and his family have used this technique. Here part of Monster Slayer on the Sun from Shootingway and a vase with plants are shown. Glitter has been added to the black and tan sands. Commercial paints have been used in addition to natural colors. Many retailers are trying to discourage such experimentation while still encouraging painters to develop individual styles. Many have requested a return to the use of more subtle color schemes and traditional subject matter. Size: 12" x 12". Price: $35.

construction process easier. The legend also had to convey, even in the most generalized and standardized manner, the materials used, the name of the figure, and a brief sentence explaining how sandpaintings are used in Navajo culture. Merchants discovered that Anglo customers would more readily buy Indian art if they emphasized its religious origins and symbolic nature; Anglos wanted to understand the esoteric meanings which the paintings contained.

Painters received conflicting messages from merchants about subject matter. Most merchants preferred subjects that were adapted from sacred sandpainting themes. They found sold best because they reflected these historic origins. They would provide artists with photographs and books (such as Newcomb and Reichard 1975 and Reichard 1977) containing the designs they wanted to see drawn. These books then served as the templates for stencils. Several retailers noticed the ironic side effect of their efforts: they felt they knew more about Navajo religion and symbolism than did many of the sandpainters and they wanted the painters, especially younger ones, to learn more about their traditional ceremonies and accompanying myths. This problem, however, is partly a result of the young age of most Navajo sandpainters.

Fig. 7.9

On the other hand, some storeowners have sought more modern designs since 1975, feeling that motifs from sacred sandpaintings are static and stereotyped. This in turn limits the artist's repertoire, and ultimately the potential market. This encouragement toward innovation is delivered with the caveat that the design still look "Indian." The result has been an expanded repertoire and a change in the conception of what a commercial sandpainting is; it has become an artistic technique. When painters first attempted this change in response to merchants demands and in their search for individual styles, they painted subjects from their own culture—yeibichai dancers and women riding horses in the desert. Then painters added non-Navajo scenes, including dancers, landscapes, and still-lifes. Retailers tried to limit these experiments to reservation-based themes so that artists would paint only what they knew. But even this advice sometimes led to marketing failures (Figs. 7.8 and 7.9). For instance, rodeo scenes have never sold at all, and merchants now refuse to carry them. The problem is that rodeo paintings were not considered "Indian activities" by Anglo customers. Ironically the rodeo is one of the Navajo male's major forms of recreation. Thus, the limits to the success of this experimentation and the ability of most sandpainters to compete as artists without their ethnic identification have become apparent.

Figure 7.9 "Cowboy on Bucking Bronco," maker unknown, 1976. While retailers suggested that sandpainters expand their repertoire of subject matter and make nontraditional sandpaintings, feeling that customers would like the increased variety, some of the efforts were not successful. Customers questioned whether certain subjects, like this rodeo painting, were Indian subjects, and hence questioned whether the painting had been made by a Navajo or an Anglo-American. This particular painting had not sold after five years—in a market where the maximum turn around time is less than six months. Retailers no longer buy paintings of rodeo activities. The lack of background and perspective is reminiscent of the 1930s school of Indian oil painting. Size: 11" x 13". Price: $20.

The earliest commercial sandpaintings had subdued colors reflecting the pale shades found in the desert in exactly the same tones and hues as used in sacred sandpaintings. In response to merchant and customer desires, and perhaps from their own love of bright, lively colors (if one can make an analogy to the riotous use of Germantown yarns in late nineteenth century rugs), sandpainters began to add new and brighter colors. Greens, turquoise blue, bright red and orange, as well as new intensities in existing colors, were added to the sandpaintings. Mica was added to black to make it sparkle and new materials, like carborundum grit, were substituted for old materials because of their color qualities. A few painters are even trying commercially dyed sands, a switch that has greatly distressed retailers and other sandpainters alike. These gaudy sands or dried paint crystals, often mixed with glitter, have led merchants to call for a return to the softer earth tones. Background sands have also changed with change in the pigments: black, red, green, gray, gold and rust are now used. These new backgrounds are found primarily in paintings designed for home decoration. Merchants are trying to promote sales to both residents of the Southwest and individuals living in Texas and California. Each regional market has different color and stylistic requirements—subdued colors for Southwestern homes and brighter, colder, and purer colors for regions outside the Southwest. Whites to lighten the total effect are liberally added to paintings wholesaled to eastern markets.

In an effort to expand the craft market, especially the souvenir market, storeowners have helped develop eccentric designs, shapes and backings. Since 1978 sandpaintings have been attached to boxes, bookends, plaques, and desk furnishings. Extreme miniaturization has been required, and designs have been altered to accommodate the end product. For example, four Anglo-owned companies use sandpaintings as clock faces. They try to use a sun face design because it consists of a large circle surrounded by feathers. However, instead of the traditional 16 feathers or 64 feathers of the Chiricahua Windway painting, 12 are used to correspond to hours of the day (Fig. 7.10).

Fig. 7.10a

Fig. 7.10b

In these ways merchants, especially the most impor-
tant wholesalers, have had an extensive influence on the trans-
formation of Navajo sandpaintings into a successful ethnic art.
Of course, some of the storeowner's attempts failed. A few in
the early 1960s tried to completely control production by
monopolizing raw materials and starting a system similar to
the putting out systems found in Mexico and Guatemala or to
the ones which existed between Navajo, Zuni, or Rio Grande
Pueblo jewelers and merchants in the early twentieth century
as Indian jewelry was being transformed into saleable items for
Anglo-Americans. Since the raw materials were expensive
and the artist did not have much cash, a merchant, for exam-
ple, would give him a piece of raw silver on credit and discuss
what piece(s) were to be made from it. The artisan would take
the silver home, complete the pieces, and deliver them to the
merchant who would then balance the books, give the sil-
versmith a wage (deducting the cost of any goods he may have
been given on credit), and give him a new piece of silver. The
artisan was thus almost always in debt and dependent on the
middleman and the middleman had a great deal of control over

*Figure 7.10 The use of new
background materials as sur-
faces for sandpainting has
resulted in a variety of new
sandpainting objects. A Navajo
sandpainting basket **a**. was de-
signed by 12-year-old Herbert
Harvey of Lukachukai in 1976.
Made in a wooden bowl, 12
inches in diameter, the design is
of the Navajo wedding basket
which is used on ceremonial
occasions. A sandpainting
clock **b**. by Freddie Nelson
of Lupton, 1977, was made on
a decoupage board. The figures
are traditional Navajo and Hopi
designs, but their use here is
meaningless. Placement is de-
termined by the use of the figures
in the clock face. Size: 15" x 15".
Price: $145.*

production. Sometimes the merchant would employ more than one individual before the piece was ready to sell to a customer. For example, a Navajo silversmith would work the silver backing for a bracelet and then a Zuni would cut, polish and insert small pieces of turquoise in a delicate pattern. A couple of wholesalers tried to use more than one individual to make a sandpainting in the mid-1960s by having new painters or those who lacked a delicate hand lay only the background and the main areas of color. Then the merchant would give the incomplete painting to a very talented individual who had the skill to paint detailed decoration and have him specialize in the all-important finishing touches. The merchant would pay each painter a wage based on his skill, just as if the artisans had worked in a shop. This system, however, proved to be unfeasible with sandpainting because raw materials were too easily available and inexpensive, and the painters in the 1960s were successfully and actively marketing the paintings themselves as they sought to expand the market. Painters began to bypass these wholesalers and take the paintings to retailers themselves. The wholesalers quickly dropped their attempts at this type of control. But even so, they felt they still had more control over sandpaintings than most other crafts because of the short turnover time. Storeowners can suggest changes, the painters can experiment quickly and cheaply, and if the experiment fails, the loss in time and money is not nearly as great as it would be with silver.

Most merchants did not use direct commissions to influence style, but relied on the general purchasing system. More often than not, rather than suggest specific designs, they simply did not purchase what they did not like. Two retailers stressed that active criticism or encouragement is rarely necessary for most sandpainters. Navajo painters know what each merchant wants, without explicit orders. Even contradictory information does not confuse them, since they present only pictures they know will appeal to each owner.

Thus the market through the merchant has had a powerful influence on the development of commercial sandpaintings. This influence, in conjunction with changes made to

appease the gods, a desire not to copy others, and a search for individual styles by makers has made commercial sandpaintings artistically different from sacred sandpaintings.

In a final analysis, the success of commercial sandpainting can be measured to some degree by the changes it has brought about in the lives of its artists. More even than a way to make a living, the craft enabled all the Navajos interviewed for this study to become self-reliant, that is, to become independent of the welfare system. From the beginning, sandpainters have earned at least a minimum wage for their effort even in light of the comparatively low retail prices of their wares. It took silversmiths and weavers, for example, much longer to receive the same kind of monetary return on their efforts. In fact, handicrafts produced in all cultures have had a low measure of return for the work expended. But sandpainting, because of its inexpensive raw materials, many of which do not require any cash outlay, has always yielded remuneration which was higher than that of other crafts before they broke into the fine art market.

Sandpaintings grew into an established craft in a remarkably short period of time. In fact, it is one of the quickest rises of a craft on record: it took sandpaintings only twenty years after the basic technological innovations had been mastered and adopted by members of the Navajo community to become stock items in all types of stores in which Native American arts and crafts are sold. In many places they were sold in large quantities. Within this twenty-year time span some artists began the process of breaking into the fine art market. It took weavers, silversmiths and basketmakers much longer to make the transition between craft and fine art. For many years weavers as well as silversmiths were paid by the pound for their work. Only in the most exceptional cases before the 1970s were they rewarded monetarily for creativity.

Part of the reason for this phenomenally fast growth was the economic situation on the reservation. Navajos were eager to try new options for they are adaptable people. The

ease of learning the basic craft enabled them to sell their earliest works and reap an immediate return on their efforts—not true for potters, weavers, or silversmiths whose time to master their crafts was considerably longer. Both men and women became artisans without the stigma which would have been attached to a man becoming a weaver, for instance. Commercial sandpaintings have another advantage. Due to increased interaction with Anglos during the second World War and greater opportunities for formal education, Navajos more readily crossed the cultural barriers and were able to adapt their work to the preferences of their potential customers whose ideas of beauty and appreciation of the craft were very different from their own. The post–World War II era was also a period with a dynamic economy characterized by enough surplus to encourage production of luxuries. In addition it was a period of increased international and intercultural awareness. With increasingly large economic systems isolationism was no longer the norm. Tourism in the United States also increased dramatically as did the popularity of and interest in the country's diverse ethnic origins. Folk art and music festivals, where members of different ethnic groups come together to celebrate and share their traditional dress, dance, food and crafts, became widespread occurrences. The government took a part in promoting these activities with the formation of agencies like the National Endowment for the Arts in 1965, and began using Indian art as symbols for logos. In addition, sandpainting developed in a period which emphasized anti-industrial values, and called for a return to a more basic way of life that included handmade crafts as products of individual effort. To say that something was handmade was to say that it was better.

The immediate success of commercial sandpaintings as a craft was also remarkable in view of the internal opposition voiced by conservative Navajos who objected to the secularization of sandpaintings and producing them in permanent form to be sold. The implementation of new rules surrounding the use of sandpaintings allowed freedom to experiment with construction techniques, design, composition and color which contributed, as in any craft, to their success in the western market and helped with the development of distinctive styles.

The commercialization of religious art is never easy, especially when some members of the community feel that development might threaten the religious system. The pragmatic nature of Navajos, their wait and see attitude—if a transgression is not punished supernaturally it is acceptable—and the ambiguity over the moment of sanctification has meant that there was never any agreement that permanent sandpaintings were bad. The Navajos in the future as in the past will most likely remain divided on this issue; however, based on the most prevalent attitude in the early 1980s, most people will be indifferent to the whole question. It is reasonable to assume that opposition will flare occasionally since production of commercial sandpaintings can be interpreted as the reason that the tribe as a whole has fallen on hard times. Opposition is not likely seriously to threaten the sandpainting industry, especially since its success is interpreted as a sign of supernatural favor. Furthermore, Navajos object to anyone telling them what to do. Hence it is reasonable to project that permanent sandpaintings will be sold as long as there is a market for Indian arts and crafts and for as long as the economic situation on the reservation does not drastically improve.

Sandpainters themselves consider their work a success. They are proud of it and are eager to show it and discuss its merits with interested individuals. In addition to economic benefits of sandpainting as a craft, sandpainters all believe they are producing objects of beauty which will show the world how Navajos see beauty. They believe these objects will be interpreted as beautiful by those who own them. In this way, Navajo sandpainters feel they are bringing happiness and blessings to the world.

APPENDIXES

1. Commercial Sandpaintings Recorded in 1977, 1978, 1979

2. Navajo Commercial Sandpainters by Community of Residence in 1977 and 1978

3. Major Collections of Sandpainting Reproductions

4. Comparison of Subject Matter of Sacred and Commercial Sandpaintings

5. Chant Source of Commercial Sandpainting by Composition

6. Navajo Kinship Relationships and Accompanying Behavior Patterns

7. Relationship Between Teachers and Students by Sex for Commercial Sandpainters

8. Reasons for Beginning to Paint by Sex of Painter and Date of Starting

9. Religious Affiliation of Sandpainters by Sex of Painter and Date of Starting

10. Educational Level of Navajo Sandpainters by Age and Sex Compared to Navajos in the U.S. Census

11. Occupation of Painters by Date of Starting and Sex of Maker

APPENDIX 1

Commercial Sandpaintings Recorded in 1977, 1978, 1979

Subject Matter	Size of Paintings in Inches			
	Small*	Medium**	Large***	Total
Single Holy Person	3137	2813	20	5970
Double Holy People	104	294	12	410
Partial Sandpainting	90	151	58	299
Full Sandpainting	1	38	264	303
Sun or Moon	171	244	43	458
Plants	48	288	6	342
Animals	44	93	14	151
Anthropomorphic beings	65	137	15	217
Mother Earth and Father Sky	129	260	20	409
Navajo dancer	132	607	23	762
Non-Navajo dancer	13	122	3	138
Person	34	238	12	284
Landscape	49	27	5	81
Still Life	99	219	17	335
Other (animal, peyote)	19	66	35	120
Totals	4135	5597	547	10279

*Includes sizes 4 x 4 to 8 x 8 inches.
**Includes sizes 9 x 5 to 16 x 20 inches.
***Includes sizes 24 x 24 to 48 x 48 inches.

APPENDIX 2

Navajo Commercial Sandpainters by Community of Residence in 1977 and 1978*

Sheep Springs

S. Allen	Curtis	Jasper Johnson
J. Bedah	Antonette Curtis	Jennette Johnson
Sharleen Bedah	Bernice Curtis	Margie Johnson
Ann Begay	Chester Curtis	Martimus Johnson
Aluena Begay	Edward Tom Curtis	Montoya Johnson
Harry Begay	Fannie Curtis	Robert Johnson
Irene Begay	Helene Curtis	Wilbur Johnson
Joe Allen Begay	Louise Curtis	Adele Lee
Joe Begay's wife	Lucy Curtis	Annie Lee
Marie Begay	Margaaret Rose Curtis	(also Shiprock)
Mary A. Begay	Mary Curtis	David V. Lee
Wayne Begay	Robert Curtis	(also Shiprock)
David Benally	Rose Curtis	Daniel Lee
F. Benjamen	Tony Curtis	Alfred Leuppe
Lillie Curtis Benjamen	Harry Denetchiley	Doris Leuppe
Evan Billie	Art Denetclaw	Gary Liston
Marie Billie	Robert Denetclaw	Albert Nelson
Fannie Blackhair	Benny Dez	Allen Newcomb
Bryan	Marie Domingo	Cleveland Nez
A. Bryan	Rose Eldridge	Alfred Miller
E. Bryan	Louise Etcitty	Francis Miller
Junior Bryan	Foster	Jasper Miller
Nathan Bryan	Boyd Foster	Patsy Foster Miller
A. Bryant	Minnie Stevens Foster	T. Nytie
M. Bryant	Shirley Foster	Davis Peshlakai
Chee	Stanley Foster	Mary Lou Peshlakai
Jackson Chee, Jr.	Nora Hennie	Stanley Peshlakai
James Chee	Hannabah James	Karen Price
Marie Chee	Pearl James	Larry Price
Walter H. Chee	Johnson	Lenora Price

*Many of the sandpainters identified themselves only by a surname, initials or first name. For instance, the signature "Yazzie" appeared on a number of paintings, but there were 46 identifiable painters with the surname Yazzie in the sample. Other signatures were illegible. Since these cases could not be assigned with absolute certainty, they were not used in any analysis.

In addition to Navajo sandpainters, 6 Anglo-American-owned companies were making sandpaintings by mechanical means in 1977 and 1978, showing that sandpaintings had come of age and were big business. Also 15 Anglo-American and Mexican-American painters, a husband and wife team from Jemez Pueblo and a Winnebago living in Detroit were actively sandpainting in the late 1970s. Two non-Navajo males who are married to Navajo women make and sell sandpaintings with their wives' families.

APPENDIX 2

(continued)

Sheep Springs *(continued)*

Lynette Price
Nancy Price
Robert Price
Wilson Price, Jr.
Wilson Price, Sr.
Judy Sam
Pauline Chee Sam
Dorothy Sandman
Linda Price Sandman
Lorenzo Sandman
Leo Sherman
Bertha Smith
Joe Smith
Thompson
Gloria Thompson
 (also Colorado)
Emerson Tso
Alberta Tsosie
Annie B. Tsosie
Carol Tsosie
Irene Nelson Tsosie
Roger W. Tsosie
Wilfred Tsosie

Walters (two brothers)
A. Watchman
Alfred Watchman
Alfredo Watchman
Amelia Chee Watchman
Anna Watchman
Aurelia Watchman
Caroline Watchman
Dorothy Watchman
Elsie Y. Watchman
Ester Watchman
Jessie Watchman
Joe Y. Watchman
Jo Lee Watchman
Pearl Watchman
R. Watchman
Richard Watchman
Rose Yazzie Watchman
Rosenta Watchman
Susie Curtis Watchman
Wallace Watchman
Tina Willie
Tina Wilson

Annie Yazzie
Art D. Yazzie
Bertha Yazzie
Ceil Yazzie
Ellison Yazzie
Emerson B. Yazzie
Emma Yazzie
Ernest Yazzie
Fannie Yazzie
Glen Yazzie
H. Yazzie
Harry Yazzie
Herbert Yazzie
James Wayne Yazzie
Jan Yazzie
Ken Tulley Yazzie
L. Yazzie
T. Yazzie
Tilly Yazzie
Tsosie Yazzie
Tullery Yazzie

AREA NORTH OF SHEEP SPRINGS

Newcomb

Notah Chee
James Curley
Gloria Dick
Gracie Dick
Joe Dick
Johnnie Dick
Guy Howe
Martha Howe
Roselyn Howe
Alfred Joe
Betty Napoleon Joe
Lorraine Tahe

Cove, Red Rock

Betty James
Christy Nakai

Sanostee

Carlene Duncan
L. E. Lewis
Mary Lewis
Gloria Nez
George Slim
Daryl Soue
Helen Yazzie
Jonah Yazzie
Laberta Yazzie
Laber Lacl ? Yazzie

Two Grey Hills

Ella Mae Begay
Harvey R. Begay
Ella M. Benally
Evelyn Benally
Chester K. Bia
Helen B. Bia
Nelson Cairbridge
Samuel Cairbridge
Curley
Melvin Curley
V. Curley
Calvin Hunt
David Peters
Nellie S. Talk

APPENDIX 2

(continued)

AREA NORTH OF SHEEP SPRINGS *(continued)*

Shiprock

Art
Arthur
Lestur Arthur
Lorisa Arthur
Sammy Arthur
Alfred Joe Begay
Don Begay
Doris Begay
Keith Begay
Gladys Ben
Herbert Ben, Jr.
Herbert Ben, Sr.
Joe Ben, Jr.
 (also Table Mesa)
Rosabelle Ben
Rose Ben
Stella Ben
Wallace Ben
Wilfred Ben

Stanley Benjamen*
Tony Benjamen*
Lehi Benally
Vincent Benally
L. C.
R. C.
Chenya Redgoat Clark
Sarah Dailey*
Alice Barber Joe
Elsie Joe
Eugene Baatsoslani Joe
George Joe*
James C. Joe*
James C. Joe, Jr.
Lester Johnson*
Judy Joe Lewis
Roy Martinez
Cecil Myerson
Jeannie Myerson

Freddie Simmons
Mary Sloan
Robert Smart
Emma J. Tom*
Dan Walters
Pauline Walters
Walter Z. Watchman
Robert Weaver
Lee Wilson
M. Wilson
Nellie Wilson
Howard Talk
Harry E. Yabney
Archie B. Yazzie*
Art D. Yazzie
Edward Ben Yazzie*
Thomas Yazzie

AREA SOUTH OF SHEEP SPRINGS

Naschiti

E. Allen
Lena Begay
Benson W. Benally
Roy N. Benally
R. Etcitty
Eva Price
Jerome Sandoval

Tohatchi

Albert Lee
Alex Lee
Frank H. Lee, Jr.
Jeremy Steven Lee
Louise Lee
Luther Lee
Peggy Lee
Rose R. Lee
Shirley Lee
Elsie Sloan
Wilbert Sloan

Twin Lakes

Maxine Lee Johnson
Helen Malone
Marie Mescal
Dos Tsosie
Angelia Yazzie*

Mexican Springs

Peter Betsai

Gamerco

Wilson Benally

APPENDIX 2

(continued)

CENTRAL RESERVATION

Chinle

Stevens
Fred Stevens, Jr.*
Fred Stevens III
 (Thunder)
Juanita Stevens
Lynn Stevens
Whilmerine Stevens
 (Rainbow)
Boyd Warner

Many Farms

Corina Boyd
Arena Marie Etsitty
Linda Etsitty
Emma Herrera
 (from Counsellor)

Rock Point

L. Begay

Rough Rock

Clarence Brown

Ganado

Betty Friday
Joseph Friday, Jr.
Harry Kee
Fanny H. Lano

Piñon

Rosita Kaye
Wilson Kaye

Lower Greasewood

Harrison Begay*
Ibrahim Jones

Crystal

Leroy Stevens*

Sawmill

Henry Jesus

Navajo, N.M.

L. Brown
Michael Brown
A. D. F.
Andrew Nelson*
Melvin Nelson*

Fort Defiance

Audry Miller Arvisco*

Window Rock

Roger Davis, Jr.

Hunter's Point

Darlene Begay

Wide Ruins, Klagetoh

Bobby H. Kee
Sara Kee
Edison Thomas

Pine Springs

Chester Kahn
Frank Kahn

Lupton

Freddie Nelson*
Martha Nelson
Rhonda Ray
Ron Yzzie

Upper Greasewood

? Perry

Lukachukai

Cecil Betomy
Charleen Betomy
Andren Henderson
Herman D. Sandoval

Teec Nos Pos

Clark
Betty Clark
E. Clark
Gary Clark
Terry Clark
U. Harrison
V. Harrison
Herbert Harvey
 (partly in Phoenix)
Timothy Harvey
 (partly in Phoenix)
Earl Lameman
Alice Tso
Marie Tso
Kathleen Willie
Elsie T. Yazzie

Montezuma Creek, Utah

Darlene Oliver
Mrs. Sam
Stanley Sam

Aneth, Utah

Paul Begay
Rose Mae Begay

APPENDIX 2

(continued)

WESTERN RESERVATION

Shonto/Black Mesa Area

"White Thongs"
Anita Jim Bancreek
Elsie Lee Fuller
Albert Jim
Edward Jim
Eleanor Tom Jim*
Leo Jim
Susan Jim

Cameron

Ernest Hunt
 (also Carefree)

Francis Tom Hunt*
 (also Carefree)
Katherine Jim

Tuba City

Barbara Akee
Benny Akee
Bobby Akee
Danny Akee
Johnnie Akee
Marie Akee
Marilyn Akee
Sadie Akee

Katherine Dugi
Ross Dugi
E. J. Mocasque
Francis T. Nez
Judie John
Daryll Tso
Tina Tso
Lylan Woody
Cornelia Akee Yazzie
Jimmie M. Yazzie
Lorraine Akee Yazzie

Moenavi

? Kaibetony

OFF-RESERVATION: EASTERN AGENCY

Lybrook, Escrito

Doris Chaves
Emellia Comanche

Cuba

N. Y. B.
Billy Castille
Eddie Castille
Rose L. Castille
Belinda Herrera
Emma Herrera
Marian Herrera
Ben J. Sam*
Pauline Sam
Anna Tachine

Torreon, Ojo Encino

Rita Mae Antonio
Woody Antonio
Chee McDonald*
Billy Sandoval
Toledo
Agnes Toledo
Ethel Toledo
James Toledo
Jerry Ted Toledo
Jessie Toledo
Lena A. Toledo
Linda Toledo
Lorraine Toledo
Lucita Toledo
R. Toledo
Raymond Toledo
R. Toledo
Raymond Toledo
Ronald Toledo
Teddy Toledo

Pueblo Pintado

Dorothy Barbome

Coyote Canyon

Jessie Begay

Crownpoint

John Lee Begay
Maggie Johnson Begay*
Nephi Begay
Etcitty
Eddie Etcitty*
Edgar Etcitty
Christine Johnson
Tony Kee Thompson

APPENDIX 2

(continued)

OFF-RESERVATION: SHIPROCK TO FARMINGTON AND SURROUNDING AREA

Fruitland

Damon
Bee Mary Damon
Billy Damon
Jim Peters
Charles Reeves
Julia Reeves

Farmington

Steven Ignacio
George John
Margaret John
Lorenzo Simpson*

Bloomfield

Calvin White

Aztec, N.M

Ethel Tsosie*

Cortez, Colorado

Calvin Willie

Egnar, Colorado

Carolyn Howe
(from Newcomb)

OFF-RESERVATION: SOUTH

Gallup

Melbin Masquat
Ruth Price Masquat*
Jerald Sherman*

Rehoboth

Mary Ben Thompson

Fort Wingate

Dwayne Billsie

Holbrook

Emma Yazzie Sloan*
Kenneth Sloan
Lillie Akee Sloan

Joseph City

Alberta Begay
(sometimes Flagstaff)

Winslow

Nelson Lewis
(sometimes
Shiprock)

Prescott

David Paladin

Mississippi

Billy Chee*

APPENDIX 2

(continued)

ADDRESS UNKNOWN

Bert	B. Francisco	Bertha Tsosie
Diane	Angelene Henry	Carolyn Nez Tsosie
Irene	K. Joe	Vivian? Tsosie
Lyden	S. Joe	Mae Watchman
Roger	C. Kealey	Al Waukena, Sr.
Clara Begay	Kohoe	Josephine Willie
Frank Begay	Eric Nanups	Lorenzo Willie
Harris Begay	Tom Pete	J. Y.
Henry Begay	Jim Peters	Yazzie
Woody Begay	N. Saltwater	A. Yazzie
Benally	H. Smith	J. Yazzie
Francis E. Benally	Fay Young Smith	Jo Ann Yazzie
M. H. Benally	Tabertina	M. Yazzie
P. Penally	Tahoma	Nattie Yazzie
C. Blechtou	Richard Talliwajob(?)	Navajo Yazzie
? Buatihonan	Att or Art Tso	P. Yazzie
C. Chicharello	F. C. Tso	Rita Yazzie
Ray Ecallo?	Jim Tso	S. Yazzie
E. Etio	Albert Tsosie	W. Yazzie
L. A. F.	Bert Tsosie	

APPENDIX 3

Major Collections of Sandpainting Reproductions

Institution	Special Collections	No. of Reproductions (including duplicates)	No. of Reproductions Used in Study
Arizona State Museum	Laura Armer collection Maud Oakes collection Margaret Scheville collection Louisa Wade Wetherill collection*	108	73
Columbia University	Bush collection	102	97
Ethnografiska Museet	Miguelito paintings*	17	17
Mae Flemming (private)		4	4
Gilcrease Institute		4	4
?	W. W. Hill (publication)	1	1
Hubbell Trading Post	*	9	9
?	Clyde Kluckhohn (publication)	5	5
Maxwell Museum	Franc J. Newcomb collection	452	64
Museum of New Mexico	*	12	12
Museum of Northern Arizona	Tom Bahti collection Robert Euler collection* Barry Goldwater collection* Katherine M. Harvey collection Gladys A. Reichard collection Louisa Wade Wetherill collection* Leland C. Wyman collection	149	144

APPENDIX 3

(continued)

Institution	Special Collections	No. of Re-productions (including duplicates)	No. of Re-productions Used in Study
Navajo Tribal Museum	*	8	8
Overholt (private)		2	2
Peabody Museum— Harvard	Tozzer collection	5	5
?	Gladys Reichard (publication)	2	2
Smithsonian Institution	Walcott collection	48	38
Southwest Museum	Gen. Charles Reeves collection*	5	2
Taylor Museum	Huckell collection*	117	117
Wheelwright Museum	Laura Armer collection Henry Dendahl collection* Father Berard Haile collection* Mary Wheelwright collection* Van Muncy collection* Kenneth Foster collection* Franc J. Newcomb collection Maud Oakes collection	562	562
?	Leland Wyman (publications)	13	13
Woodard's Gallup	*	1	1
Miscellaneous publications		21	21
Totals		1647	1201

*Contains paintings made by Navajo singers.

APPENDIX 4

Comparison of Subject Matter of Sacred and Commercial Sandpaintings

Type of Subject Matter	Type of Sandpainting	
	Sacred	Commercial
Holy People		
People of the Myth (general)*	148	295
Monster Slayer*	26	16
Holy Man or Boy*	57	4
Holy Woman or Girl*	28	14
Born-for-Water*	17	—
Reared-in-Earth*	6	—
Changing Grandchild*	1	—
Twins*	6	—
Changing Woman*	4	—
Scavenger*	26	1
Hopi maiden	2	—
Eagle Catcher	1	—
Yeis*	17	31
Female Gods*	25	—
Male Gods*	17	—
Talking God*	36	8
Calling God or House God*	18	—
be jotcid	7	—
Water Sprinkler*	4	—
Fringed Mouth*	6	1
Fire God or Black God*	2	2
Humpback*	12	91
Red God (or Racing God)*	5	—
Big God*	4	—
First Man**	1	2
First Woman**	2	2
Mountain Gods	17	22
Mountain Gods with packs	3	—
Long Bodies	4	—
Sun God	1	—

APPENDIX 4

(continued)

Type of Subject Matter	Type of Sandpainting	
	Sacred	Commercial
Sun Ray Girl	1	—
Pollen Boy*	38	86
Ripener Girl*	18	5
Dancers	9	16
First Dancers	1	5
Heroine-changing maiden	5	—
Girls	2	—
Long Haired Dancers	7	3
Old Deer Catcher***	1	—
his daughter***	1	—
Prophet	1	—
Cloud People*	29	2
Lightning People	1	—
Storm People	2	4
Hail People	3	—
Thunder People**	1	1
Sky People	2	9
Water People	2	—
Rain Girl*	2	4
Rain Boy*	2	4
Rain People	7	11
Wind People**	49	6
Whirlwind People**	10	18
Cyclone Boy**	8	—
Rainbow People*	20	39
Heat People	1	—
Star People**	11	3
Fire People	1	—
Summer People	1	—
White Nostril People	1	—
Arrow People*	7	12

APPENDIX 4

(continued)

Type of Subject Matter	Type of Sandpainting	
	Sacred	Commercial
Mirage People	1	—
Feather People	2	—
Fish People**	3	2
Eagle People	1	—
Snake People**	32	8
Buffalo People**	8	—
Kingbird People	1	—
Dragonfly People	1	1
Antelope People	1	—
Deer People	1	—
Elk People	1	—
Mountain Sheep People	4	—
Horned Toad People**	7	—
Bear Man**	10	—
Big Snake Man**	10	—
Ant People**	14	2
Coyote People**	2	—
Coyote Girl**	5	9
Plant People*	1	3
Cacti People*	25	3
Squash People*	1	3
Corn People*	18	6
Sunflower People*	2	—
Tobacco People*	—	6
Animals		
General Animals	19	—
Food or Game animals*	32	7
Deer*	15	1
Antelope*	5	—
Mountain Sheep*	1	—

APPENDIX 4

(continued)

Type of Subject Matter	Type of Sandpainting	
	Sacred	Commercial
Buffalo**	17	10
Horse	2	—
Snakes**	151	7
Horned Toads**	36	11
Turtle**	1	3
Frog**	7	25
Gila Monster*	12	—
Otter*	5	4
Chipmunk*	4	—
Gopher*	1	—
Squirrel*	1	—
Porcupine**	9	—
Weasel**	3	4
Bears**	27	2
Wolf*	12	2
Hunting Cats**	15	2
Coyote**	2	5
Birds* (some undependable)	14	7
Eagles*	45	19
Ducks	1	—
Turkey*	1	—
Bat*	2	2
Spider**	2	—
Ants**	1	—
Butterfly**	1	3
Fish**	5	1
Dragonfly*	—	8
Plants		
Medicine Plant or Herb*	102	27
Corn*	167	130

APPENDIX 4

(continued)

Type of Subject Matter	Type of Sandpainting	
	Sacred	Commercial
Beans*	66	73
Squash*	64	80
Tobacco*	62	61
Cacti*	4	2
Berries	1	—
Trees	2	—
Yucca	1	—
Reed	1	—
Sunflower*	2	—
Ear of Corn	—	3
Variants	—	12
Anthropomorphic		
Thunders**	55	42
Water Creature**	10	16
Water Monster**	9	—
Water ox**	1	—
Hornworm*	3	—
Cloud Monster**	3	—
Big Fly*	18	1
Night Sky*	5	12
Sky*	1	10
Earth*	12	—
Mother Earth/Father Sky*	35	113
Winds** (some persuadable)	16	4
Sun/Moon*	118	168
Landscapes, Locations, and Paraphernalia		
Mountains	54	9
Houses	34	5
Skies	19	2

APPENDIX 4

(continued)

Type of Subject Matter	Type of Sandpainting	
	Sacred	Commercial
Den	3	—
Anthill	10	4
Nest	9	—
Emergence Place	5	6
Log	1	15
Trail	4	—
Teepee	1	3
Web	2	—
Track	4	—
Rainbow*	29	6
Cloud*	27	8
Star**	61	10
Lightning	11	5
Arrows	40	9
Knife or flint	4	2
Prayerstick	6	—
Basket	10	3
Feathers	19	14
Medicine Bag	2	—
Hoop	6	—
Shield	1	—
Tobacco Pouch	4	3
Arrowheads.	5	4
Dance Wand	4	—
Rattle	2	—
Medicine Bow	1	—
Total number of paintings	1201	1036

*Denotes persuadable deity (classification is based on Reichard 1963).
**Denotes unpredictable or undependable deity.
***Denotes unpersuadable deities to man.

APPENDIX 5

Chant Source of Commercial Sandpainting by Composition

Chant	Single Figure	Reproduction Partial*	Full	Combination**	Total	%
Blessingway						
Blessingway	6	3	1	—	10	0.9
Creation Myth†	1	—	5	—	6	0.6
Holyway						
Shootingway	164	32	46	15	257	24.4
Hailway	7	4	5	1	17	1.6
Red Antway	8	1	4	—	13	1.2
Big Starway	—	—	8	—	8	0.8
Mountainway	7	3	4	—	14	1.3
Beautyway	24	16	22	9	71	6.7
Nightway	91	15	22	2	130	12.3
Big Godway	2	4	1	—	7	0.7
Plumeway	3	3	5	3	14	1.3
Coyoteway	5	—	2	—	7	0.7
Navajo Windway	19	15	10	2	46	4.4
Chiricahua Windway	18	12	14	5	49	4.6
Hand Tremblingway	—	—	1	—	1	0.1
Beadway	—	1	2	—	3	0.3
One of two chants††	63	37	7	11	118	11.2
Unable to identify because too generalized	235	28	3	18	284	26.9
Totals	653	174	162	66	1055	100.0

*A partial reproduction contains at least two figures but fewer than three-quarters of the figures in the equivalent sacred sandpainting.

**A combination is either two sacred sandpaintings combined into one composition or combined with a nontraditional motif.

†The creation myth painting is used in Blessingway, especially Enemy Monster Blessingway, or Upward Reachingway, an Evilway chant.

††The paintings were identified but the source painting was used in more than one chant; therefore more specific identification could not be made.

APPENDIX 6

Navajo Kinship Relationships and Accompanying Behavior Patterns

Kinship Relationship		Behavior Pattern
Consanguines		
Mother-child	non-bashful	respect/joking
Father-child	non-bashful	respect/joking
Brother-brother and parallel cousins	non-bashful	patterned joking
Sister-sister and parallel cousins	non-bashful	patterned joking
Brother-sister	bashful	mild avoidance/patterned joking
Cross cousins—same sex	non-bashful	rivalrous joking
Cross cousins—opposite sex	non-bashful	most strenuous joking
Maternal grandparents	non-bashful	joking but authority
Paternal grandparents	non-bashful	joking but authority
Mother's brother-sister's child	non-bashful	symmetrical joking
Mother's sister-sister's child	non-bashful	joking
Father's sibling-brother's child	non-bashful	joking permitted, reciprocal
Affinals		
Wife's mother-daughter's husband	bashful	deep respect-avoidance
Wife's father-daughter's husband	bashful	respect/rough joking
Man and spouse's siblings	bashful	respect/some joking permitted
Man and sibling's spouses	bashful	respect
Husband's mother-son's wife	non-bashful	direct requests/some respect
Husband's father-son's wife	no data	
Husband's sister-brother's wife	non-bashful	direct and reciprocal requests

APPENDIX 6

(continued)

Kinship Relationship	Behavior Pattern	
Brother's wife-husband's brother	bashful	mild avoidance
Brother's wife-brother's wife	bashful(?)	?
Wife's brother's wife-Husband's brother's wife	bashful	?
Wife's brother's wife-Husand's sister's husband	bashful	?
Wife's brother-sister's husband	non-bashful	should help, joking
Wife's mother's brother-Sister's daughter's husband	bashful	authority
Husband's mother's brother-Sister's son's wife	non-bashful	?

Source: Aberle 1973; Hill 1943; Reichard 1928

APPENDIX 7

Relationship Between Teachers and Students by Sex for Commercial Sandpainters

Teacher's relation to student	Sex of Student						Totals	Category Totals	
	Male Student N	Category Subtotal N	%	Female Student N	Category Subtotal N	%	N	N	%
Nuclear Family		68	(44.4)		76	(51.0)		144	(47.7)
brother	26			15			41		
sister	10			23			33		
mother	8			15			23		
father	24			23			47		
Offspring		1			2			3	
son	1			2			3		
Clan Relative		30	(19.6)		9	(6.0)		39	(12.9)
unspecified clan sister	4			2			6		
unspecified clan brother	13			2			15		
sister's son	2			1			3		
mother's brother	4			1			5		
mother's sister	4			1			5		
mother's sister's daughter	2			1			3		
mother's mother's sister's son	1			1			2		
Father's Clan Relative		2	(1.3)		3	(2.6)		5	(1.7)
father's sister's son	1			1			2		
father's sister	1			—			1		
father's clan brother	—			1			1		
father's sister's daughter	—			1			1		
Miscellaneous "Relative"		4	(2.6)		3	(2.0)		7	(2.2)
mother's father's sister's son	3			—			3		
father's brother's son	1			—			1		
clan brother's daughter	—			2			2		
father's mother's father's sister's daughter	—			1			1		

$x^2 = 17.01$, df=6, p=.01)

No daughters and only three sons served as teachers. Only nine sandpainters were taught by individuals who were members of a younger generation than the student, reflecting the tendency for individuals to learn from their elders or their peers, a pattern common in all societies.

APPENDIX 7

(continued)

Teacher's relation to student	Sex of Student						Totals N	Category Totals	
	Male Student N	Category Subtotal N	%	Female Student N	Category Subtotal N	%		N	%
Affines		18			31			49	
spouse	18			31			49		
		18	(11.8)		18	(12.1)		36	(11.9)
sister's husband	3			3			6		
brother's wife	1			2			3		
wife's father	1	husband's father		1			2		
wife's brother	2	husband's brother		2			4		
wife's sister	1	husband's sister		3			4		
wife's sister's husband	2	husband's sister's husband		1			3		
clan sister's husband	2			—			2		
mother's sister's husband	2			1			3		
wife's mother's mother's sister's son	1			—			1		
wife's mother	1			—			1		
father's sister's second husband's son	2			—			2		
spouse's clan brother	—			1			1		
brother's wife's sister's husband	—			1			1		
spouse's brother's wife	—			2			2		
father's clan sister's husband	—			1			1		
Non-relatives		12	(7.8)		7	(4.7)		19	(6.3)
male teacher									
singer-teacher	2			—			2		
neighbor	2			1			3		
Christian Church member	1			—			1		
co-worker	2			1			3		
friend	4			—			4		
female									
neighbor	—			1			1		
friend	1			4			5		
	153		(99.9)	149		(99.9)	302		(100)

APPENDIX 8

Reasons for Beginning to Paint by Sex of Painter and Date of Starting

	Sex of Painter								Total	
	Male				Female					
	1962–69		1970–78		1962–69		1970–78			
Reasons Given	N	%	N	%	N	%	N	%	N	%
Spending money	6	26.1	45	36.0	8	36.4	54	44.6	113	38.8
Needs money	3	13.0	35	28.0	8	36.4	39	32.3	85	29.2
To pay bills	1	4.3	2	1.6	5	22.7	15	12.4	23	7.9
Make good money	8	34.8	8	6.4	1	4.5	9	7.4	26	8.9
Unemployed/laid off	6	26.1	35	28.0	1	4.5	3	2.5	45	15.5
More money than other jobs	3	13.0	5	4.0	—		2	1.7	10	3.4
Capital purchase	—		1	0.8	—		—		1	0.3
Save money for education	1	4.3	1	0.8	—		1	0.8	2	1.0
Help relative	6	26.1	17	13.6	9	40.9	25	20.7	57	19.6
Can pursue herding	1	4.3	4	3.2	2	9.1	4	3.3	11	3.8
Can stay on reservation	1	4.3	—		—		—		1	0.3
Can stay home with children	1	4.3	1	0.8	2	9.1	10	8.3	14	4.8
Independence	3	13.0	—		1	4.5	9	7.4	13	4.5
Enjoys traveling	—		—		—		6	5.0	6	2.1
Bored with housework	—		—		1	4.5	1	0.8	2	0.7
Hates to travel	—		—		2	9.1	—		2	0.7
Disabled/sick	—		1	0.8	—		1	0.8	2	0.7
To help relatives financially	—		—		1	4.5	—		1	0.3
Fun to make	1	4.3	2.	1.6	1	4.5	7	5.8	11	3.8
Relaxing	—		2	1.6	—		—		2	0.7
Aesthetic satisfaction	4	17.4	—		2	9.1	—		6	2.1
Hobby	—		10	8.0	—		2	1.7	12	4.1
Fame	2	8.7	—		1	4.5	—		3	1.0
Not messy	—		1	0.8	—		—		1	0.3
Gift of Mother Earth	1	4.3	—		—		—		1	0.3
Easy to make	—		2	1.6	1	4.5	2	1.7	5	1.7
Save Navajo heritage	3	13.0	—		—		—		3	1.0
Education	3	13.0	—		1	4.5	—		4	1.4
No. of respondents	23		125		22		121		291	

APPENDIX 9

Religious Affiliation of Sandpainters by Sex of Painter and Date of Starting

Religious Affiliation	Date Began**								Totals
	1962–1969				1970–1978				
	Male N	%	Female N	%	Male N	%	Female N	%	
Traditional	10	45.5	7	38.9	12	15.4	16	21.0	45
Fundamentalist	7	31.8	5	27.8	23	29.5	33	43.4	68
Mormon	1	4.5	—		6	7.7	—		7
Catholic	—		—		3	3.8	11	14.5	14
Protestant	—		1	5.6	3	3.8	2	2.6	6
NAC*	—		—		15	19.2	2	2.6	17
none	—		—		2	2.6	1	1.3	3
Combinations									
tradition/ fundamentalist	1	4.5	2	11.1	7	9.0	1	1.3	11
traditional/ Mormon	1	4.5	2	11.1	1	1.3	1	1.3	5
traditional/ NAC	2	9.1	1	5.6	5	6.4	4	5.3	12
Fundamentalist/ NAC	—		—		1	1.3	1	1.3	2
Traditional/ Catholic	—		—		—		4	5.3	4
Totals	22	99.9	18	100.0	78	100.0	76	99.9	194
no data	1		4		47		45		97
Total	23		22		125		121		291

*Native American Church
**No date when began = male = 2 Fundamentalist, 3 no data; female = 4 Fundamentalist, 2 no data.

Summary by Date

Religious Affiliation*	Date When Began				Totals N	%
	1962–69 N	%	1970–78 N	%		
Traditional	17	(42.5)	28	(18.5)	45	(23.6)
Christian	14	(35.0)	81	(53.6)	95	(49.7)
NAC	—		17	(11.3)	17	(8.9)
Combination	9	(22.5)	25	(16.6)	34	(17.8)
Totals	40	(100)	151	(100)	191	(100)

*No religion—3.

APPENDIX 10

Educational Level of Navajo Sandpainters by Age and Sex*

	Males**				Females†				Navajos in U.S. Census	
	Under 25	%	Over 25	%	Under 25	%	Over 25	%	No.	%
No school	—		4	13.8	—		2	11.1	12,549 (38.0)	
1 to 4 years	1	2.4	6	20.7	—		8	44.4	3,532 (10.7)	
5 to 7	2	4.8	3	10.3	1	2.1	3	16.7	4,684 (14.2)	
8	—		2	6.9	1	2.1	—		2,330 (7.1)	
9 to 11	7	16.7	5	17.2	14	29.8	1	5.6	3,687 (11.2)	
12	28	66.7	8	27.6	28	59.6	4	22.2	4,576 (13.9)	
13 to 16	4	9.5	—		2	4.3	—		1,299 (3.9)	
17 or more	—		1	3.4	1	2.1	—		325 (1.0)	
Totals	42	100.1	29	99.1	47	100.0	18	100.0	32,982 (100)	
Mean	11.7 years		7.2 years		11.4 years		5.4 years		—	
Median	12 years		8 years		12 years		4 years	5.3 years		
% graduated from high school	76.2		31.0		66.0		22.2		18.8	

*Age is adjusted to 1970.
**Males still in school when interviewed = ages in 1970 (2, 2, .3, 5, 5, 9, 10 10, 10, 10, 11, 12 [college], 14 [college]).
†Females still in school when interviewed = ages in 1970 (2, 3, 5, 8, 8, 9, 9, 12, 12 [college]).

APPENDIX 11

Occupation of Painters by Date of Starting and Sex of Maker

	Time Period*									
	1962–1969				1970–1978					
Occupation	Male	%	Female	%	Male	%	Female	%	Total	%
Income producing										
livestock	2		2		8		7		19	
crafts	2		—		2		—		4	
laborer	1		1		6		1		9	
gardener housekeeper	1		—		1		2		4	
waitress	—		—		—		1		1	
auto mechanic	3		—		1		—		4	
nurse or teacher's aide	—		—		—		2		2	
construction/ sawmill	—		—		6		—		6	
secretary/ clerk/teacher	—		1		2		3		6	
business	—		—		1		—		1	
preacher	1		—		—		—		1	
Total	10	43.5	4	19.0	27	31.0	16	14.8	57	23.8
Non-income producing										
housewife	—		11		—		50		61	
disabled	—		—		1		—		1	
unemployed	7		—		26		7		40	
Total	7	30.4	11	52.4	27	31.0	57	52.8	102	42.7
In school	6	26.1	6	28.6	33	37.9	35	32.4	80	33.5
N	23	100.0	21	100.0	87	99.9	108	100.0	239	100.0
no data	—		1		38		13		52	

*No data on time period: male 2 in school, 4 no data; female 4 in school, is unknown.

BIBLIOGRAPHY

Aberle, David F.
 1966 "The Peyote Religion Among the Navajo." In *Viking Fund Publications in Anthropology*, no. 42. Aldine Publishing Co., Chicago.
 1967 "The Navajo Singer's Fee: Payment or Presentation." In *Studies in Southwestern Ethnolinguistics*, edited by D. H. Hymes and W. E. Bittle, pp. 15–32. Mouton Co., The Hague.
 1969 "A Plan for Navajo Economic Development." In *Toward Economic Development for Native American Communities*. A paper submitted to the Subcommittee on Economy in Government of the Joint Economic Committee, Congress of the United States, 91st Congress, vol. 1, Development Prospects and Problems. Government Printing Office, Washington, D.C.
 1973 "The Navajo." In *Matrilineal Kinship*, edited by David Schneider and Kathleen Gough. University of California Press, Berkeley and Los Angeles.
Abramson, J. A.
 1976 "Style Change in an Upper Sepik Contact Situation." In *Ethnic and Tourist Arts: Cultural Expressions from the Fourth World*, edited by N. H. Graburn, pp. 249–265. University of California Press, Berkeley and Los Angeles.
Adair, John
 1944 *The Navajo and Pueblo Silversmiths*. University of Oklahoma Press, Norman.

[219]

Albuquerque Herald
 1923 Untitled article on opening of El Navajo Hotel: in
 files at the Museum of Northern Arizona. Dated May
 26, 1923.
Amsden, Charles
 1930 "The Changing Indian: The Intertribal Ceremonial
 at Gallup." In *The Masterkey*, vol. 4, no. 4, pp.
 101–109.
Amsden, Charles A.
 1934 *Navajo Weaving: Its Technic and History*. The Fine
 Arts Press, Santa Ana.
 1949 *Navajo Weaving: Its Technic and History*. University
 of New Mexico Press, Albuquerque.
Anderson, Richard L.
 1979 *Art in Primitive Societies*. Prentice-Hall, Englewood
 Cliffs, N.J.
Anonymous
 1923 Navajo Sandpaintings as Decorative Motive. In
 El Palacio, vol. 14, no. 12, pp. 174–183.
 1927 "Review of Westlake Book." In *El Palacio*, vol. 19,
 no. 1, p. 36.
 1938a The House of Navajo Religion. In *El Palacio*,
 vol. 45, nos. 24–26, pp. 116–118.
 1938b Illustration. "Whirling Logs" painting by Bruce
 Richards. *Arizona Highways*, vol. 14, no. 12, p. 24.
 1941a "Navajo Sandpainting for Museum." In *El Palacio*,
 vol. 48, no. 2, pp. 29–30.
 1941b "Sandpainting Exhibit at Museum of New
 Mexico." In *El Palacio*, vol. 48, no. 8, p. 184.
 1953 *Native Crafts for Camp and Playground*. National
 Recreation Association Publications, New York.
 1964 "New Southwest Museum Exhibit Features Aborigi-
 nal American Arts." In *The Masterkey*, vol. 38,
 no. 4, pp. 125–129.
Arizona Highways
 1974 Special issue on Southwestern jewelry, vol. 50, no. 1.
Arizona Republic
 1952 Anonymous newspaper clipping on E. George de-
 Ville, vol. 63, no. 19. Friday, June 6, 1952.
 1953 Anonymous newspaper clipping on E. George de-
 Ville, vol. 64, no. 81. Sunday, November 15, 1953.
Armer, Laura
 1925 "A Navajo Sandpainting." In *University of Califor-
 nia Chronicle*, vol. 27, pp. 233–239.
 1931a "Sandpainting of the Navajo Indians." Leaflets of
 the Exposition of Indian Tribal Arts, N.Y.

1931b "Navajo Sandpaintings." In *American Anthropologist*, vol. 33, p. 657.

1953 "The Crawler, Navaho Healer." In *The Masterkey*, vol. 27, no. 1, pp. 5–10.

1960 "A Visit to the Hopi." In *Desert Magazine*, vol. 23, no. 5, pp. 24–26.

1961 "I Give You Na Nai (Singer of Mountain Chant)." In *Desert Magazine*, vol. 24, no. 2, pp. 15–17.

Bahti, Tom
1970 *Southwestern Indian Ceremonials*. K. C. Publications, Flagstaff.

Baird, Bonnie
1962 Untitled newspaper article on Luther Douglas. In *Idaho Tribune* (in files of Navajo Tribal Museum).

Baker, G. Carpenter
1940 "They Borrowed Their Art from the Ancients." In *Desert Magazine*, vol. 4, no. 1, pp. 11–12.

Bartos, Sally and La Verne Bartos
n.d. "Little Friends Coloring Book." *The Navajo Times*, Window Rock.

Bascom, William R.
1973 "A Yoruba Master Carver: Duga of Neko." In *The Traditional Artist in African Societies*, edited by Warren L. d'Azevedo, pp. 62–78. Indiana University Press, Bloomington.

Beals, Ralph L.
1943 "The Aboriginal Culture of the Cahita Indians." In *Ibero-American*, vol. 19. University of California Press, Los Angeles.

Bedinger, Margery
1973 *Indian Silver; Navajo and Pueblo Jewelers*. University of New Mexico Press, Albuquerque.

Begay, Harrison and Leland C. Wyman
1967 *The Sacred Mountains of the Navajo*. Northland Press, Flagstaff.

Ben-Amos, Paula
1973 Pidgin Languages and Tourist Arts. School of American Research. (Mimeograph) Santa Fe.

1976 "A La Recherche da Temps Perdu: On Being an Ebony-Carver in Benin." In *Ethnic and Tourist Arts, Cultural Expressions from the Fourth World*, edited by Nelson H. H. Graburn, pp. 320–333. University of California Press, Berkeley and Los Angeles.

Berndt, Ronald Murray
1964 *Australian Aboriginal Art*. Ure Smith Pty. Ltd. Sydney.

Berndt, Roland Murray and Catherine H. Berndt
 1964 *The World of the First Australians: An Introduction to the Traditional Life of the Australian Aborigines.* Thomas and Hudson, Ltd., London.

Berry, Rose V. S.
 1929 "The Navajo Shaman and His Sacred Sandpainting." In *El Palacio*, vol. 26, no. 2, pp. 23–38.

Biebuyck, Daniel P.
 1976 The Decline of Lega Sculpture. In *Ethnic and Tourist Arts: Cultural Expressions from the Fourth World*, edited by Nelson H. H. Graburn, pp. 334–349. University of California Press, Berkeley and Los Angeles.

Boas, Franz
 1955 *Primitive Art.* Dover Publications, Inc., New York.

Bond, D. Clifford
 1944 Sandpainting Illustration and untitled article. In *Arizona Highways*, vol. 20, no. 8, pp. 33, 36–37.

Bourke, John G.
 1892 "The Medicine-Men of the Apache." *Ninth Annual Report of the Bureau of Ethnology, 1887–1888.* Government Printing Office, Washington, D.C.

Braynard, Frank Osborn
 1978a *Famous American Ships.* Hastings House Publishers, New York.

Briggs, Charles
 1974 "Folk Art Between Two Cultures: The Wood-Carvers of Cordova, New Mexico." University of Chicago (manuscript), Chicago.
 1979 *The Wood Carvers of Cordova, New Mexico: Social Dimensions of an Artistic "Revival."* University of Tennessee Press, Knoxville.

Brody, J. J.
 1971 *Indian Painters and White Patrons.* University of New Mexico Press, Albuquerque.
 1974 "In Advance of the Ready Made: Kiva Murals and Navaho Dry-paintings." In *Art and Environment in Native America*, edited by Mary Elizabeth King and Idris R. Taylor, pp. 11–22. Texas Tech Press, Lubbock.

Brody, J. J.
 1976 "The Creative Consumer: Survival, Revival and Invention in Southwest Indian Arts." In *Ethnic and Tourist Arts: Cultural Expressions from the Fourth World*, edited by Nelson H. H. Graburn, pp. 70–84. University of California Press, Berkeley and Los Angeles.

Brugge, David M.
 1963 Navajo Pottery and Ethnohistory. *Navajoland Publications*, no. 2. Navajo Tribal Museum, Window Rock.
 1976 "Small Navajo Sites: A Preliminary Report on Historic Archaeology in the Chaco Region." In *Limited Activity and Occupation Sites*, edited by Albert E. Ward. *Contributions to Anthropological Studies*, no. 1, Albuquerque.
Bunzel, Ruth L.
 1932 "Introduction to Zuñi Ceremonialism." *Forty-seventh Annual Report of Bureau of American Ethnology*, pp. 467–544. Government Printing Office, Washington, D.C.
 1972 The Pueblo Potter: A Study of Creative Imagination in Primitive Art. *Columbia University Contributions to Anthropology*, no. 8. Dover Publications, Inc., New York.
Callaway, D. G., J. E. Levy and E. B. Henderson
 1976 The Effects of Power Production and Strip Mining on Local Navajo Populations. *Lake Powell Research Project Bulletin*, no. 22. Institute of Geophysics and Planetary Physics, University of California, Los Angeles.
Clark, Anna Nolan
 1940 "Medicine Man's Art." In *New Mexico Magazine*, vol. 18, no. 5, pp. 20, 35–37.
Collier, John
 1935 "Contemporary Arts and Crafts: Century of Progress Chicago 1934." In *Indians at Work*, vol. 2, no. 88257, pp. 1–17.
Colton, Harold S.
 1959 *Hopi Kachina Dolls, with a Key to their Identification*. University of New Mexico Press, Albuquerque.
Coolidge, Dane and Mary Roberts Coolidge
 1930 *The Navajo Indians*. Houghton Mifflin, Boston.
Crowley, Daniel J.
 1970 "The Contemporary-Traditional Art Market in Africa." In *African Arts*, vol. 4, no. 1, pp. 43–49, 80.
Cummings, Byron
 1936 "Navajo Sandpaintings." In *The Kiva*, vol. 1, no. 7.
 1952 "Indians I Have Known." In *Arizona Silhouettes*, Tucson.
Cummings, Emma
 1936 "Sand Pictures in the Arizona State Museum." In *The Kiva*, vol. 1, no. 7.

Curtis, Edward S.
> 1907 "The Apache, The Jicarillas, The Navajo." In *North American Indian*, vol. 1. Cambridge University Press, Cambridge.

Cushing, Frank
> 1883 "Zuñi Fetishes." *The Second Annual Report of the Bureau of Ethnology*. Government Printing Office, Washington, D.C.

Day, Samuel E., Jr.
> 1880- Collection, Special Collections Division, Northern
> 1940 Arizona University Library, Flagstaff.

Dine be Azee Iil' iini'yee'ahot'a
> 1979 By-Laws. Navajo Public Health Authority, Window Rock.

Dockstader, Frederick J.
> 1954a "The Kachina and the White Man: A Study of the Influences of White Culture on the Hopi Kachina Cult." *Cranbrook Institute of Science Bulletin*, no. 35. Bloomfield Hills, Michigan.
> 1954b "Sandpaintings by Captain L. A. Douglas." Brochure for showing at Kennedy Galleries, Inc., N.Y.
> 1955 "Sandpainting." *Cranbrook Institute of Science Newsletter*, vol. 24, no. 8, p. 91.

Dorsey, George A.
> 1903 "The Arapaho Sun Dance; The Ceremony of the Offerings Lodge." In *Field Columbian Museum, Anthropology Series*, vol. 4. Chicago.
> 1905 "The Cheyenne. I. Ceremonial Organization, II. The Sun Dance." In *Field Columbian Museum, Anthropology Series*, vol. 9, no. 1 and 2, Chicago.

Dorsey, George A. and H. R. Voth
> 1901 "The Oraibi Soyäl Ceremony." In *Field Columbian Museum Anthropology Series*, vol. 3, no. 1. Chicago.
> 1902 "The Mishongnovi Ceremonies of the Snake and Antelope Fraternities." In *Field Museum of Natural History, Anthropological Series*, vol. 3, no. 3, pp. 162–261. Chicago.

Douglas, Conda E. and Russell P. Hartman
> 1980 *Luther Douglas Navajo Indian Ceremonial Sandpaintings*. Blatchley Gallery of Art, College of Idaho, Caldwell.

Dozier, Edward P.
> 1970 *The Pueblo Indians of North America*. Holt, Rinehart and Winston, Inc., N.Y.

DuBois, Constance Goddard
 1908 "The Religion of the Luiseño Indians of Southern
 California." In *University of California Publications
 in American Archaeology and Ethnology*, vol. 8,
 no. 3, pp. 69–186. University of California Press,
 Berkeley and Los Angeles.
Duclos, Antoinette S.
 1942 "Navajo Warp and Woof." In *Arizona Highways*,
 vol. 18, no. 8, pp. 11–15.
Dunn, Dorothy
 1952a "Pablita Velarde: Painter of Pueblo Life." In *El
 Palacio*, vol. 59, no. 11, pp. 335–341.
 1952b "The Art of Joe Herrera." In *El Palacio*, vol. 59,
 no. 12, pp. 357–373.
 1960 "Studio of Painting, Santa Fe Indian School." In *El
 Palacio*, vol. 67, no. 1, pp. 16–27.
 1968 *American Indian Painting of the Southwest and
 Plains Areas*. University of New Mexico Press,
 Albuquerque.
 1972 "A Documented Chronology of Modern American
 Indian Painting of the Southwest." In *Plateau*,
 vol. 44, no. 4, pp. 150–162.
Dutton, Bertha Pauline
 1941 "The Navajo Windway Ceremonial." In *El Palacio*,
 vol. 48, no. 4, pp. 73–82.
 1957a "Indian Artistry in Wood and Other Media." In *El
 Palacio*, vol. 64, nos. 1–2, pp. 3–28.
 1957b "Indian Art: Ceremonial to Commercial." In *Smoke
 Signals*, no. 22, pp. 4–7.
 1962 *Navajo Weaving Today*. The Museum of New
 Mexico Press, Santa Fe.
 1963a *Indians of the Southwest: Pocket Handbook*. South-
 west Association on Indian Affairs, Inc., Santa Fe.
 1963b *Sun Father's Way: The Kiva Murals of Kuaua,
 A Pueblo Ruin, Coronado State Monument,
 New Mexico*. University of New Mexico Press,
 Albuquerque.
Dyk, Walter
 1938 *Son of Old Man Hat, A Navajo Autobiography*. Har-
 court Brace and Co., N.Y.
Editors of El Palacio
 1974 *Navajo Weaving*. Museum of New Mexico Press,
 Santa Fe.
Eickemeyer, Carl and Lilian Westcott Eickemeyer
 1895 *Among the Pueblo Indians*. The Merriam Co., N.Y.

Elkan, Walter
 1958 "East African Trade in Wood Carving." In *Africa*,
 vol. 28, pp. 314–323.
El Paso Times
 1955 Anonymous newspaper clipping on E. George de-
 Ville, April 18, 1955.
Fagg, William
 1969 "The African Artist." In *Tradition and Creativity in
 Tribal Art*, edited by Daniel P. Biebuyck, pp. 42–57.
 University of California Press, Berkeley and Los
 Angeles.
Fewkes, J. Walter
 1900a "Tusayan Flute and Snake Ceremonies." *19th
 Annual Report of Bureau of American Ethnology*,
 1897–1898, pp. 957–1011, Part 2. Government Print-
 ing Office, Washington, D.C.
 1903 "Hopi Kachinas Drawn by Native Artists." *21st
 Annual Report of Bureau of American Ethnology*,
 1899–1900, pp. 3–126. Government Printing Office,
 Washington, D.C.
 1927 "The Katchina Altars in Hopi Worship." *Smith-
 sonian Report 1926*, pp. 469–486. Government
 Printing Office, Washington, D.C.
Fewkes, J. Walter and J. G. Owens
 1892 "The Lá-Lá-Kon-ta: A Tusayan Dance." In *Ameri-
 can Anthropologist*, o.s., vol. 3, no. 2, pp. 105–129.
Fondo Editorial de la Plastica Mexicana
 1971 "The Ephemeral and the Eternal of Mexican Folk
 Art," vol. 2, Mexico.
Forbes, Anne
 1950 "A Survey of Current Pueblo Indian Paintings." In
 El Palacio, vol. 57, no. 8, pp. 235–251.
Forbes, Jack D.
 1960 *Apache, Navaho and Spaniard*. University of Okla-
 homa Press, Norman.
Foster, Kenneth L.
 1964 Navajo Sandpaintings. *Navajo Tribal Museum Series
 3*. Navajoland Publications, Window Rock.
Franciscan Fathers
 1910 *An Ethnographic Dictionary of the Navaho Lan-
 guage*. St. Michael's Press, St. Michaels, Arizona.
Fraser, Douglas
 1971 "The Discovery of Primitive Art." In *Anthropology
 and Art: Readings in Cross-Cultural Aesthetics*,
 edited by Charlotte M. Otten, pp. 20–36. Natural
 History Press, Garden City, N.Y.

Frisbie, Charlotte Johnson

 1967 *Kinaalda: A Study of the Navajo Girls' Puberty Ceremony*. Wesleyan University Press, Middleton, Conn.

 1968 "The Navajo House Blessing Ceremonial." In *El Palacio*, vol. 75, no. 3, pp. 27–35.

 1977a Navajo Jish or Medicine Bundles and Museums. *Council for Museum Anthropology*, vol. 1, no. 4.

 1977b "*Jish* and the Question of Pawn." In *The Masterkey*, vol. 51, no. 4, pp. 127–139.

Gatschet, Albert

 1885 "Chiricahua Apache Sun Circle Painting." In *Miscellaneous Collections, Smithsonian Institution*, vol. 34, pp. 144–147. Government Printing Office, Washington, D.C.

Gifford, E. W.

 1933 "The Cocopa." In *University of California Publications in American Archaeology and Ethnology*, vol. 31, no. 5, pp. 257–334.

Gilpin, Laura

 1968 *The Enduring Navaho*. University of Texas Press, Austin.

Goldwater, Robert J.

 1967 *Primitivism in Modern Art*. Vintage Books, N.Y.

Goodwin, Grenville

 1945 "A Comparison of Navaho and White Mountain Apache Ceremonial Forms and Categories." In *Southwest Journal of Anthropology*, vol. 1, no. 4, pp. 498–506.

Gordon, Antoinette K.

 1963 *Tibetan Religious Art*. Paragon Book Reprint Corp., N.Y.

Graburn, Nelson H. H.

 1967 "The Eskimo and 'Airport Art'." In *Trans-action*, vol. 4, no. 10, pp. 28–33.

 1969 "Art and Acculturative Processes." In *International Social Science Journal*, vol. 21, no. 3, pp. 457–463.

 1972 "A Preliminary Analysis of Symbolism in Eskimo Art and Culture." In *Proceedings of the XL International Congress of Americanists*, Rome, vol. 2, pp. 165–170.

Graburn, Nelson H. (Ed.)

 1976 *Ethnic and Tourist Arts; Cultural Expressions from the Fourth World*. University of California Press, Berkeley and Los Angeles.

Grattan, Virginia L.
 1980 *Mary Colter, Builder Upon the Red Earth*. Northland
 Press, Flagstaff.
Haile, Berard
 1938 "Navaho Chantways and Ceremonials." In *Ameri-
 can Anthropologist*, vol. 40, no. 4, pp. 639–652.
 1950 *Legend of the Ghostway Ritual in the Male Branch of
 Shootingway; Suckingway, Its Legend and Practice*.
 St. Michael's Press, St. Michaels, Arizona.
Haile, Berard, Maud Oakes and Leland Wyman
 1957 "Beautyway: A Navajo Ceremonial." In *Bollingen
 Series LIII*, Pantheon Books, N.Y.
Harvey, Byron III
 1963 "New Mexico Kachina Dolls." In *The Masterkey*,
 vol. 37, no. 1, pp. 4–8.
 1965 "A Sidelight on Navajo Blankets." In *The Master-
 key*, vol. 39, no. 1, pp. 36–38.
 1970 "Ritual in Pueblo Art: Hopi Life in Hopi Painting."
 In *Contributions from the Museum of the American
 Indian, Heye Foundation*, vol. 24. N.Y.
Hegemann, Elizabeth Compton
 1962 "Navajo Silver." *Southwest Museum Leaflets*,
 no. 29. Southwest Museum, Los Angeles.
Henderson, Eric
 1979 "Skilled and Unskilled Blue Collar Navajo Workers:
 Occupational Diversity in an American Indian
 Tribe." In *The Social Science Journal*, vol. 16,
 no. 2, pp. 63–80.
Henderson, Eric and Jerrold E. Levy
 1975 "Survey of Navajo Community Studies 1936–
 1974." *Lake Powell Research Project Bulletin*,
 no. 6. Institute of Geophysics and Planetary Physics,
 University of California, Los Angeles.
Heraldo, C.
 1974 *Lo Efimero y Eterno del Arte Popular Mexicano*,
 vol. II. Fondo Editorial de la Pleistica Mexicana,
 Mexico.
Hill, Willard Williams
 1936a "Navaho Rites for Dispelling Insanity and
 Delirium." In *El Palacio*, vol. 41, nos. 14, 15, 16,
 pp. 71–74.
 1936b "Navaho Warfare." *Yale University Publications
 in Anthropology*, no. 5. Yale University Press, New
 Haven.

1938 "The Agricultural and Hunting Methods of the Navajo Indians." *Yale University Publications in Anthropology*, no. 18. Yale University Press, New Haven.

1943 "Navaho Humor." *General Series in Anthropology*, no. 9. American Anthropological Association, Menasha.

1944 "The Navajo Indians and the Ghost Dance of 1890." In *American Anthropologist*, vol. 46, no. 4, pp. 523–527.

Holz, Loretta
1977 *How to Sell Your Art and Crafts: A Marketing Guide for Creative People*. Charles Scribner's Sons, N.Y.

Hubbell, Roman
1947 Affidavit Concerning Value of Reproductions of Sandpaintings. Taylor Museum of the Colorado Springs Fine Art Center.

James, George Wharton
1904 *The Indians of the Painted Desert Region; Hopis, Navahoes, Walapais, Havasupais*. Little, Brown, Boston.

1974 *Indian Blankets and Their Makers*. Dover Publications, N.Y.

James, H. L.
1976 "Posts and Rugs: The Story of Navajo Rugs and Their Homes." *Southwestern Monuments Association Popular Series*, no. 15, Southwest Parks and Monuments Association, Globe, Arizona.

Jeançon, Jean Allard and F. H. Douglas
1932 "Indian Sandpainting: Tribes, Technics and Uses." *Denver Art Museum Leaflets* no. 43 and 44. Denver.

Joe, Eugene Baatsoslanii, Mark Bahti and Oscar T. Branson
1978 *Navajo Sandpainting Art*. Treasure Chest Publications, Inc., Tucson.

Johnson, Barbara
1960 "The Wind Ceremony: A Papago Sand-Painting." In *El Palacio*, vol. 67, no. 1, pp. 28–31.

Johnson, Bernice Eastman
1962 *California's Gabrieliño Indians*. Southwest Museum Press, Los Angeles.

Judd, Neil Merton
1931 *Indian Sculpture and Carving*. Exposition of Indian Tribal Arts, Inc., N.Y.

Kaplan, Bert and Dale Johnson
 1964 "The Social Meaning of a Navajo Psychopathology and Psychotherapy." In *Magic, Faith and Healing*, edited by Ari Kiev, pp. 203–229. Free Press, N.Y.

Kaufmann, Carole
 1969 Changes in Haida Indian Argillite Carvings. Unpublished doctoral dissertation, Department of Anthropology, University of California at Los Angeles.
 1976 "Functional Aspects of Haida Argillite Carvings." In *Ethnic and Tourist Arts: Cultural Expressions from the Fourth World*, edited by Nelson H. H. Graburn, pp. 56–69. University of California Press, Berkeley and Los Angeles.

Kent, Kate Peck
 1961 *The Story of Navaho Weaving*. The Heard Museum of Anthropology and Primitive Art, Phoenix.
 1976 "Pueblo and Navajo Weaving Traditions and the Western World." In *Ethnic and Tourist Arts: Cultural Expressions from the Fourth World*, edited by Nelson H. H. Graburn, pp. 85–101. University of California Press, Berkeley and Los Angeles.

Keur, Dorothy Louise
 1941 "Big Bead Mesa: An Archaeological Study of Navajo Acculturation, 1745–1812." *Memoirs of the Society for American Archaeology*, no. 1. Menasha.

Kielhorn, Lila M.
 1936 "Weavers of Dreams." In *Arizona Highways*, vol. 12, no. 11, pp. 8–9, 23–24.

Kirk, Ruth F.
 1943 "Zuñi Fetish Worship." In *The Masterkey*, vol. 17, no. 4, pp. 129–135.

Kluckhohn, Clyde E.
 1923 "The Dance of Hasjelti." In *El Palacio*, vol. 15, no. 12, pp. 187–192.
 1939 "Some Personal and Social Aspects of Navajo Ceremonial Practice." In *Harvard Theological Review*, vol. 32, no. 1, Cambridge.
 1949 "The Philosophy of the Navaho Indians." In *Ideological Differences and World Order*, edited by Filmer Stuart Cuckow Northrop. Yale University Press, New Haven.
 1962 *Culture and Behavior: Collected Essays of Clyde Kluckhohn*, edited by Richard Kluckhohn. Free Press of Glencoe, N.Y.

1966 "The Ramah Navaho." *Bureau of American Ethnology Bulletin 196.* Government Printing Office, Washington, D.C.

Kluckhohn, Clyde and Dorothea Leighton
1962 *The Navaho.* Doubleday and Co., Inc., N.Y.

Kluckhohn, Clyde and Leland C. Wyman
1940 "An Introduction to Navaho Chant Practice." *Memoirs of the American Anthropological Association*, no. 53. Menasha.

Kroeber, A. L.
1923 "The History of Native Culture in California." *University of California Publications in American Archaeology and Ethnology*, vol. 20. University of California Press, Berkeley and Los Angeles.

1928 "Native Culture of the Southwest." *University of California Publications in American Archaeology and Ethnology*, vol. 23, no. 9, pp. 375–398. University of California Press, Berkeley and Los Angeles.

Kunitz, Stephen J. and Jerrold E. Levy
1981 "Navajos." In *Ethnicity and Medical Care*, edited by Alan Harwood. Harvard University Press, Cambridge.

Lamphere, Louise
1969 "Symbolic Elements in Navajo Ritual." In *Southwestern Journal of Anthropology*, vol. 25, no. 3, pp. 279–305.

1977 *To Run After Them: Cultural and Social Bases of Cooperation in a Navajo Community.* The University of Arizona Press, Tucson.

Lange, Charles H.
1968 *Cochiti, A New Mexico Pueblo, Past and Present.* Southern Illinois University Press, Carbondale.

Levy, Jerrold
1962 "Community Organization of the Western Navajo." In *American Anthropologist*, vol. 64, no. 4, pp. 781–801.

Liebler, H. Baxter
1969 *Boil My Heart for Me.* Exposition Press, Jericho, N.Y.

Low, Setha M.
1976 "Contemporary Ainu Wood and Stone Carving." In *Ethnic and Tourist Arts, Cultural Expressions from the Fourth World*, edited by Nelson H. H. Graburn, pp. 211–226. University of California Press, Berkeley and Los Angeles.

Lowie, Robert Harry
 1954 "Indians of the Plains." *Anthropological Handbook*,
 no. 1. American Museum of Natural History,
 McGraw Hill Book Co., N.Y.
Luckert, Karl W.
 1979 *Coyoteway, A Navajo Holyway Healing Ceremonial*.
 The University of Arizona Press, Tucson.
Mallery, Garrick
 1893 "Picture-Writing of the American Indians." *Annual
 Report* No. 10 *of the Bureau of American Ethnology
 1888–1889*. Government Printing Office,
 Washington, D.C.
Mathews, R. H.
 1896 "Australian Ground and Tree Drawings." In *American Anthropologist*, o.s., vol. 9, no. 2, pp. 33–49.
Matthews, Washington
 1885 "Mythic Dry-paintings of the Navajos." In *American Naturalist*, vol. 19, no. 10, pp. 931–939.
 1886 "Some Deities and Demons of the Navajos." In
 American Naturalist, vol. 20, no. 10, pp. 841–850.
 1887 "The Mountain Chant: A Navajo Ceremony." *Fifth
 Annual Report Bureau of American Ethnology,
 1883–1884,* pp. 379–467. Government Printing
 Office, Washington, D.C.
 1890 "The Gentile System of the Navajo Indians."
 In *Journal of American Folklore*, vol. 3, no. 9,
 pp. 89–110.
 1897 "Navaho Legends." In *American Folk-lore Society
 Memoirs*, vol. 5. Boston and New York.
 1902 "The Night Chant, A Navaho Ceremony." *Memoirs
 of the American Museum of Natural History*, vol. 6.
 American Museum Press, N.Y.
Maxwell, Gilbert S.
 1963 *Navajo Rugs; Past, Present and Future* (In collaboration with Eugene L. Conrotto). Desert-Southwest
 Publications, Palm Desert, California.
Mayer, Ralph
 1979 *The Painter's Craft: An Introduction to Artists'
 Methods and Materials*. Penguin Books, Harmondsworth, England.
McAllester, David P.
 1954 "Enemy Way Music: A Study of Social and Esthetic
 Values as Seen in Navajo Music." *Papers of the
 Peabody Museum of American Archaeology and
 Ethnology*, vol. 41, no. 3. Cambridge.

McGregor, John S.
> 1943 "Burial of an Early American Magician." In *Recent Advances in American Archaeology*. Proceedings of the American Philosophical Society, vol. 86(2):270–298.

McNitt, Frank
> 1962 *The Indian Traders*. University of Oklahoma Press, Norman.

Mead, Sidney M.
> 1976 "The Production of Native Art and Craft Objects in Contemporary New Zealand Society." In *Ethnic and Tourist Arts, Cultural Expressions from the Fourth World*, edited by Nelson H. H. Graburn, pp. 285–298. University of California Press, Berkeley and Los Angeles.

Miller, Wick
> 1930 "The Navajo and His Silver-work." *New Mexico Magazine*, vol. 8, no. 8, pp. 15–25.

Mills, George
> 1959 *Navaho Art and Culture*. Taylor Museum of the Colorado Springs Fine Arts Center, Colorado Springs.

Mookerjee, Ajitcoomar
> 1946 *Folk Art of Bengal, A Study of an Art For, and Of, The People*. University of Calcutta Press, Calcutta, India.

Morphy, Howard
> 1977 "Schematisation, Meaning and Communication in Toas." In *Form in Indigenous Art: Schematisation in the Art of Aboriginal Australia and Prehistoric Europe*, edited by Peter J. Ucko. *Prehistory and Material Culture Series*, no. 13, Australian Institute of Aboriginal Studies. Gerald Duckworth and Co., London.

Morphy, Howard and Robert Layton
> n.d. Choosing Among Alternatives: Cultural Transformation and Social Change in Aboriginal Australia and the French Jura. (manuscript)

Munn, Nancy D.
> 1966 "Visual Categories: An Approach to the Study of Representational Systems." In *American Anthropologist*, vol. 68, no. 4, pp. 936–950.

Neumann, David L.
> 1933 "Navajo Silver Dies." In *El Palacio*, vol. 35, no. 7–8, pp. 71–75.

Newcomb, Franc Johnson
> 1936 "Symbols in Sand." *New Mexico Association on Indian Affairs*, no. 11. Santa Fe.
> 1964 *Hosteen Klah, Navaho Medicine Man and Sand Painter*. University of Oklahoma Press, Norman.

Newcomb, Franc Johnson, Stanley Fishler and
 Mary C. Wheelwright
> 1956 "A Study of Navajo Symbolism." Papers of the Peabody Museum, vol. 32, no. 3. Harvard University, Cambridge.

Newcomb, Franc Johnson and Gladys Amanda Reichard
> 1937 *Sandpaintings of the Navaho Shooting Chant*. J. J. Augustin, N.Y.
> 1975 *Sandpaintings of the Navaho Shooting Chant*. Dover Publications, Inc., N.Y.

Oakes, Maud Van Cortlandt, Joseph Campbell and Jeff King
> 1943 *Where the Two Came to their Father; A Navajo War Ceremonial*. Pantheon Books, N.Y.

Olin, Caroline Bower
> 1972 "Navajo Indian Sandpainting: The Construction of Symbols." Doctoral dissertation, University of Stockholm, Department of Art.

Opler, Morris E.
> 1943 "The Character and Derivation of the Jicarilla Holiness Rite." *The University of New Mexico Bulletin* No. 390, *Anthropological Series*, vol. 4, no. 3. University of New Mexico Press, Albuquerque.
> 1944 "The Jicarilla Apache Ceremonial Relay Race." In *American Anthropologist*, vol. 46, no. 1, pp. 75–97.

Padres Trail
> 1968 "Indian Art" (expressing Christian themes in Navajo tapestry and sandpainting). In *Padres Trail*, vol. 31, no. 4, pp. 3–14.

Parsons, Elsie Clews
> 1920 "Notes on Ceremonialism at Laguna." In *Anthropological Papers of the American Museum of Natural History*, Vol. 19, Part 4. American Museum Press, N.Y.
> 1925a "A Pueblo Indian Journal, 1920–1921." *American Anthropological Association Memoirs*, no. 32. American Anthropological Association, Menasha.
> 1925b *The Pueblo of Jemez*. Yale University Press, New Haven.
> 1936 "Taos Pueblo." *General Series in Anthropology*, no. 2. American Anthropological Association, Menasha.
> 1939 *Pueblo Indian Religion*. University of Chicago Press, Chicago.

1941 "Notes on the Caddo." In *American Anthropological Association Memoirs*, no. 57. George Banta Publishing Co., Menasha.

1962 "Introduction and Commentary." In *Isleta Paintings*, edited by Ester S. Goldfrank. *U.S. Bureau of American Ethnology Bulletin*, no. 181. Smithsonian Institution, Washington, D.C.

Pepper, George Hubbard
1920 "Pueblo Bonito." *Anthropological Papers of the American Museum of Natural History*, vol. 27. American Museum Press, N.Y.

Powell, Peggy
1960 "David Villaseñor: Artist with Sand." In *Desert Magazine*, vol. 23, no. 2, pp. 2–3.

Reichard, Gladys A.
1928 *Social Life of the Navajo Indians, With Some Attention to Minor Ceremonies*. Columbia University Press, N.Y.

1934 *Spider Woman: A Story of Navajo Weavers and Chanters*. Macmillan Co., N.Y.

1936 *Navajo Shepherd and Weaver*. J. J. Augustin, N.Y.

1939a *Navajo Medicine Man; The Sandpaintings of Miguelito*. J. J. Augustin, N.Y.

1939b *Dezba; Woman of the Desert*. J. J. Augustin, N.Y.

1944a Prayer: The Compulsive Word. *Monographs of the American Ethnological Society*, No. 7. J. J. Augustin, N.Y.

1944b *The Story of the Navajo Hail Chant*. Columbia University Press, N.Y.

1963 "Navajo Religion: A Study of Symbolism." *Bollingen Series*, no. 18. Princeton University Press, Princeton, N.J.

1974 *Weaving a Navajo Blanket*. Dover Publications, Inc., N.Y.

1977 *Navajo Medicine Man Sandpaintings*. Dover Publications, Inc., N.Y.

Salt Lake Tribune
1939 Anonymous clipping on Mae deVille, December 31, 1939.

Salvador, Mari Lyn
1976 "The Clothing Arts of the Cuna of San Blas, Panama." In *Ethnic and Tourist Arts: Cultural Expressions from the Fourth World*, edited by Nelson H. H. Graburn, pp. 165–182. University of California Press, Berkeley and Los Angeles.

Santa Fe Railroad
1923 Navajo House Blessing, on the Opening of the Santa Fe Hotel; El Navajo. Unpublished, in files of Museum of Northern Arizona, Flagstaff.

Sapir, Edward
1935 "A Navajo Sandpainting Blanket." In *American Anthropologist*, vol. 37, no. 4, pp. 609–616.

Schaafsma, Polly
1963 "Rock Art in the Navajo Reservoir District." *Museum of New Mexico Papers in Anthropology*, no. 7. Museum of New Mexico Press, Santa Fe.
1980 "Indian Rock Art of the Southwest." *School of American Research Southwest Indian Art Series*. University of New Mexico Press, Albuquerque.

Schevill, Margaret E. Link
1947 *Beautiful on the Earth: A Study of Navajo Mythology*. Hazel Dreis Editions, Santa Fe.

Schwab, George
1947 "Tribes of the Liberian Hinterland." *Papers of the Peabody Museum of American Archaeology and Ethnology*, vol. 31. Harvard University Press, Cambridge.

Shepardson, Mary
1963 "Navajo Ways in Government." In *American Anthropologist*, vol. 65, no. 3, part 2.

Shreve, Margaret
1943 "Modern Papago Basketry." In *The Kiva*, vol. 8, no. 2.

Sloan, John and Oliver La Farge
1931 "Introduction to American Indian Art." *The Exposition of Indian Tribal Arts, Inc.*, Parts I and II, N.Y.

Smith, Dame Margaret
1939 "Navajo Rug." In *Arizona Highways*, vol. 15, no. 2, pp. 12–13, 27–29.

Smith, Watson
1952 "Kiva Mural Decorations at Awatovi and Kawaika-a." *Papers of the Peabody Museum of American Archaeology and Ethnology*, vol. 37. Harvard University Press, Cambridge.

Snodgrass, Jeanne O.
1968 "American Indian Painters: A Biographical Directory." *Heye Foundation Contributions*, vol. 21, part 1. Museum of the American Indian, N.Y.

Spencer, Katherine
1957 "Mythology and Values: An Analysis of Navaho Chantway Myths." *Memoirs of the American Folklore Society*, vol. 48. Philadelphia.

Spicer, Edward
 1961 "The Yaqui." In *Perspectives in American Indian Culture Change*, edited by Edward Spicer. University of Chicago Press, Chicago.
 1962 *Cycles of Conquest: The Impact of Spain, Mexico, and the United States on the Indians of the Southwest, 1533–1960*. The University of Arizona Press, Tucson.

Spier, Leslie
 1921 "The Sun Dance of the Plains Indians: Its Development and Diffusion." *Anthropological Papers of the American Museum of Natural History*, vol. 16, part 7. American Museum of Natural History Press, N.Y.
 1923 "Southern Diegueño Customs." *University of California Publications in American Archaeology and Ethnology*, vol. 20. University of California Press, Berkeley and Los Angeles.
 1978 *Yuman Tribes of the Gila River*. Dover Publications, Inc., N.Y.

Spinden, Herbert J.
 1931 "Indian Symbolism." *Exposition of Indian Tribal Arts*, no. 2. N.Y.

Stephen, Alexander MacGregor
 1936a "Hopi Journal." In *Columbia University Contributions to Anthropology*, vol. 23, parts 1 and 2, edited by Elsie Clews Parsons. Columbia University Press, N.Y.

Stevenson, James
 1891 "Ceremonial of Hasjelti Dailjis and Mythical Sandpainting of the Navajo Indians." *8th Annual Report of the Bureau of American Ethnology 1886–1887*, pp. 229–285. Government Printing Office, Washington, D.C.

Stevenson, Matilda Coxe
 1894 "The Sia." *11th Annual Report of the Bureau of American Ethnology 1889–1890*. Government Printing Office, Washington, D.C.
 1904 "The Zuñi Indians: Their Mythology, Esoteric Societies and Ceremonies." *23rd Annual Report of the Bureau of American Ethnology 1901–1902*. Government Printing Office, Washington, D.C.

Stewart, Omer Call
 1938a "The Navajo Wedding Basket." In *Plateau*, vol. 10, no. 9, pp. 25–28.
 1938b "Navaho Basketry as Made by Ute and Paiute." In *American Anthropologist*, vol. 40, no. 4, pp. 758–759.

Stewart, Omer Call and David F. Aberle
　　1957 "Navajo and Ute Peyotism: A Chronological and Distributional Study." *University of Colorado Studies,* no. 6. University of Colorado Press, Boulder.

Stirling, Matthew Williams
　　1942 "Origin Myth of Acoma and Other Records." *Bureau of American Ethnology Bulletin* 135. Government Printing Office, Washington, D.C.

Strong, William Duncan
　　1929 "Aboriginal Society in Southern California." *University of California Publications in American Archaeology and Ethnology*, vol. 26. University of California Press, Berkeley and Los Angeles.

Tanner, Clara Lee
　　1948 "Sandpaintings of the Indians of the Southwest." In *The Kiva*, vol. 13, nos. 3–4, pp. 26–36.
　　1957 *Southwest Indian Painting*. The University of Arizona Press, Tucson.
　　1960 "Contemporary Southwest Indian Silver." In *The Kiva*, vol. 25, no. 3, pp. 1–22.
　　1968 *Southwest Indian Craft Arts*. The University of Arizona Press, Tucson.
　　1973 *Southwest Indian Painting: A Changing Art*. The University of Arizona Press, Tucson.

Thompson, Robert Farris
　　1969 "Ábàtàn: A Master Potter of the Egbado Yoruba." In *Tradition and Creativity in Tribal Arts*, edited by Daniel Biebuyck. University of California Press, Berkeley and Los Angeles.
　　1971 "Black Gods and Kings: Yoruba Art at UCLA." *Occasional Papers of the Museum and Laboratories of Ethnic Arts and Technology*, no. 2, University of California Press, Los Angeles.

Toor, Frances
　　1939 *Mexican Popular Arts*. Frances Toor Studios, Mexico.

Tozzer, Alfred Marston
　　1902 "A Navajo Sandpicture of the Rain Gods and its Attendant Ceremony." In *International Congress of Americanists*, vol. 13, pp. 147–156. N.Y.
　　1909 "Notes on Religious Ceremonies of the Navajo." In *Putnam Anniversary volume*, pp. 299–343, G. E. Stechert & Co., N.Y.

Tracy, A.
 1961 "Kamba Carvers." In *African Music*, vol. 2, pp. 55–58.
Trafzer, Clifford E.
 1973 "Anglos Among the Navajos: The Day Family." In *The Changing Ways of Southwestern Indians: A Historical Perspective*, edited by Albert H. Schroeder. Rio Grande Press, Glorieta, New Mexico.
Tschopik, Harry, Jr.
 1941 "Navajo Pottery Making: An Inquiry Into the Affinities of Navajo Painted Pottery." *Papers of the Peabody Museum of American Archaeology and Ethnology*, vol. 17, no. 1, Harvard University Press, Cambridge.
Underhill, Ruth Murray
 1948 "Ceremonial Patterns in the Greater Southwest." *Monographs of the American Ethnological Society*, no. 13. J. J. Augustin, N.Y.
 1953 "Here Come the Navaho!" *United States Indian Service, Indian Life and Customs*, no. 8. Haskell Institute Printing Shop, Lawrence, Kansas.
 1956 *The Navajos*. University of Oklahoma Press, Norman.
United States Bureau of Census
 1973 *Census of the Population: 1970, Subject Reports, Final Report* PC(2)-IF, *American Indians*. Government Printing Office, Washington, D.C.
Villaseñor, David
 1963 *Tapestries in Sand; The Spirit of Indian Sandpainting*. Naturegraph Company, Healdsburg, California.
 1967 "Permanent Sandpaintings." In *The Masterkey*, vol. 41, no. 4, pp. 148–153.
Villaseñor, David and Jean Villaseñor
 1972 *How to do Permanent Sandpainting*. Litho-Color, Orange, California.
Vivian, R. Gwinn, Dulce N. Dodgen and Gayle H. Hartmann
 1978 "Wooden Ritual Artifacts from Chaco Canyon, New Mexico: The Chetro Ketl Collection." *Anthropological Papers of the University of Arizona*, no. 32. The University of Arizona Press, Tucson.
Vogt, Evon Z.
 1961 "Navaho." In *Perspectives in American Indian Culture Change*, edited by Edward H. Spicer, pp. 278–336. University of Chicago Press, Chicago.

Vogt, Evon Z., editor
1969 "Handbook of Middle American Indians," vols. 7 and 8. *Ethnology.* University of Texas Press, Austin.

Voth, H. R.
1901 "The Oraibi Powamu Ceremony." In *Field Museum of Natural History Anthropological Series*, vol. 3, no. 2, pp. 61–665. Field Museum of Natural History Press, Chicago.
1903 "The Oraibi Öáqöl Ceremony." *Field Columbian Museum Antrhopological Series*, vol. 6, no. 1, Publication No. 84. Field Museum of Natural History Press, Chicago.
1912 "The Oraibi Marau Ceremony." *Field Museum of Natural History Anthropological Series*, vol. 11, no. 1. Field Museum of Natural History Press, Chicago.

Wade, Edwin L.
1976 The Southwest Indian Art Market. Doctoral dissertation, unpublished. Department of Anthropology, University of Washington.

Waterman, Thomas Talbot
1910 "The Religious Practices of the Diegueño Indians." *University of California Publications in American Archaeology and Ethnology*, vol. 8, no. 6, pp. 271–358. University of California Press, Berkeley and Los Angeles.

Watson, Editha L.
1968 "An Odd Sandpainting Rug." In *El Palacio*, vol.75, no. 3, pp. 22–25.

Wellman, Paul Iselin
1945 Untitled article, *Kansas City Times*, January 25 (in files of Museum of Northern Arizona).

Westlake, Inez B.
1930 *American Indian Designs.* H. C. Perleberg, Philadelphia.

Wheat, Joe Ben
1976 "Weaving." In *Arizona Highways, Indian Arts and Crafts*, edited by Clara Lee Tanner, pp. 30–67. Arizona Highways, Phoenix.

Wheelwright, Mary
1938 "Tleji or Yeibechai Myth by Hosteen Klah." *Museum of Navajo Ceremonial Art Bulletin*, no. 1. Museum of Navajo Ceremonial Art Publications, Santa Fe.
1940 "Myth of the Big Star Chant and Coyote Chant." *Museum of Navajo Ceremonial Art Bulletin*, no. 2. Museum of Navajo Ceremonial Art Publications, Santa Fe.

1942 *Navajo Creation Myth: The Story of the Emergence*. Museum of Navajo Ceremonial Art Publications, Santa Fe.

1945 "Atsah or Eagle Catching Myth and Yohe or Bead Myth." *Museum of Navajo Ceremonial Art Bulletin*, no. 3. Museum of Navajo Ceremonial Art Publications, Santa Fe.

1946 "Hail Chant and Water Chant." *Museum of Navajo Ceremonial Art, Navajo Religion Series*, vol. 2. Museum of Navajo Ceremonial Art, Santa Fe.

Wheelwright, Mary C.
1949 "Emergence Myth According to the Hanelthnayhe or Upward-reaching Rite." *Museum of Navajo Ceremonial Art, Navajo Religion Series*, vol. 3. Museum of Navajo Ceremonial Art, Santa Fe.

1951 "Myth of the Mountain Chant and Beauty Chant." *Museum of Navajo Ceremonial Art Bulletin*, no. 5. Museum of Navajo Ceremonial Art Publications, Santa Fe.

White, Leslie Alvin
1942 "The Pueblo of Santa Ana, New Mexico." *Memoirs of the American Anthropological Association*, no. 60. Menasha.

Whittemore, Mary
1941 "Participation in Navajo Weaving." In *Plateau*, vol. 13, no. 3, pp. 49–52.

Williams, Aubrey Willis, Jr.
1970 "Navajo Political Process." *Smithsonian Contributions to Anthropology*, vol. 9. Government Printing Office, Washington, D.C.

Williams, Nancy
1976 "Australian Aboriginal Art in Yirrkala: The Introduction and Development of Marketing." In *Ethnic and Tourist Arts: Cultural Expressions from the Fourth World,* edited by Nelson H. H. Graburn. University of California Press, Berkeley and Los Angeles.

Wissler, Clark
1912a "Social Organization and Ritualistic Ceremonies of the Blackfoot Indians." *Anthropological Papers of the American Museum of Natural History*, vol. 7. American Museum Press, N.Y.

Witherspoon, Gary
1977 *Language and Art in the Navajo Universe*. University of Michigan Press, Ann Arbor.

Worth, Sol and John Adair

1972 *Through Navajo Eyes: An Exploration in Film Communication and Anthropology*. Indiana University Press, Bloomington.

Wyman, Leland C.

1952 "The Sandpaintings of the Kayenta Navaho." *University of New Mexico Publications in Anthropology*, vol. 7. University of New Mexico Press, Albuquerque.

1960 *Navaho Sandpainting: The Huckel Collection*. Taylor Museum, Colorado Springs.

1962 *The Windways of the Navaho*. Taylor Museum, Colorado Springs.

1965 "The Red Antway of the Navaho." *Museum of Navajo Ceremonial Art, Navajo Religion Series*, vol. 5. Museum of Navajo Ceremonial Art, Santa Fe.

1967 "Big Lefthanded, Pioneer Navajo Artist." In *Plateau*, vol. 40, no. 1, pp. 1–13.

1970a *Blessingway*. With three versions of the myth recorded and translated from the Navajo by Father Berard Haile. The University of Arizona Press, Tucson.

1970b "Sandpaintings of the Navajo Shootingway and the Walcott Collection." *Smithsonian Contributions to Anthropology*, no. 13. Government Printing Office, Washington, D.C.

1975 *The Mountainway of the Navajo*. With a myth of the female branch recorded and translated by Father Berard Haile. The University of Arizona Press, Tucson.

1983 *Southwest Indian Drypainting*. School of American Research and University of New Mexico Press, Albuquerque and Santa Fe.

Wyman, Leland and Flora L. Bailey

1943 "Navajo Upward-Reaching Way: Objective, Behavior, Rationale and Sanction." *University of New Mexico Anthropological Series Bulletin*, vol. 4, no.2. University of New Mexico Press, Albuquerque.

1946 "Navajo Striped Windway, an Injury-way Chant." In *Southwestern Journal of Anthropology*, vol. 2, no. 2, pp. 213–238.

1964 "Navaho Indian Ethnoentomology." *University of New Mexico Publications in Anthropology*, no. 12. University of New Mexico Press, Albuquerque.

Wyman, Leland and Clyde Kluckhohn
> 1938 "Navaho Classification of Their Song Ceremonials." *Memoirs of the American Anthropological Association*, no. 50. Menasha.

Young, Robert W. (Ed.)
> 1958 *The Navajo Yearbook, Report No. 7.* Bureau of Indian Affairs, Window Rock.
> 1961 *The Navajo Yearbook, Report No. 8, 1951–1961, A Decade of Progress.* Navajo Agency, Window Rock.

Zingg, Robert Mowry
> 1938 "The Huichols: Primitive Artists." *Contributions to Ethnology,* no. 1, University of Denver. G. E. Stechert and Co., N.Y.

ACKNOWLEDGMENTS

SINCE BEGINNING THIS PROJECT in 1977 my indebtedness to many individuals has grown tremendously. Intellectual stimulation was given by more people than I can ever thank. Almost everyone with whom I have ever talked about my project has expressed keen interest and made helpful suggestions. Jerrold Levy provided the stimulus and guidance to turn the term paper of a first year graduate student into a major study. My debt to him for encouragement, advice, training, and ideas can never be repaid; in fact, much of this monograph can and should be credited to him. Throughout this study I have benefited enormously from the critical advice of Constance Cronin, Richard Henderson, T. Patrick Culbert, Edwin Ferdon, Clara Lee Tanner, Barbara Babcock, Raymond Thompson, Alice Schlegel, Robert Netting and Keith Basso. Louise Lamphere, Charlotte Frisbie, and David Brugge read drafts and freely shared their research experience. Discussions with Jane Rosenthal, Keith Dixon, Barbara Staniskawski, Arthur Wolf, Emil Haury, Roger Owens, Scott Russell, Lynn Robbins, Patricia Crown, J. J. Brody, Dorothy Washburn, Richard Ford, Kate Peck Kent, James Neely, Bertha Dutton, Christine Szuter, Thomas Sheridan, Arthur Dockstader, Randall McGuire, Frederick Dockstader, Norman and Vita Henderson, Otis Dudley Duncan, Bernard Fontana, Lawrence Santi,

Holly Chaffee, Christine Conti, Kathy Kamp, Susan McGreevy, Donald Callaway, John Tanner, Salli Wagner, Colin Renfrew, John Wilson, Barton Wright, Gwinn Vivian, Emory Sekaquaptewa, John Alexander, Ann Herdlund, Joe Ben Wheat, Alfonso Ortiz, Katherine Spencer Halpern, Richard Ahlborn, Nelson Graburn, Charles Briggs and unnumerable others are all acknowledged with thanks. My special thanks go to Eric Henderson who helped me organize my project, analyze the data, and continually told me that I could do it. I would also like to thank Rebecca and Nathaniel Ford for the many tedious hours they spent helping me grind stones and experiment making sandpaintings. Ruth Perry, Harriet White, Anita Iannuci, John Whittaker and Jennifer Fox I would like to thank for their technical assistance.

I would also like to thank the personnel of the many museums I visited and with whom I corresponded. The Taylor Museum, the Maxwell Museum, the Laboratory of Anthropology, the Arizona State Museum, the Southwest Museum, the Los Angeles County Museum of Natural Science, the Museum of New Mexico, the Smithsonian Institution, the Navajo Tribal Museum and the Museum of Northern Arizona all helped in my quest for historic data and reproductions of sacred sandpaintings. Some of the field expenses for this research were provided by grants from the Comins Fellowship for the Study of American Indian Art, the University of Arizona, the Graduate Student Development Fund, the University of Arizona, and a Department of Anthropology Dissertation Grant from the Museum of Northern Arizona. Funds for computerization of data were provided by the Department of Anthropology at the University of Arizona. Time and space for analyzing data and writing were provided by a Weatherhead Fellowship at the School of American Research and by a postdoctoral fellowship at the Smithsonian Institution. My thanks to all these institutions for allowing me to complete my project. I wish to thank the University of Arizona Press for publishing this work.

Hospitality and friendship were extended by many, many people. First I am deeply grateful to the many Navajo sandpainters who allowed me to come into their homes, talk

with them and watch them paint. Their patience and desire to befriend a young woman who walked into their midst unannounced was extraordinary. I would also like to thank the many merchants who allowed me to interview them, photograph and record the sandpaintings in their shops and initiated me into the intricacies of the arts and crafts industry. My thanks also go to Marie Varenhorst, David Villaseñor, Rex Boulin, Conda E. Douglas, Fred Stevens, Jr., and the Atkinsons for information which allowed me to reconstruct the history of commercial sandpaintings.

I owe a particular debt of gratitude to the many people who gave me shelter when I was running short of funds while in the field and especially to Kate and Jack Rutledge and Patrick and Bobbi Culbert who both took me into their homes and nursed me back to health without accepting a penny in return. I also wish to thank my husband Richard Ahlstrom for guiding me through statistical and computer analyses, proofreading, bouying up my confidence, and generally giving me encouragement and support whenever I needed it. Finally and most importantly I would like to thank my parents who have loved and supported me all these years. We made my dissertation on which this book is based a real family project.

N. J. P.

INDEX

Aberle, David F., 7, 67, 127, 129, 130, 134, 135
Adair, John, 8, 49, 50, 127
American Anthropological Association, 32
American House Creative Art Gallery, 114
American Indian Film Groups, U. of California, 32
Amsden, Charles A., 8, 44, 45, 65
Anthropologists, role of, first reproduction by, 37; in preservation of religion, 28–29; in museums, 27; in publishing, 26–28; in secularization, 4, 23–30
Arizona Highways, 94
Arizona State Museum, 34, 37, 38, 111, 113
Armer, Laura, 27, 32
Art shows, Indian, 35
Arviso, Jesus, 23
Atkinson, Leroy, 106

Bahti, Tom, 95
Baird, Bonnie, 113
Beautiful on the Earth, 61

Bedinger, Margery, 49, 64
berdache, 26
Boulin, Rex, 107
Brody, J. J., 10
Brugge, David M., 10
Buffalo Museum of Science, 39
Bunzel, Ruth L., 126
Bureau of Indian Affairs, 8, 35, 107

Callaway, D. G., 8
Ceremony. *See* Religion
Chapman, Kenneth, 54
Coexistence of sacred and secular, 5, 75
Collections: by Anglos, 24; by singers, 23; Fred Harvey Co., 28; film, 32; museums, 27, 28, 39, 113, 114; of reproductions, 23–26; photographs, 24, 33; published, 26–27; private, 27; scarcity of commercial collections, 173; traders, 23; unwieldy, 172
Contemporary Crafts Museum, 113
Coolidge, Dane and Mary Roberts, 47, 63, 64, 68
Coulter, Mary Jane, 51

Cranbrook Institute of Science, 113
Cummings, Byron, 38
Curtis, Edward S., 24
Cushing, Frank, 10

Day, Charles, 23
Day, Sam Jr., 23, 51, 67, 100
Demonstrations and exhibits,
 33–39, 76–77, 106–107, 114
Dendahl, Henry, 53
de Ville, E. George, 100–105
de Ville, Mae (Mae de Ville
 Fleming), 100–104, 117
Dockstader, Frederick J., 112
Douglas, Luther A., 100, 107,
 110–114, 117
Drypaintings, 9–10
Duclos, Antoinette S., 42
Dunn, Dorothy, 54–57
Dyk, Walter, 127

Earth color paintings and painters,
 57–59
Easel art and artists, 53–56
Economic system of Navajos:
 borrowed items from Pueblos, 5,
 9–10; cash and wage labor, 6;
 handicrafts, 5, 7–8, 176–177;
 income from sandpaintings,
 145–147, 161–163, 189–190;
 livestock, 6; mixed economy
 with unpredictable resources, 7;
 place of sandpaintings in, 2;
 practical response, 7; role of
 trading post, 7–8, 175–176
El Navajo Hotel, 51–52
Ethnografiska Museet,
 Stockholm, 28
Euler, Robert, 28
Evans, Will, 44

Fishler, Stanley, 40, 68, 70
Forbes, Anne, 9
Fort Worth Childrens Museum, 113
Foster, Kenneth L., 28
Foster, Minnie Stevens, 118
Franciscan Fathers, 11, 23, 49, 62
Frisbie, Charlotte Johnson, 28, 80

Gallup ceremonial, 35, 36, 83
Gallup Ceremonial Association, 107

Haile, Berard, 12, 13, 15
Harvey Co., Fred, 28, 51, 60, 118
Henderson, Eric, 6, 72, 129
Hill, Willard Williams, 127
Holy People (Yei/Yeibichai):
 as subject matter in sacred
 sandpainting, 17–21; displeasure
 with inaccuracy, 125; displeasure
 with photographs, 31; isolated
 picture of, 38, 97; patient
 identified with, 19; persuadable
 deities, 93; unpredictable and evil
 deities, 86; in rugs, 41–46;
 individual decision to use, 66;
 in easel art, 54; types of,
 9, 51, 87, 94; in pictographs, 9
Hosteen Latsanith Begay, 31
*How to Do Permanent
 Sandpainting*, 119, 120
Hubbell, Roman, 28, 32, 67, 176
Huckel, John H., 27, 30, 51
Hyde Expedition, 46

Indian Arts and Crafts Board. *See*
 U.S. Dept. of the Interior
International Congress of
 Americanists, 32

James, George W., 44
James, H. L., 64
Johnson, Dale, 81

Kaplan, Bert, 81
Keur, Dorothy Louise, 9
Kielhorn, Lila M., 42
Klah, Hosteen, 25–27, 29, 33, 37,
 39, 46–48, 64, 68–70, 79, 110
Kluckhohn, Clyde E., 12–14, 19,
 20, 31, 81, 93, 128, 135
Krantz, Vic, 43

La Farge, Oliver, 35
Lamphere, Louise, 8, 128, 130,
 131, 134
Lange, Charles H., 40, 45

Learning/teaching: design and symbolism, 125; differences compared with other crafts, 126; education as a factor in starting, 160–161; experimenting, 122–124; kinship factors, 130–136; learning patterns affecting diffusion, 137–142; men/women, 132–134; observing, 122; outlining, 124; payment for teaching, 125; ownership of knowledge, 127; teacher-student relationships, 130–136; technical skills, 125; types of learning, 122–125

Levy, Jerrold E., 6, 8, 20
Liebler, H. Baxter, 62
Line, John, 31, 40
Los Angeles County Museum, 19
Low, Setha M., 31
Luckert, Karl W., 28
Lummis, Charles, 64

McAllester, David P., 28, 81
McNitt, Frank, 44
Mallery, Garrick, 10
Marketing of sandpaintings, 103, 113, 114; influences of, on art form, 179–180; colors, 186; eccentric shapes, 186; legends, 183; innovations, 185; quality control, 182; and signatures, 183; and subject matter, 184; and standardization, 182; submarkets, 164–173; fine art, 170–173; sandpaintings for gifts and home decoration, 167–168; sandpainting reproductions, 165; souvenir and tourist sandpaintings, 164–166; success, 189; techniques, 173–178; direct to customers, 177–178; indirect, 173–175; specialization, 179

Matthews, Washington, 23, 67–69
Miguelito, 27, 28, 30, 52, 66–68, 80
Motifs, sandpainting: Anglo use of, 60; economic considerations affecting, 179–197; education and communication, 62; in Navajo easel and mural art, 53–59; in pictographs, 9, 10; in rugs, 41–48; in silver, 49–50; in wall art, 50–53; new designs of, 94–96; published forms of, 59; Pueblo kivas, 9, 10; religious considerations affecting, 75–93

Murphy, Matthew M., 24
Museum of Navajo Ceremonial Art, 27, 32, 34, 39, 70
Museum of New Mexico, The, 28, 53, 61
Museum of Northern Arizona, The, 58, 101

Navajo concept of art, 1, 2
Navajo Medicine Man, the Sandpaintings of Miguelito, 27, 184
Navajo Medicine Man's Association, 33, 73
Navajo Tribal Museum, 61
Newcomb, Arthur, 24, 40, 64
Newcomb, Franc J., 24, 40, 47, 48, 53, 58, 61, 68–70, 75, 77, 80, 84, 92, 184

Oakes, Maud, 13–15, 27
Olin, Caroline Bower, 36, 40

Padres Trail, 62
Peabody Museum of Archaeology and Ethnology, 37
Pictographs, 9
Picture writing, Navajo mnemonic, 39–40
Pigments, 9, 57, 59, 102, 113, 115
Pottery, 8, 9, 126
Precautions taken by painters: avoiding dangerous subjects, 86; changing aspects of paintings, 75–84; prayers before and after construction, 110; precedents, 70; sings conducted for protection, 79–80, 82; singer performing cure, 79

Preservation of culture, 23–30, 105–107, 153

Rationalization for secularization, 28–29, 38, 41, 65, 74–78, 82, 93, 119, 126–127

Rationalizations for commercialization, 76–79, 82–86, 89, 93, 95–97, 106

Reactions of community, acceptance, 65; anxiety, 68; attempts to outlaw, 73–74; danger to Sheep Springs, 71; need for precedent, 67, 68; neutrality, 99; opposition, 71–74; singer's control, 65, 126–127; similarity to carvings, 74

Reciprocity, Law of: and fees for ceremony, 13; for reproductions, 30; for teaching, 30, 125, 135

Reichard, Gladys, A., 10–20, 29, 44, 48, 52, 53, 58, 61, 64, 67–70, 75–77, 79–81, 84, 88, 89, 93, 113, 126, 184

Religion, Navajo: ceremonial system, 11–14; changing, 5; chants of, 12, 13, 15, 24, 26, 41; and conflict, 4–5; and converting to Christianity, 157; curing, 1, 13, 14–20; and harmony, 12; and houseblessing using sandpainting, 52; and missions, 158; and patient-deity identification, 19; preservation of, 28, 29, 35, 41; and prophylactic ceremonies and measures, 12, 68, 80, 81; and ritual control of evil, 12; traditional, 9–11

Religious affiliation of painters, 96–99, 157–159

Sam Chief (Yellow Singer), 30, 37, 38

Sandpainter, sacred. *See* Singer

Sandpainters, danger to commercial, 15, 19, 20, 48, 63–64, 66, 68, 69, 86

Sandpainting ceremony, 14–21

Sandpainting, commercial techniques of, 102, 104, 112–113, 115–117

Sandpainting, origin of, 9–11

Sandpainting, sacred, 12–18, 77

Sandpaintings of the Navajo Shooting Chant, 26, 184

Santa Fe Indian Market, 35, 36

Santa Fe Indian School, 87, 99

Sapir, Edward, 65, 78

Schevill, Margaret E. L., 61

School of American Research, 54

Secularization, process of: and first movie, 32; preceded by commercialization, 4; and photographs, 24, 30–31; and publication, 26, 27; and reproductions, 23–30. *See* Demonstrations, Holy People, Weaving

Shiprock Fair, 44, 109

Silversmithing, 4, 8, 49–50, 64, 126–127, 136, 174–176

Singer (medicine man, *Hataali*), 11, 19, 21, 24, 65, 126, 127; ritual control of, 65; and role in creating rationalization, 29–30, 36–39, 52, 66–70, 75–80

Sloan, John, 35

Smith, G. Paul, 61

Smith, Dame Margaret, 42

Smithsonian Institution, Bureau of Ethnology, 31

Snodgrass, Jeanne O., 111

Social organization of Navajos: by clan, 128; and kinship relationships, 130; and residence patterns, 129; and role in diffusion, 137–142; and role in learning patterns, 130–136

Southwest Association of Indian Affairs, The, 35

Spread of sandpainting, 121, 136, 137–142

Staples, B. J., 34, 36

Stevens, Fred Jr., 39, 70, 73, 100, 105–118, 121, 135, 173

Stevens, Leroy, 118

Stevenson, James, 81

Tanner, Clara Lee, 43–44

Tapestries in Sand, 119

Taylor Museum (Colorado Springs Fine Art Center), 113, 114

Teachers of sandpainting. *See* Learning/Teaching
Tilden, Sam, 52, 61, 80
Tozzer, Alfred M., 37
Trafzer, Clifford E., 100

Villaseñor, David V., 7, 118–120

Walcott Collection, 55
Weaving, 4, 20, 41–48, 63–66, 76, 79–80, 126, 174–176
Westlake, Inez B., 35, 60
Wetherill, Louisa, 37, 43
Wetherill, Richard, 46

Wheat, Joe Ben, 42, 46, 63
Wheelwright, Mary Cabot, 27, 40, 68, 70
Wheelwright Museum. *See* Museum of Navajo Ceremonial Art
World's Fairs and expositions, 33, 35, 43, 46, 111
Wyman, Leland C., 11–15, 17, 19, 20, 24, 54, 62, 81, 84, 93

Yana-pah, 43–44, 65–66
Yei/Yeibichai. *See* Holy People
Young, Robert W., 7, 158